759.2

One Hundred Years
of
Traditional British Painting

One Hundred Years
of
Traditional British Painting

BY
ADRIAN VINCENT

DAVID & CHARLES
Newton Abbot London

British Library Cataloguing in Publication Data

Vincent, Adrian
 100 years of traditional British painting.
 1. British paintings, 1900-1976. Critical studies
 I. Title
 759.2
 ISBN 0-7153-9446-0

Typeset by Character Graphics, Taunton.
and printed in The Netherlands by Royal Smeets Offset, Weert,
for David & Charles Publishers plc
Brunel House, Newton Abbot, Devon.

CONTENTS

ACKNOWLEDGEMENTS

The assistance of the following art dealers and auctioneers in lending colour photographs for this book is gratefully acknowledged:

Bonhams (Auctioneers),
Montpelier Galleries, Montpelier Street, London, SW7.

Bourne Gallery,
31 Lesbourne Road, Reigate, Surrey, RH2 7JS.

Fine-Lines (Fine Art),
The Old Rectory, 31 Sheep Street, Shipston-on-Stour,
Warwicks. CV36 4AE.

Sir William Russell Flint Galleries Ltd.,
The Georgian House, Broad Street, Wrington, Bristol,
Avon.

Frost & Reed Ltd.,
41 New Bond Street, London, W1Y 0JJ.

David James,
291 Brompton Road, London, SW3.

Polak Gallery,
21 King Street, St James's, London, SW1Y 6QY.

The Priory Gallery,
The Priory, Church Road, Bishop's Cleeve,
Nr. Cheltenham, Glos.

Royal Exchange Gallery,
14 Royal Exchange, London, EC3V 3LL.

Brian Sinfield,
The Granary, Filkins, Glos.

Sotheby's,
Summers Place, Billingshurst, Sussex, RH14 9AD.

E. Stacy-Marks Ltd.,
24 Cornfield Road, Eastbourne, E. Sussex, BN21 4QH.

INTRODUCTION

The term 'British Traditional Art' is one which covers all forms of conventional art which have been practised by various generations of painters. The subject matter was unimportant so long as it conformed to the well-established (or traditional) rules laid down by the then rigid tastes of the Royal Academy and other similar bodies. The term is being used more and more in the auction rooms and private picture galleries to cover a wide variety of subjects, so that a marine subject may be referred to as a traditional painting and occupy a position in the same catalogue as a landscape. In most cases, the abstract paintings and those belonging to the various latter-day movements in painting are not included under the umbrella of traditional art.

British traditional painting has been with us for a long time – broadly speaking, from the seventeenth century, when it often showed influences from abroad. The Dutch school of marine painting is one such example: the van de Veldes came to this country and influenced maritime art for nearly a century, before the English marine artists found their own means of expression within the bounds of conventional maritime painting.

All the same, no serious assaults were made on the bastions of British traditional art until the mid-nineteenth century, when the Pre-Raphaelite movement was formed in 1848 by seven young men who had got together, determined to break all the existing academic rules and conventions by returning to the painting styles of the early Florentine artists, such as Botticelli and Gozzoli, to whom they ascribed a purity of motive completely lacking in much Victorian narrative painting. Ironically, in the end the followers of Rosetti and Burne-Jones turned full circle by producing works of art that were just as sentimental and specious as those aspects of Victorian art which Rosetti, Holman Hunt and Millais had so despised.

When their work first began to appear it was greatly admired by many critics for its use of large expanses of flat colour and the luminosity of its painting, achieved by applying the colours on a wet white ground. Eventually it was stifled by its own artificialities, so that by the 1890s it was as dead as the proverbial dodo so far as the fashionable buying public was concerned. Occasionally, however, its influences could still occasionally be seen, as in *A Maiden in the Glade*, by Henry Meynell Rheam (1859-1920) shown on page 44, where the meditative attitude of the subject and her medieval dress immediately evokes the work of some Pre-Raphaelites.

The intentions of the Brotherhood, as they had called themselves, had been admirable enough. Their aim had been to free British art from its mental laziness, which they considered had led it down a cul-de-sac, and to attack all that was held dear by the Royal Academy, whose fusty approach to art had always been something of a byword among those artists who aspired to paint something more than the ever popular large set-pieces. The cause of the Brotherhood's decline in popularity lay both in their choice of subject matter, often with literary connotations (which had led many of them to paint mawkish and quasi-religious subjects) and their style, in which the same fussy attention to detail was given to the background and middle ground as to the foreground. This latter was out of tune for an age that expected to find in a painting the sort of painterly realism the Royal Academy had so carefully fostered over the years at its summer exhibitions.

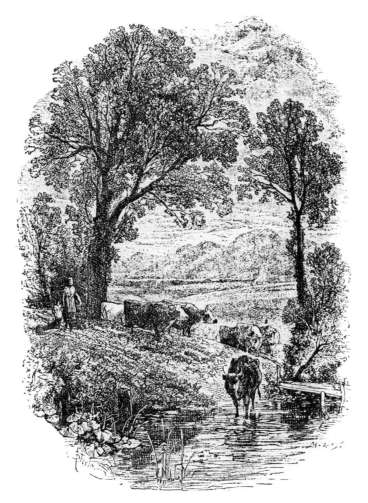

A new threat to British traditional painting came in the 1880s with the arrival of Impressionism in Britain, after artists like Degas and Monet had shown the way in France with their use of a bright palette and their attempts to show the effect of light on their subjects. Through the 1880s the two dominant influences on a new generation of British artists were Impressionism and the *plein air* painting of Bastien-Lepage. Three leading British painters who took up the trend of the Impressionists' concerns were Phillip Wilson Steer (1860-1942), Walter William Sickert (1860-1942), and James Abbott McNeill Whistler (1834-1903), but all three retained a wholesome respect for the old traditions of British traditional painting. In fact Steer, who had started off as a keen supporter of the French Impressionists, was to transfer his allegiance to landscape painting in the traditions of Constable and John Robert Cozens. As he grew older his work took on a more lyrical quality.

As for Sickert and Whistler, the former greatly admired the work of Degas, while at the same time holding the conviction that there was no basic difference between the old art and the new. He remained convinced to the end that the only lasting framework for an artist, was to acknowledge, in his work, his debt to the past. Perhaps this was why he remained a member of the Royal Academy, with all its hidebound traditions, until 1935, only seven years before his death. Whistler's excursions into Impressionism were to cost him dear. After being attacked in print by the critic John Ruskin, who accused him of 'throwing a pot of paint in the public's face' with his painting *Nocturne in Black and Gold – the Falling Rocket*, he sued Ruskin and was awarded one farthing damages, which led to Whistler being made bankrupt over the costs of the action. Although an innovator, his small seascapes and landscape paintings were little poems in watercolour and not all that far removed from some of the traditional painting of his time. As an etcher, he has been classed with Rembrandt and Goya.

By the time Whistler died in 1903, Post-Impressionism and Expressionism were having an impact on the art market spear-headed by the Fauves (the wild beasts) whose use of violent colours and contemptuous dismissal of all academic principles upset the more conservative critics. Some of the first pictures executed in this manner were by Matisse, who was to lead the group of French artists whose application of pure colour for decorative and emotional purposes was to have a revolutionary impact on modern art.

On top of all these onslaughts on British traditional painting, Cubism and the Futurist Movement were yet to

come in the years before World War I. In the face of all this, it would not have been surprising if British traditional painting had withered away for the sheer lack of artists to support it. Traditional painters of the rural scene had, moreover, to find a way to please viewers who, by the end of the Victorian era, were beginning to tire of pretty scenes adorned with winsome milkmaids and children playing among the buttercups of some pastoral Eden.

Surprisingly though, the mainstream of English traditional painting remained relatively untouched by all the newly emerging forms of art. Narrative (genre) painting, for instance, was still as popular as ever. Leading practitioners of genre painting at the turn of the century included Sir Frank Dicksee (1853-1928), Sir William Quiller Orchardson (1832-1910) and Sir Hubert von Herkomer (1849-1914). The fact that all of them had been knighted bears testimony to the lasting popularity of the old school of genre painting, which had achieved a degree of respectability seldom found in earlier years (unless under royal patronage, such as several of the marine painters had been).

The reputation of Frank Dicksee, a product of the Royal Academy Schools, was made by his painting *Harmony*. It gave more than a passing nod to the Pre-Raphaelites, with its study of a young man raptly watching a girl playing an organ and with the whole scene illuminated by light coming through a stained glass window. Dicksee's future was doubly assured when it was bought by the Chantrey Bequest, part of a residuary estate left for the encouragement of British art by the well known sculptor, Sir Francis Chantrey, on his death in 1841. As the estate had been managed by the Royal Academy since 1875, it inevitably reflected the taste of the RA, rather than what was actually the finest art around at the time. To be fair, though, it has to be said that some excellent paintings were bought by the Bequest, and it certainly launched many worthy artists on their road to fame. Dicksee attended an art session at the Langham Sketching Club where members had been asked to make sketches on the theme of music, and *Harmony*

was the resultant painting.

Although he eventually concentrated on portrait work, Dicksee continued to paint genre pictures, including *The Two Crowns*, which was exhibited in 1900 and was voted Picture of the Year by the *Daily News* readers. This picture, now with the Tate Gallery, was also purchased by the Chantrey Bequest. A lifelong supporter of the RA and its traditional values, Dicksee eventually became its president in 1924 and was knighted the following year.

Sir William Quiller Orchardson was born in Edinburgh and lived long enough to see in the Edwardian period. By the time he was twenty he had mastered the essentials of his craft, mainly at the Trustees Academy, before coming to London in 1862, where he lived at 37 Fitzroy Square. Although by then he was already a superb artist, with the ability to use empty space with telling effect, his work did not immediately attract attention, probably because it was too quiet for a viewing public which had been used to the arresting, though often meretricious type of painting, that was then being shown at the Royal Academy.

To begin with, Orchardson's subjects had indeed been quiet ones that reflected his inward-looking and rather dour personality. The period from 1862 to 1880 had been one in which he had continued to work while awaiting the right subject that would appeal to him and to the public.

Fame came to him at last in 1881 with his large oil, *On Board the Bellerophon*, in which he showed the brooding figure of Napoleon taking his lonely farewell of France from the deck of the ship that was taking him to exile. It was a picture that made Napoleon a figure of sympathy (which he hardly deserved after having laid waste the manhood of Europe), but it caught the public's imagination, and was to become one of Orchardson's most famous paintings, adorning the walls of countless boarding houses as a print for many years. Twelve years later the artist again painted Napoleon in *The Last Phase*, in which he depicted him as a bald and gross-looking figure dictating his memoirs to his secretary. Later he exhibited a series of drawing-room pictures in which great care had been taken with the painting of the furniture and costumes of the early nineteenth century. Two of his paintings, which have now become famous and show him at his best, were *Mariage de Convenance* and *The First Cloud*, painted in the 1880s. The first painting marked his move to depicting characters in modern dress, and is a biting social study of an obviously rich and elderly man facing his bored young wife across the dinner table. The aridity of their relationship is emphasised by the dark empty spaces around them that serve to heighten the gulf between them, already made obvious by the expressions on their faces. With his painting *The First Cloud*, Orchardson again made a telling use of space, with the two figures in the painting again widely separated, with the woman sweeping from the room while her husband watches her go with a set expression on his face. The husband, incidentally, was posed by the artist Tom Graham, a friend of Orchardson's from their days as

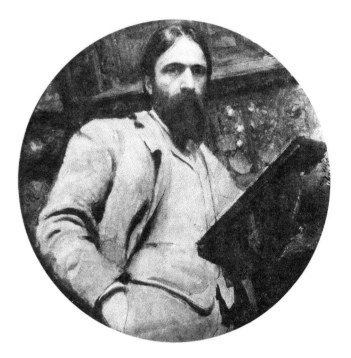

students at the Trustees Academy. The tableau, with the wife making her exit is almost like a curtain scene from an Edwardian stage play.

The Bavarian Hubert von Herkomer was brought to England when he was eight by his father, who was a wood carver of some ability. While living with his father he received his initial training at the Southampton School of Art, and then went on to study at the South Kensington Schools. He exhibited for the first time at the Royal Academy in 1869, but did not become famous until 1875, when he showed his painting *The Last Muster, Sunday at the Royal Hospital, Chelsea*. He was only twenty-six at the time, but it was a painting he was to remember all is life, as his wife was dying in the bed beside him while he worked.

As an artist who was steeped in the traditions of genre painting, and who had gone on record as saying that it was in England he learned that 'truth in art should be enhanced by sentiment' — a statement that would be greeted with derision today — he painted many oils in which he followed this precept. He combined social realism with a sentiment that was never cloying, though there were times when he went out of his way to play to the Victorian love of melodrama. His best paintings in this genre were *On Strike*, exhibited at the RA in 1891, and *Hard Times*, which is now in the Manchester Art Gallery.

A highly industrious man who seemed to be able to turn his hand to anything in the field of art, von Herkomer also painted portraits, including among his illustrious patrons Richard Wagner and Lord Kitchener. He founded a school

of art at Bushey, Hertfordshire, composed music and designed stage scenery, as well as turning out an enormous number of illustrations for such popular magazines as *The Cornhill Magazine* and *The Quiver*. He was knighted in 1907.

It was a period when this type of narrative painting was at the height of its popularity, with the art market being flooded with paintings that were famous in their day. Frank Topham's *Rescued From the Plague*, William Frederick Yeames' *When Did You Last See Your Father?* Alexander Stanhope Forbes' *The Health of the Bride* and William Stott's *The Ferry*, as well as many others too numerous to mention here, all made their appearance more or less in the last decade of the nineteenth century. Some may make us wince with their calculated sentimentality, but there is no denying the quality of the painting and draughtsmanship that was put into most of them.

While artists like these were trying to capture the imagination of the public with their narrative paintings, the landscape artists were trying to match their success in the market with their studies of the English, Scottish and Welsh landscapes: notably George Vicat Cole (1833-1893) who was one of the most popular landscape artists of the late Victorian period. (See page 53 for an example of his work.)

Although some paid their dues to artists like Constable and David Cox, the work of many landscape artists was undergoing a subtle change, in as much as there was far less striving after the sorts of effects needed to make a painting stand out in the badly lit rooms of the nineteenth century.

For an instance, an artist like Arthur Winter Shaw (fl. 1891-1936) no longer felt it necessary to paint highly detailed pictures in strong colours. Instead, he used pale washes on most of his watercolours, although when using oils he would invariably strive to catch the subtle effect of light on a country landscape, giving it an attractive luminous quality as with his oil shown on page 72.

Shaw was just one of thousands of nineteenth-century artists who worked well into the twentieth century. There is space only to mention a few.

There was Henry Tonks (1862-1937), a late-comer to painting. Although he had been vaguely attracted to art school, he trained to be a surgeon, first at Sussex County Hospital in Brighton and then at the London Hospital, where he began to be absorbed by drawing. But it was not until he had won his Fellowship to the Royal College of Surgeons, and eventually had been appointed Senior Resident Medical Officer at the Royal Free Hospital, that he perversely turned his back on medicine to become an artist. Working in oils and watercolours, he painted figure subjects, interiors and landscapes. An irascible man with an off-putting icy stare, he does not seem to have been a very likable person. His sarcastic remarks, aimed mostly at his women students while he was teaching at the Slade School of Art, were well known, and could not have endeared him to his pupils. On the other hand, he could be most kind and helpful to those whom he considered showed promise. In contradiction to his appearance and manner, he was basically a painter who found poetry in ordinary things. 'A painter who is not a poet ought to be in stocks,' he once wrote. As an artist whose roots were firmly in the eighteenth- and nineteenth-century art, he hated Impressionism and Post-Impressionism, although he was a member of the New English Art Club, which had been formed in 1885 by a group of artists as a protest against the academic art of the Royal Academy, and to provide a venue for exhibiting their work.

Most of the club members had been trained in foreign schools, and they included some of the most important names of their time in art. Though it was in no way a revolutionary body, to have listened to the academicians of the time one would have thought otherwise. Most academicians saw no future in it, and Lord Leighton, an ar-

tist of considerable ability and President of the RA for some years, doubted whether the club would last for three years. It remains in existence today, holding annual exhibitions.

A well-known landscape artist of this period was John Birch, better known as Lamorna Birch (1869-1955) after he had changed his name to avoid being confused with another John Birch who was painting in Newlyn at the time. Although he had had some training, he was basically a self-taught artist who settled in Lamorna, Cornwall, in 1902, where he took on his acquired name at the suggestion of Stanhope Forbes, leader of the famous Newlyn School.

Born in Egremont, Cheshire, Lamorna Birch began his working life as an industrial designer in a linoleum factory in Manchester, while spending all his spare moments painting and building up a small local reputation as an artist. In 1889 he visited Newlyn, where he met Stanhope Forbes who advised him to study in Paris. Taking his advice, he went to Paris, but stayed there for less than a year studying at the *atelier* Colarossi, where he came under the influence of the Impressionist painters Monet and Camille Pissarro, whose style he later adapted to suit his own for his paintings of Cornish and Scottish landscapes.

Shortly after he had settled in Lamorna he bought Flagstaff Cottage, the harbourmaster's house overlooking the bay. At the same time he made for himself two studios in a nearby wooded valley, one near a stream, which gave him unlimited opportunities to indulge in his fanatical passion for fishing. It was by this stream that he began to try to capture, with his brush, the movement of running water with the sun playing on it as it gently swirled downstream. One of the many paintings of this stream is illustrated on page 33.

Lamorna Birch travelled widely, often for no other reason, one suspects, than to find a new place to fish, although he was always careful to keep his eyes open for new, worthwhile subjects to paint. Apart from touring around England, Scotland and the Continent, he also vis-

HENRY TONKS
(British Museum)

ited Australia and New Zealand. But however far and wide he travelled, he was always glad to get back to his beloved Lamorna, where he died at the age of eighty-five.

An even more important landscape artist who was very active at the turn of the century and beyond was Sir George Clausen (1852-1944), whose work was greatly influenced by the French painter Bastien-Lepage, the founder of *plein air* painting. Although he became famous almost overnight with his oil *The Girl at the Gate*, which was painted very much in the style of Bastien-Lepage, Clausen was to turn his back on this form of *plein air* painting and seek his inspiration in the work of Courbet, whose work he had come to admire because he considered that in his paintings, 'everything has been cleared away but the essentials'. Despite these two models for much of his work, he remained a typical Victorian artist whose paintings of the rural scene were often little more than pretty postcard pictures that gave no indication of the true social conditions of their subject matter.

During the early part of his career as a painter he had belonged to the New English Art Club, but this must have been more a matter of expediency than anything else, as, once he had become established, he transferred his allegiance to the Royal Academy, which made him an RA in 1907. By the time World War I had broken out he had become very much a member of the Establishment, painting *In the Gun Factory at Woolwich Arsenal* for the Ministry of Information. His *The English People Reading Wycliffe's Bible* was painted at a later date for the House of Commons and led to his being knighted in 1927.

Clausen continued working until he was in his nineties, by which time he was painting small watercolours of the Essex countryside around his home at Dutton Hill. By then he had also become very much a 'grand old man' of art, who was able to look back on a long and highly successful career as an artist.

A landscape artist not unlike Clausen was Edward Stott (1859-1918) who had also come under the influence of Bastien-Lepage. He was also a devoted admirer of the work of Millet, who had spent twenty-seven years painting gritty, realistic studies of French peasant life. Like Millet, Stott painted scenes of everyday country life, usually after hav-

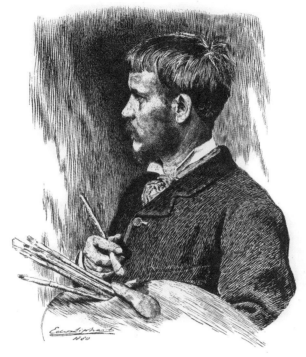

BASTIEN LEPAGE
(*British Museum*)

ing first made chalk studies of the animals and people he was going to put into his painting.

Born in Rochdale, he studied art in Manchester before going on to the Ecole des Beaux Arts in Paris. He eventually settled in Amberley in Sussex, where he spent the last twenty-nine years of his life painting his idyllic scenes of country life. On his death he left £25,000 to the RA to provide travelling scholarships for its students.

Stott's work is similar to that of Henry Herbert La Thangue (1859-1929), another painter in oils and watercolours of landscapes and rustic scenes. Both had come under the influence of Bastien-Lepage, whose early death in 1884 had been almost ignored by the English critics, thanks mainly to the vicious attacks made on his work by Whistler and Sickert. In one obituary of the time the writer condescendingly referred to him as being 'the author of a sort of new departure in landscape art'. Considering the enormous influence he had on the work of so many of the British landscape artists, to say nothing of the Newlyn School of painters (see page 86 for a typical example of their work), the lack of response to his death at the time is quite incredible.

La Thangue trained at the Royal Academy Schools and in Paris, and became an artist of amazing technical vigour. He was an uncompromising interpreter of rural subjects whose paintings come as a great relief after the work of the many lesser Victorian artists who specialised in painting sentimental rural scenes.

He became a member of the New English Art Club in

1886, mainly because of his detestation of the Royal Academy and all it stood for. Having referred to it as being 'the diseased root from which all other evils grew', he then began to exhibit at the RA, eventually being elected an RA in 1912. Many other artists who belonged to the New English Art Club have been accused of betraying it later by joining the RA. In the case of La Thangue, one can only hope that he had become an RA merely to attack the enemy from within.

Almost until the year of his death La Thangue was looking for some new, unspoilt, and hitherto undiscovered village where he could live among the sort of rural 'characters' he liked painting so much. His search was doomed to disappointment, because by the end of World War I, the sort of quiet rural retreat he was looking for had all but disappeared.

Other artists who were still flourishing up to World War I included Alfred Augustus Glendening, Snr. (fl. 1861-1903), a London landscape artist who had begun his working life as a railway clerk, Robert Gallon (fl. 1845-1925), who had been exhibiting at the Royal Academy and all the major galleries since 1868, Henry John Yeend King (1855-1924), who generally painted in bold colours and made use of the *plein air* technique, Thomas MacKay (fl. 1893-1913), a Liverpool watercolour artist whose work is always recognisable for its hazy poetic quality, and William Tatton Winter (1855-1928), who painted mostly around Surrey and Kent.

Other figures painting around this time were B.J. Williams (1831-1923), who later added the surname Leader to his name so that it would not be thought that he was a member of the Williams family of artists, and Charles Brooke Branwhite (1851-1929), who was the son of C. Branwhite, the Bristol landscape artist who was well known for his frost scenes. Like his father, Charles Brooke Branwhite was capable of painting fine atmospheric landscapes, both in oils and watercolours.

Examples of the work of all the artists mentioned are to be found in the colour section of the book.

With the changes in attitude wrought by World War I, 'narrative' or 'genre' became derogatory terms in painting, and works that had once brought pleasure to thousands became outmoded. Almost overnight, the artists who had specialised in paintings of this sort now found themselves relegated to the attic room of art; their work now seemed fit only for magazine illustrations, or to provide colour plates illustrating the text of famous events in a child's history book.

It is not really surprising that this should have happened during those grim war years. The lighting restrictions, the ever-dwindling supplies of food, the shortage of news from the Front, and the daily casualty lists were the sorts of things that occupied people's minds to the exclusion of almost everything else. If they wanted to take their minds off the war by looking at pictures 'that told a story' there was always the little cinema around the corner where they could look at *moving* pictures.

The war also killed off for all time the worst sentimental excesses of the painters of the rural scene. With the death toll on the Western Front steadily mounting, no one was in the mood to buy one of those cosy, nostalgic pictures of a form of country life that had never really existed anyway, outside the artist's imagination. The fact that they are now very much in fashion once more says a lot for the quality of work that was put into much of this type of genre painting.

Otherwise, British traditional art went on its steady course, producing from time to time such notable artists as Harry Watson (1871-1936), whose superb oil *Crossing the Brook* is reproduced on page 35 and Henry James Sylvester Stannard (1870-1951) a now famous watercolour artist who specialised in painting rural landscapes, often with a tumbledown cottage in them as the focal point. In 1924 one of the most famous of all the modern British landscape painters began his career by winning a special prize at the Royal Drawing Society; his name was Edward Brian Seago (1910-1974) and he was only fourteen at the time.

Seago was born in Norwich on 31 March 1910, and was to be intimately connected with East Anglia all his life, though his work often took him to many places abroad (see biographical details). He was one of the very few modern artists who was able to capture weather effects on a landscape, as Constable had done in his own time. No one could paint better than Seago those famous flat landscapes dominated by the great open skies of Norfolk, which can suddenly change from a cloudless blue to a sky filled with storm-laden clouds, all of it often caught with little more than a few deceptively simple washes in his watercolours. A fine example of his work is to be found on page 49, where his work is discussed in far more detail.

Another famous artist of the time was Russell Flint (1880-1969), who was still flourishing when Seago was beginning to make his reputation. Although best known for his semi-nudes, set against a Spanish background, Flint painted many fine landscapes in watercolours at the early part of his career, before turning to the sorts of paintings

on which his popularity has always rested.

The one area of art where there have been no great revolutionary changes is in marine painting – that most traditional of all the British art forms. Even today, a modern marine artist like Robert Stephen Dews (born 1949) still prefers to paint the old type of sailing vessels, probably for much the same reason that so many other modern marine artists opt for painting the old-time sailing ships – they dislike the look of modern shipping. (See John Worsley's comments on page 13.)

On the other hand, there were marine artists who were far more interested in the sea than in the ships that sailed on them. Such an artist was David James (fl. 1881-1897) who painted along the coasts of Devon and on the Scilly Isles, and is known for his studies of ships sailing on blue seas. His work has been likened to that of Henry Moore (1831-1895), who tried to capture in his paintings the restless and unpredictable movements of the sea, and is considered to be one of the finest sea painters of his time.

Very little is known about David James, except that he lived in Plymouth for a couple of years before moving on to Bowden, Devon, where he stayed for less than a year, before moving on yet again to Dalston in Cumberland. He is known to have exhibited at least four times at the RA.

By 1900, at least the constricting shackles of the highly formalised Dutch School of marine painting had, at long last, been shaken off. Gone forever, outside the walls of an art museum, were those oil paintings of men-of-war sailing into battle with their cannons belching smoke and flame. In their place were now modern ships of commerce sailing to some distant port, sunbathed studies of the old sailing ships done in the *plein air* style, yachts skimming across the waters and studies of fishermen at work on the sea, dredging the depths for yet another silvery catch to take home – to mention only a few of the subjects that now engaged the brushes of maritime artists.

Probably one of the best known artists who painted with a fresh outlook on marine art was William Lionel Wyllie (1851-1931). He began to exhibit at the Royal Academy as far back as 1868 and worked in his studio, overlooking Portsmouth Harbour, almost until his death in 1931. He had always been known as a prolific painter, but no one realised just how enormous his output had been until his death, when some 5,000 unsold paintings were discovered in his studio. These were bought for the proposed National Maritime Museum at Greenwich, which was eventually opened to the public in 1937. From the many examples of his work around, his splendid oil, *Spritsail Barges Under Sail*, is reproduced on page 92.

Another such artist was Edward Dixon (1872-1934), whose watercolours have been acclaimed for their lively studies of shipping on the Thames. In many of his paintings, in oils and watercolours, ocean-going liners fight for space in the waters with paddle tugs, yachts and the local fishing smacks. A lively example of Dixon's work is illustrated on page 94.

One of the most interesting maritime artists belonging to this period was Thomas Jacques Somerscales (1842-1927), who had the doubtful pleasure of spending twenty-seven years in Valparaiso and Santiago, Chile.

The son of a sailor, he had received a decent education in Hull and Cheltenham before joining the Royal Navy as a teacher in 1862. He sailed in the flagship *Zealous* to the South Seas, where he picked up a fever in Tahiti. He was transferred to another ship, but it soon became apparent that his health was not improving, and at his own request he was invalided ashore at Valparaiso in 1865.

In those days Valparaiso was little more than a series of dirty streets bounded by some evil-smelling beaches on one side and a series of barren hills on the other. It was also much subject to earthquakes. What Somerscales thought of it all can only be imagined, but one can be reasonably certain that he was not impressed. Nor could his opinion of the place have been improved when it was bombarded by the Spanish fleet in 1866, which left a large part of the town in ruins. After that, most men would have caught the next ship home. Instead, Somerscales stayed there until 1892, finally departing for Hull with a wife on his arm and four sons in tow.

As it turned out, the time he had spent in Valparaiso had not been wasted, although it had started off badly. On his arrival there he had been offered the post of drawing teacher to one of the local schools, only to find himself promptly sacked for refusing to attend morning prayers. Two of his colleagues, including George Sutherland, whose sister he was to marry in Valparaiso, left with him, and together the three set up a school of their own. It was at this stage in his career that Somerscales seriously took up painting for the first time.

When he finally departed for home he left behind a large number of useful contacts, which led to one of them commissioning him to paint *The First Naval Squadron of Chile*, which he took back to Chile on one of several return trips there. The painting was hung in the National Congress of Santiago.

In 1893 he exhibited his first picture at the Royal Academy. He painted many pictures after that, including studies of ships off the Chilean and British coasts, but it was not until his oil, *Off Valparaiso*, was bought by the Chantrey Bequest that he became famous. It is now in the possession of the Tate Gallery. An example of his work is illustrated on page 85.

Other Victorian artists who were still extremely active during the early part of the twentieth century included George Stanfield Walters (1838-1924), who was highly prolific and who painted a large number of coastal scenes, both in oils and watercolours, and Frederic Winkfield (fl. 1873-1920), a Manchester man who settled in London and exhibited twenty-one pictures at the Royal Academy, as well as a large number of others at all the major London galleries. An example of this latter artist's work may be seen on page 95. Another was John Terrick Williams (1860-1936), an artist with a distinctive style that shows the influence of the Impressionists. One of his oils, *Harbour Scene Low Tide*, is reproduced on page 92.

Around this period the now internationally famous Montague Dawson (1895-1973) was beginning to make his name with his paintings of the old style sailing ships scudding along in full sail, before a strong breeze. This eventually led to his being called 'the King of the Clipper Ships'. His career began to take off during World War I, shortly after he joined the Royal Navy. While he was stationed at

JOHN WORSLEY'S 'ALBERT'

Falmouth he met the already well-known marine painter, Charles Napier Hemy, whose work was greatly to influence his own paintings. (See page 83 for Hemy's oil, *The Fisherman*, a particularly fine example of his work.) About this time also Dawson began to contribute illustrations to *The Sphere*, which were mostly in monochrome.

Although he had never had any formal training, his father was Henry T. Dawson, a self-taught marine artist who had exhibited twenty-eight pictures at the RA and was an enthusiastic yachtsman. It was therefore fairly inevitable that the son should have had a natural talent for painting, which was channelled into marine painting.

After Dawson was discharged from the Navy, he took up painting as a full-time occupation. His progress since then, to his present eminence as a marine artist, was one in which his reputation was steadily built up under the careful guidance of the fine art dealers Frost & Reed, who have handled all his output and reproduction rights since the 1920s.

As well as exhibiting occasionally at the Royal Academy, Dawson's work was also seen regularly at the Society of Marine Artists, which came into being in 1939, with the marine artist and illustrator, Charles Pears, as its first President. Its activities were brought to a halt by World War II, but it surfaced again in 1946, and has since helped to give enormous impetus to the work of many marine artists by holding annual exhibitions of their work in the Pall Mall Galleries in London. The work of two of these artists are represented in this book.

The better known of these two is probably John Worsley, whose long and distinguished career in the field of marine painting rivals that of Montague Dawson. It is a career that includes having been one of the very few official war artists to be actively involved in the hostilities of World War II. After surviving the sinking of his first ship in November 1940, he eventually was appointed official Naval War Artist on the staff of the Commander-in-Chief, Mediterranean, who had received instructions from Admiral William James 'to get in the lion's mouth'. After taking part in the landings at Reggio and Salerno, as well as in other coastal operations, Worsley found himself in Malta for a short while before going to record the naval front opening up in the Adriatic after the fall of Italy. It was then that, characteristically, he put his painting aside for a while to take part in the daring plan to ferry some 2,000 British prisoners of war from Veneto to Yugoslavia, before the Germans could recapture them. This time, however, his luck ran out. The Germans counter-attacked and he was captured with some of Tito's partisans and the small group of British sailors who had taken part in the operation.

He was sent to the POW camp Marlag 'O', near Bremen, where he promptly involved himself in an escape plan which, for the idea to succeed, needed a dummy naval officer to be made. Worsley made the dummy and the escape was a successful one. The incident was subsequently woven into a film called *Albert RN*, in which a dummy, such as the one that Worsley had made, played an important part. The film is still to be seen occasionally on television.

One would have thought that, after all those hectic war years, Worsley would have settled down to a quiet existence, painting away in some coastal region. Instead, after painting a number of pictures for the Imperial War Museum, he went to work in Canada and the USA for the Esso Standard Oil Company, where he painted the life and activities of the men working in the oilfields of Alberta, Texas, Oklahoma and Louisiana.

Worsley still leads a very active life, working in his studio in Putney, London, doing glass engraving, sculpture and marine painting, as well as being President of the RSMA. (See page 87 in the colour section of this book for an example of his work.)

The other member of the RSMA whose work is represented in this book, on page 91, is Roy Cross, who originally made his living as a freelance artist in the technical and engineering fields before moving on to produce art for the industrial and advertising world. This no doubt accounts for his meticulous draughtsmanship, which is apparent in every picture he has painted since he became a marine artist. Many of them now grace the walls of boardrooms of famous companies. The largest influence on his work has been that of Montague Dawson and, like Dawson, his work also reflects his leanings towards painting old-time sailing ships. This means countless hours of research and study before he even puts a brush to canvas.

(Limited editions of prints taken from some of his oils have been published in Sweden, the USA and in Britain.)

One can only hazard a guess as to the way that maritime art will go in the future. We have reached a stage where many of today's marine paintings have strong blue seas and ship's paint that is whiter than white. This is very much in accordance with the tastes of modern viewers, more accustomed to the use of the colour values they see on their television screens, than to the soft muted colours used in so much of nineteenth-century painting.

Another factor must surely play its part in all this: in a maritime world where seas are so often occupied by drab-looking tankers, freighters and other unromantic-looking

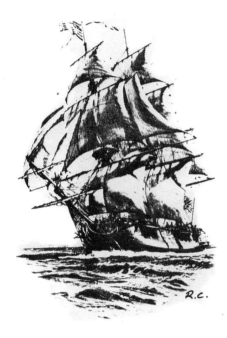

vessels, the present-day marine artist must be hard put to inject any colour in his work when painting this type of shipping, which John Worsley has referred to as 'just lumps of metal with engines attached'. One can see what he means and there is no immediate answer to it, except by going back to the past, as so many of today's artists have done, by painting the old sailing ships. This may seem a retrogressive step but, judging by the enormous popularity of Montague Dawson's sailing ships, there are worse ways to deal with the problem for any talented artist who wants to obtain a decent standard of living from his work. At least it maintains a form of traditional painting that has been going on in this country since the beginning of the nineteenth century.

In the area of animal art, one might have hoped that with the death of Landseer in 1873, we had seen the end of this type of animal artist whose *The Highland Shepherd's Chief Mourner* and *Dignity and Impudence* had been painted with a knowing eye cast in the direction of the Victorians' love of every sentimental cliché in the book. But

they still continued to appear, those paintings of doggy pathos, perpetuated by artists like Landseer and Briton Reviere, whose *Fidelity*, depicting a sad-looking, liquid-eyed dog showing concern over his master's grief, satisfied all the demands of the Victorian public, in as much as it told a highly emotive story.

One of the few artists who avoided painting in those terms was Henry Stacy-Marks (1829-1898), a genre and animal painter, who spent countless hours sketching them in London Zoo, finding much in the way of droll humour in their behaviour. It must be emphasised, however, that he was never a humorous artist, but rather one whose intense love of birds never betrayed him into being sentimental about them. Mercifully, he never tried to turn them into comic 'characters' or to give them human attributes.

It was inevitable in an age where the horse was still the main form of transport that it should become a favoured subject for any artist whose talents lay in the direction of animal painting. After the death of George Stubbs in 1806, the mantle of being the major British horse painter fell on the shoulders of George Frederick Herring (1785-1865), a coachman-turned-painter, whose work became so popular in his lifetime that he was able to lead the life of a country squire. Of his three sons who also painted, probably the best known of them was John Frederick Herring, Jnr. Many of his paintings have been compared to his father's work, but the son's paintings have a charm of their own and were painted with a fastidious attention to detail. (See page 71 for a typical example of his work.)

With an animal artist like Frank Paton (1856-1909) we are back in the saccharine world of those Victorian artists who capitalised on the charms of the domestic cat. As with most animal artists, he concentrated on the ways of the cat when it was at its most charming and on its best behaviour, rather than when it was tearing up the furniture with its claws or hunting birds.

Among all the cat artists who were around at the time, the most famous was Louis Wain (1860-1939), whose humorous, but somewhat bizarre, pictures of cats in human situations were vastly popular with the public right up to the early thirties, thanks mostly to the tremendous success of the *Louis Wain Annuals*, which appeared from 1901 until 1921. These annuals were sold in their thousands in their time, but it is now almost impossible to find a single copy of any one in the secondhand book-shops. Sadly, that early success was to end suddenly when Louis Wain became insane and had to be committed to a lunatic asylum.

Wain had always been considered something of an eccentric, but it was not until the early twenties, when he moved to 41 Brondesbury Road in Kilburn, that his madness surfaced. His frightening displays of temper were directed mainly against three of his five sisters, who were constantly being attacked and accused of selling his personal property and stealing his cheques. To make a fairly impossible situation worse, he began to rearrange the fur-

niture endlessly, sometimes getting up in the middle of the night to rearrange it yet again.

I spent my earliest childhood in this area, in Victoria Road, just around the corner from where Wain and his three surviving sisters must have been living at the time, and I remember it distinctly as being a highly respectable area, full of large Victorian houses looking out on to streets lined with plane trees, where the stillness of a routine day was disturbed only by the calls of the muffin-man or the cats' meat-man, and the clatter of hooves as the milkman and his horse made their rounds. So one can guess only too well what the neighbours thought of the constant commotion going on in the Wain household.

In the end, the situation got so much out of hand that a doctor had to be called in. Schizophrenia was diagnosed and in June 1924 Wain was certified insane and taken to Middlesex County Asylum in Tooting. Another fifteen years were to pass before Wain died in 1939 in the happier atmosphere of Napsbury Hospital, near St. Albans, where he had been able to spend his last years, thanks to the kindness of strangers who raised a subscription so that he might enjoy less grim surroundings. The details of the onset of his madness is discussed in more detail on page 75 where one of the two pictures illustrating his work shows the beginning of his insanity.

CRACKER THE BULL TERRIER

Cecil Aldin (1870-1935), whose charming canine studies must be known to almost everyone who loves dogs, was an artist whose paintings and illustrations are obviously the work of a man who was at peace with himself and the world, unlike Louis Wain, whose work always had a faintly unhealthy air about it. His cheerful outlook on life is most apparent in his autobiography, despite its morbid title *Time I Was Dead*, which was published in 1934, only a year before his death. One of his pictures appears on page 74.

His first ambition while at school was to become a coachman, marry his governess and drive her to church every Sunday, this ambition being brought about after he had been taken to see the Lord Mayor's Show. His parents, being somewhat more realistically inclined, sent him off to study art under Albert Moore, a well-known neo-classical artist, whose studies of Grecian ladies lolling around in diaphanous draperies, made him the last person for Aldin to study under, as his fondness for dogs was already becoming apparent. Wisely, Aldin left and took himself off to study animal anatomy at the South Kensington Art School.

A few months later he happened to attend a dog show and was busily sketching when he was approached by someone who suggested he should go and see a Miss Emily Moore, the owner of the Swan Hotel at Leatherhead, and a great lover of dogs. The upshot was that he was given a commission to sketch her Irish terrier. It was probably the worst sketch he ever made but it launched him on his career as a highly successful artist and illustrator of hunting scenes, old coach houses and studies of his favourite models and pets, Cracker the bull terrier and Mickey the Irish wolf-hound.

His death on 6 January 1935, was front page news, for by then his name was a household word. Even in America

his passing was noted by *The New York Times*, which referred to him as 'the leading figure in the revival of English sporting art.'

Actually, *The New York Times*' comment was something of an exaggeration, as other sporting artists of some stature had appeared on the scene long before Cecil Aldin's death, notably John Emms (1843-1912) and Lionel Edwards (1878-1966), who were both leading sporting artists who specialised in painting hunting scenes, though both lacked the humour that was apparent in most of Aldin's work. Of the two, Lionel Edwards was the more important artist. His work has always been most popular with the hunting set, many of whom probably own some of the books illustrated by Edwards. Somewhere between Edwards and Emms lies the work of Heywood Hardy, an example of whose work may be seen on page 81.

George Wright (1860-1942) is another artist whose work should not be ignored, as he was one of the best sporting painters of his time, especially when he was painting a hunting or coaching scene. His work has now risen sharply in value over recent years and is now much sought after by collectors of this type of painting. An example of his work is illustrated on page 82.

The height of the Edwardian period also saw the growing popularity of game bird painters such as Archibald Thorburn (1860-1935) and Henry Stannard (1844-1920). Their main patrons were members of the monied class, who saw nothing strange in wanting to hang the work of bird artists on their walls and slaughtering the game birds in their thousands during a weekend shoot. Many of the large estates in those days employed as many as twenty gamekeepers merely to maintain stocks of game birds that were reared in pens and then eventually released and shot during the season which began, and still does, on the 'glorious 12th' (of August). Not that this seemed to worry unduly the game bird artists. But then this was a time when tiger shoots in India were organised just for the fun of it.

Many artists of the late twenties and early thirties, while

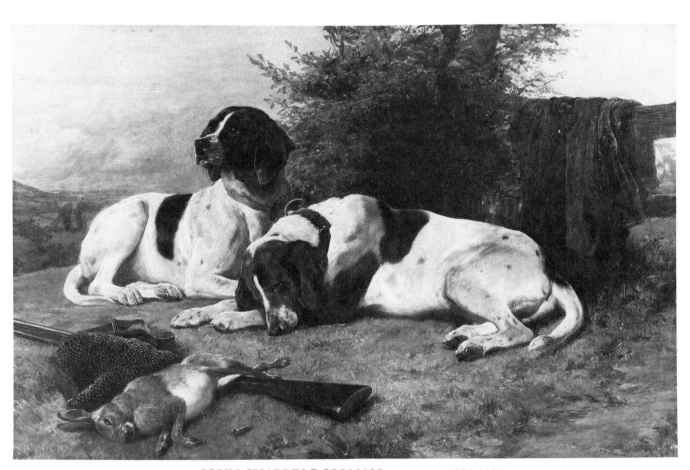

JOHN CHARLES DOLLMAN RWI RI ROI 1851-1934

An example of the work of John Charles Dollman who exhibited at the RA and other major galleries from 1872 until 1934. He first made his name as an historical and genre painter, but later became more famous for his studies of sporting dogs, such as the one shown here. In subject matter, a number of his paintings closely resembled the paintings of Arthur Wardle who died in 1949. Sotheby's, Billingshurst, Sussex.

not primarily animal painters, featured them prominently in their works. One such artist was Joseph Harold Swanwick (1866-1929), who painted many oils and watercolours in which heavy farm horses played an important part in the composition of the picture. A very similar type of artist was C.J. Adams (1854-1931). Examples of the work of both these painters can be seen on pages 70 and 72 respectively.

Sir Alfred James Munnings (1878-1959), the finest horse painter since Stubbs, stands in a class of his own in the field of animal painters. As with many traditional artists of his time, he detested all forms of modern art and made many scathing remarks about it and its exponents, particularly Picasso, whom he saw as nothing more than a showman.

His name has always been associated with East Anglia, and particularly with Norwich, where he trained as a poster designer from the age of fourteen, when he started off by designing wrappers for Caley's chocolates.

In time Munnings was to look back with great affection on the city of Norwich as he had known it in the 1890s:

> Norwich was then a beautiful place and looked almost the same as it had done in the days of Crome and Cotman. I now realise what a playground it must have been for an artist. No wonder it had its famous Norwich School of artists...

Even more associated with the name of Munnings are his superb studies of racing horses lining up for the start, which were painted mainly at Newmarket. Other typical Munnings' subjects were his paintings of horse fairs, hunting scenes and gypsy life (see page 69).

Considering the number of artists in the past who kept the tradition of animal painting alive, it is surprising that so few major animal artists have appeared on the scene in recent times. One of the best known is David Shepherd, whose work is familiar even to those who have only a nodding acquaintance with art. What is perhaps less known is the enormous contribution he has made to the cause of wildlife preservation, which had its roots in a visit he made in 1960 to the Serengeti National Park in Tanzania, when

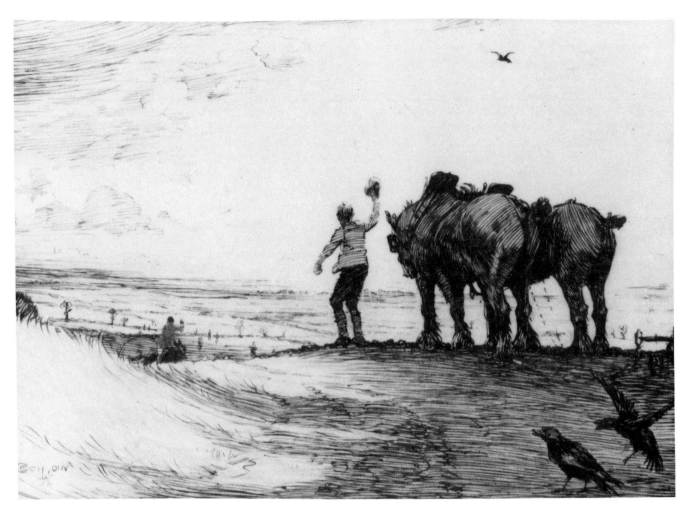

CECIL ALDIN 1870-1935

This pen and ink drawing shows Aldin working in quite a different style than usual. The two humble farm horses watch the noble hunting horses riding by and are watched in turn by two sinister-looking carrion crows. It has a touch of the style of Arthur Rackham to it. Sotheby's, Billingshurst, Sussex.

he came upon 255 dead zebras lying around a waterhole. Learning that the water had been poisoned by a poacher indulging in an orgy of senseless killing, he realised for the first time just how far man will go merely to satisfy his greed for money. He was to encounter other acts of barbarous cruelty to wildlife too horrifying to mention here, all of which hardened his resolve to do everything he could to help wildlife.

Since then Shepherd has raised nearly £2 million by selling many of his pictures, the proceeds of which have gone to the cause about which he feels so deeply.

None of this may seem to have anything to do with the quality of Shepherd's painting. In fact, it has a great deal to do with it. When he is painting wildlife, his work shows an empathy with the animals, which is rarely, if ever, seen in the work of other animal artists, though this may be obvious only to animal lovers.

None of his studies of African wildlife are the least bit sentimentalised, in the way that most Victorian painters depicted their animal subjects. These were often reduced to 'cuteness' in the manner of the American artist Norman Rockwell whose domestic animals within the family circle merely appeared as charming creatures, rather than a dog or cat that might be less than endearing on an off-day. Shepherd, on the other hand, always brings out the inherent dignity of his wild animals. They seem to pose for him with the relaxed air of being with someone they can trust to do them justice. For more details of this artist's work in other fields of painting, see his extended biography on page 27. Examples of his work are illustrated on pages 76 and 77.

Since World War II, traditional art has remained in good hands, especially in the field of landscape painting, with such artists as Frank Wootton, who is equally at home

painting hunting scenes, and Roger Desoutter. The latter's paintings have always been influenced by the French Post-Impressionist, Alexandre Jacob, whose love of painting winter sunlight on snow and icebound rivers can be seen in much of Desoutter's work. Desoutter is equally well known for his marine paintings, many of which are now in private collections in various parts of the world.

Other artists represented in this book include Kenneth Denton, a fine landscape artist who describes himself as a 'traditional painter with a modern technique'. Like Desoutter he also likes to paint marine subjects, especially the vessels on the Medway. Other first rate artists represented in this book include Anthony Sheath, David Dipnall and John Caesar-Smith.

A form of traditional art that is beginning to flourish in a way never before seen in this country is flower painting. Essentially a product of the Dutch and Flemish artists of the Renaissance period, it had little impact on British painting for a long time. In fact, it was not until the late nineteenth century that this prejudiced attitude towards flower painting began to change. Today, some of our best artists are flower painters. Such names as Bennett Oates,

James Noble, Gerald Cooper and the late Harold Clayton, will be well known to those acquainted with flower painting. Examples of their work, together with others of a slightly earlier period, are illustrated on pages 63-68.

All these post World War II artists are now highly successful painters. But what of the artists of the future who wish to maintain our heritage of traditional paintings, rather than going into the realms of modern art? Almost certainly they will receive little or no help from the art critics, who are more interested in 'modern' art than in traditional painting, which is rather looked down on these days by the cognoscenti because of its realistic and often near-photographic treatment. Nor is the situation helped by the small army of self-termed critics writing the occasional article for the Sunday newspapers, who see their task merely as one of entertaining the readers at the expense of the artist.

To be fair, the situation was little better in the nineteenth century than it is today. One has only to remember the appalling treatment meted out to Turner by many critics. When criticism was favourable, it often amounted to no more than a great deal of effusive twaddle, written to fill

out the columns. Here, for example, is a brief extract from an article that appeared during the latter part of the nineteenth century in the *Art Journal* on Henry Le Jeune, an artist who specialised in painting idyllic studies of children.

...In all that Le Jeune produces there is an abundant evidence of elevated sentiment, refined taste and high purpose, resulting from a well ordered and accomplished mind; by his art he is a sound, eloquent teacher of moral and religious truths, and as such is entitled to our respect and esteem.

What it comes down to in the end for the artist, is his relationship with the gallery owners. If one of them likes his work, they will support him and help to make his name known to the public.

In a way the escalating prices in the art world, that have put so many paintings beyond the reach of all but the wealthy, have helped to revitalise our awareness of the tremendous talent that is at work among today's artists. In that respect it can only be helpful to the artist who is still struggling to make a name for himself.

THE ARTISTS:
Brief Biographies

ABBREVIATIONS

fl.	flourished	P	President	ROI	Royal Institute of Painters in Oil-colours
exh.	exhibited	RA	Royal Academy (Academician)	RP	Royal Society of Portrait Painters
F	Fellow	RBA	Royal Society of British Artists	RSA	Royal Scottish Academy
ARSA	Associate of the Royal Scottish Academy	RBSA	Royal Birmingham Society of Artists	RSMA	Royal Society of Marine Artists
BI	British Institution	RCA	Royal College of Art	RSW	Royal Scottish Society of Painters in Watercolours
MFH	Master of Fox Hounds	RE	Royal Society of Painters, Etchers and Engravers	RWA	Royal West of England Academy
NWS	New Society of Painters in Watercolours	RHA	Royal Hibernian Academy	RWS	Royal Society of Painters in Watercolours
OWS	Old Society of Painters in Watercolours	RI	Royal Institute of Painters in Watercolours	SS	Suffolk Street Galleries

CHARLES JAMES ADAMS
1859-1931

Adams was a landscape, genre and animal artist who was born in Gravesend on 28 February 1859. He studied at the Leicester School of Art for a while, before going on to the RA Schools in London. He began to exhibit at the RA from 1882, showing thirty-seven pictures there, most of them after 1893. His pictures also appeared fairly regularly at the SS and NWS. Much of his work was done in oils, although most of his paintings that turn up in the auction rooms seem to be watercolours.

He lived for some time at 19 West Street, Leicester, and then at various other addresses, moving from one place to another so quickly that researchers found it difficult to follow his movements. We do know, however, the dates at which he was living at most of his addresses, which may be of some help to someone trying to date and identify the area where a certain picture was painted.

After leaving Leicester he was in Upper Sydenham in 1895, and in Horsham, Surrey, in 1897. He moved on yet again to Billingshurst, Sussex, where he was still living in 1900. His other moves were to Midhurst in Sussex in 1901, and Guildford in 1904, finally ending up in Farnham in Surrey in 1905, where he lived for many years.

An example of his work may be found in Leicester City Art Gallery.

CECIL CHARLES WINDSOR ALDIN, RBA
1870-1935

Cecil Aldin, one of England's most prolific humorist, sporting and animal artists, was born in Slough on 28 April, 1870. His father was a builder, whom Aldin always claimed had built a large part of Kensington. He spent his early childhood in Durham Villas, close to Kensington High Street. After being removed from Eastbourne College when his father had found himself in temporary straitened circumstances, he was at school in Warwickshire for a while.

When his school days were over he went to study under William Frank Calderon, Founder and Principal of the School of Animal Painting, and a well-known sporting artist, who had a studio near Midhurst in Sussex. It was here that Aldin began his hunting career, using a disused blacksmith's forge in a side street of the town in which to kennel his hounds. It was the beginning of a lifetime's devotion to the hunting field, and led to him becoming MFH of the Southern Berkshire Foxhounds. Aldin's experience in the field gave him the material for many of his books and humorous drawings, which made him a popular figure, especially among the hunting set.

Aldin was as English as they come, with his love of dogs and horses and sometimes heavy-handed humour, which all served to make him the ideal contributor to such magazines as *The Sporting and Dramatic News*, *The English Illustrated Magazine*, *The Queen* and *The Lady*, and others that catered for those whose roots lay in the English countryside. Apart from the illustrations he did for Kipling's *Jungle Stories*, published in the *Pall Mall Budget* in 1894-95, all his subject matter was geared to appeal to lovers of dogs and the English scene, and it made him the ideal illustrator for such books as *Handley Cross* and the *Pickwick Papers*. He illustrated many other books in his lifetime, a large number with drawings of his own dogs.

As time went by he began to develop arthritis in his hands, which eventually became so bad that he decided to move with his wife to Majorca. He lived there from 1930 to 1934 and then decided to return to England. On the way back he had a heart attack and upon his arrival home he was taken immediately to the London Clinic, where he died on 6 January 1935.

HELEN ALLINGHAM, RWS
1848-1926

Helen Allingham (née Paterson) was born near Burton-on-Trent, Derbyshire, on 26 September 1848. She studied at the Birmingham School of Art, and then went to London in 1867 to complete her studies at the RA Schools, where she was much influenced by the work of Birket Foster.

Two years later she began calling on all the major publishing houses with a portfolio of her work. Her talents were immediately recognised and she began to contribute book and magazine illustrations, including Thomas Hardy's *Far From the Madding Crowd*, which was running as a serial in the *Cornhill Magazine* in 1874.

For a long time her name was closely coupled with that of *The Graphic* to which she contributed a great number of illustrations, first as a freelance and then while working on the staff of the paper. While working there she met and married the Irish poet William Allingham, who is now best remembered for his elegaic poem:

> Four ducks in a pond,
> A grass-bank beyond,
> A blue sky of spring,
> White clouds on the wing;
> What a little thing
> To remember for years –
> To remember with tears!

Allingham's marriage was one which was to lead her into the closed circle of the Pre-Raphaelites, whose work

CECIL ALDIN

her husband had always supported. Once they had set up house in Cheyne Walk, Chelsea, she found herself also mixing with some of the literary giants of the day, including Carlyle and Ruskin.

In 1881 the Allinghams moved to Witley, near Godalming in Surrey, where Helen found she had Birket Foster for a near neighbour. With the Surrey countryside on her doorstep, she had found the ideal place to paint the subjects she loved so much. She died on 28 September 1926, aged just seventy-eight, a well-established figure in the world of landscape painting in watercolours.

JESSEY FAIRFAX BATES
Exh. 1896-1928

Mrs Jessey Fairfax Bates was the daughter of the Midlands artist William Jabez Muckley, and was known for her flower studies and interior scenes. While she was still living in Malvern, Worcestershire, one of her paintings, entitled *A Corner of the Studio*, was accepted for the Royal Academy exhibition of 1896. After that, she moved to other areas in the country, namely Essex, Shropshire and Wales.

LAMORNA BIRCH, RA, RWS, RWA
1869-1955

Some basic details of Lamorna Birch's life are to be found on page 32 in the introduction to this book. Less known are some of the little incidental facts that help to give a slightly more rounded picture of this talented artist. His great love of fishing, for instance, dates back to when he was seventeen and living in lodgings with a gamekeeper while working in a mill at Halton, near Lancaster. It was then that he began his everlasting love affair with the English countryside, and it was from the gamekeeper that he learned how to fly fish.

When he first arrived in Newlyn he had only £25 in his pocket. He found lodgings in Boleigh Farm, near Lamorna, but did not settle there until some years later when the girl who was to become his wife came to him for painting lessons. They were married within a few months and settled down in Lamorna, where they brought up two daughters.

Apart from numerous excursions abroad, life proceeded in an orderly and tranquil manner, with Lamorna Birch painting with unflagging energy until his final illness. Even then, he was still struggling to paint in watercolours the beauty of the local countryside from his bedroom window.

His work can be seen in the art galleries of Exeter, Glasgow and Manchester, and at Nottingham University.

CHARLES BROOKE BRANWHITE
1851-1929

Before going on to study at the South Kensington School of Art, the Bristol-born landscape artist, Charles Brooke Branwhite first studied under his father, Charles Branwhite, himself a landscape artist who painted in the West Country. Branwhite Jnr lived all his life in Bristol, first at 12 Royal Promenade and then in the Redland area of the city.

JOHN CAESAR-SMITH
born 1930

John Caesar-Smith was born in Peterborough, the son of a brickyard worker. He had a natural love of the countryside and won a scholarship to grammar school, attaining an honours in art in the school certificate. His father died and so, at sixteen, he was apprenticed into engineering.

At the age of thirty-nine he finally decided to devote himself to painting, and in 1970 he converted a seventeenth-century beamed and thatched inn near Peterborough into a studio where he now works with his wife, Tricia, a wildlife artist in her own right.

Caesar-Smith is best described as a romantic landscape artist, and few can produce better scenes of trees, water, field and woodland.

LAMORNA BIRCH

HAROLD CLAYTON
1896-1979

Harold Clayton was born in the City of London and, as a student, studied at Hackney, Harrow, Hornsey and St Martin's School of Art – mostly under the tutorship of Norman James, RA.

Many of his pictures were exhibited at the Royal Academy, not only in oils and watercolours, but in wood engraving as well. He worked mainly in Hampstead and Suffolk, and for several years lived in complete isolation in a 300-year-old farmhouse in one of the most beautiful parts of Devon. Here he grew many of the beautiful flowers he used in the compositions of his paintings.

He eventually returned to his beloved Devon, where he spent the last three years of his life. A number of his paintings were reproduced in print form and as signed limited editions.

GEORGE VICAT COLE, RA
1833-1893

The landscape artist, George Vicat Cole, was the son of the successful artist, George Cole, a self-taught landscape and animal painter. Vicat Cole received his early training in his father's studio, copying the works of Turner, Constable and David Cox. The most important part of his training under his father's direction, came when he learned to sketch from nature during the summer months, both in England and abroad.

By the time he was nineteen he had become professional enough to exhibit at the BI and the Society of British Artists in Suffolk. He showed at the RA from 1853 until 1892, and became anAcademician in 1880. In all, he exhibited seventy-six paintings at the RA.

As with many artists, he had his hard times and was forced to sell his pictures for far less than they were worth. However, despite his occasional struggle to pay the bills, he was still a highly successful artist whose popularity rivalled that of B.W. Leader.

He was born in Portsmouth on 17 April 1833, and died in Campden Hill House, Kensington, in 1893.

His work is represented at the British Museum, the Victoria and Albert Museum and at the Cartwright Hall, Bradford.

GERALD COOPER

Gerald Cooper, apart from being recognised as the world's finest flower painter, really concerned himself throughout his career with Education in Art. He was an Associate of the Royal College of Art, as well as being a member of the National Society of Painters. He was also principal of one of the largest and most important schools of art in the country, having under him about 2,000 students. He has been a member of the Bray Committee on Art Education, which comes under the Ministry of Education, for some four years and he was also a member of the National Committee on Art Education. He was an examiner for the Ministry for art examinations in both painting and drawing.

He exhibited at the New English Art Society and for about thirty years at the Royal Academy and National Society as well as in important private collections in this country and abroad. Gerald Cooper has shown at most of the principal provincial art galleries throughout Great Britain. His life has been very full of art activities and in the early stages he was a painter of children's portraits. He has also worked successfully as a landscape painter and sculptor.

GERALD COULSON
born 1926

Gerald Coulson was born in Kenilworth, Warwickshire, in 1926 and taught himself to draw and paint at an early age. On leaving school, he trained as an aircraft engineer, technical adviser and illustrator, which encouraged him to take up flying and led to his subsequent qualification as a pilot in 1961.

He began his career as a full-time painter in the late 1960s, having been elected a member of the Society of Aviation Artists in 1955 and of the Industrial Painters Group in 1957. He became a member of the Guild of Aviation Artists in 1971.

A painter of landscapes, coastal scenes, wildlife, railway, motoring and aviation subjects, his paintings are often dominated by big skies and the English landscape, although he is an artist whose unbounded talents lead him in a variety of exciting directions.

Examples of his paintings can be seen hanging in the RAF Museum at Hendon, RAF Cranwell, and at the RAF Staff College. The National Railway Museum at York also has his work on display.

ROY CROSS

ROY CROSS, RSMA
born 1924

Roy Cross was born in London on 23 April 1924, in an area close to the London Docks. He grew up while Britain and America were in the throes of the Great Depression. Although his father was in work as a plumber, the family had no money to spare, so the only recreation Cross had were long walks around the dock area with his father. These proved an excellent grounding for his work as an artist, for it was then that he began to make sketches of what he had seen on their walks.

By the time he was eleven years old, Cross was selling some of his early efforts to his classmates. Four years later his talents had been recognised by his teachers, who urged his parents to send him to art school. But as there were no grants available and no money at home for that sort of training, he became a clerk in a shipping company. One of his duties was to take bills of lading to the various offices in the dock area, where he was again exposed to maritime influences. At that time, though, his main interest was in aircraft, and he maintained that interest for many, years before he became a marine artist.

He joined the Air Training Corps when World War II was imminent, but as his eyesight was not good enough for him to become a pilot, he entered as a radio mechanic and remained so until he was put to work in an aircraft factory drawing technical illustrations.

By the end of the war he still had had no formal art training, and after a brief spell at the Camberwell School of Arts and Crafts, he went on to the St Martin's School of Art in London, attending classes twice a week while freelancing. Finding the school's approach far too academic for his needs (which were geared in those days to producing commercial art work), he left and struck out on his own as a full-time freelance commercial artist.

He is, therefore, essentially a self-trained artist, as were so many nineteenth-century artists who became famous. In his case, it certainly did him no harm at all, not only in Britain but in the USA. When he became the chief illustrator for Airfix Products, a leading manufacturer of model aircraft and ships, he seemed all set for a lifetime of being a highly successful commercial illustrator.

His switch to marine paintings began when he started to work in oils, rather than in gouache, which had previously been his favourite medium. Although a great admirer of the work of Montague Dawson, his marine paintings are executed in a style that is distinctively his own. For a late starter, Cross has done extremely well as a marine painter. In 1976 all four paintings that he submitted to the Royal Society of Marine Artists were accepted for hanging at one of their annual exhibitions. Cross is now on the Council of the RSMA.

The rest is a quiet success story in which his career has steadily progressed to the stage where his work in marine painting is now eagerly collected in both this country and the USA.

MONTAGUE DAWSON
(Courtesy of Frost & Reed Ltd)

MONTAGUE DAWSON, FRSA, RSMA
1895-1973

Montague Dawson was privileged as a boy to spend much of his leisure time with Napier Hemy, RA, and from his early youth was interested in the sea and sailing craft.

He spent his life amongst ships of all classes, frequently at sea, especially during the two world wars, when he was in both the Merchant Navy and the Royal Navy. His favourite sports were yacht racing and sailing, and he had one of the finest collections of model yachts and sailing ships in Great Britain. Technically he must be considered one of the finest marine painters ever.

Dawson's works have been exhibited at the Royal Academy and the RSMA, and at marine exhibitions throughout the country. His paintings are to be found in many public buildings and in the offices of London and Liverpool shipping and insurance firms. His works have been shown in many important galleries throughout the world, and ten of his pictures are in the Imperial War Museum.

KENNETH RAYMOND DENTON
born 1932

Kenneth Denton was born in Chatham, Kent, on 20 August 1932. His mother was the daughter of a Master Painter, while his father had a military background. The family lived at Rochester, but during the war Kenneth was evacuated into the country, near Barham. It was at the school there that the attraction of painting first came to him.

In 1944 Denton won a scholarship to Rochester School of Art (later the Medway College of Art) where he was educated in general painting. He left college, was apprenticed to a Master Painter and Gilder and then he returned to the Medway College of Art, where he passed all his examinations.

During his National Service in the Army, Denton received many commissions for paintings which he completed in his free time. After leaving the Army in 1954 he showed his work frequently, including galleries in Bond Street.

After his marriage in 1956, Denton found he could not support his family entirely by painting, and so went into business as a signwriter and gilder for eight years. In 1960 he taught part-time, first at the Maidstone College of Art, and later at the Medway College of Art. He also became an examiner.

In 1963 he went into full-time teaching at the Royal School of Military Engineering, and also gave private tuition in landscape painting. During this time he took up painting again, and found that in the interval, his technique had developed, rather than deteriorated. He devoted all his free time to painting, and eventually gave up teaching to paint full-time.

ROGER DESOUTTER
born 1923

Born and educated at Mill Hill, Roger Desoutter obtained a degree in engineering at Loughborough College. In 1942, he was chosen to join the team of Sir Frank Whittle, engaged in the design and development of the first jet engines, which occupied him until 1945. He spent most of his spare time during this period making sketches in pen and ink, and pastels, as well as producing technical drawings for engineering publications.

He had to abandon all hopes of a full-time artistic career in 1947, when the unexpected death of his father necessitated his joining the family engineering business of which he is now chairman. He married in 1950 and was encouraged by his wife to devote all his spare moments to the study of oil painting, resulting in several of his works being exhibited and sold for the first time at the Guildhall Annual Exhibition of the Society of Aviation Artists in 1955.

In the years to come, Desoutter sought to extend his talents in painting and turned his attentions from aeronauti-

cal studies to encompass landscape and marine subjects.

In 1962 he acquired a boat, becoming a keen amateur yachtsman, at the same time discovering a new dimension in marine art. Desoutter feels that having a boat is an invaluable aid and that it is essential to go to sea and experience the elements at first hand in order to achieve a credible understanding and success in marine painting.

He particularly enjoys depicting the areas around estuaries and coastal inlets; tranquil scenes painted at sundown or in the early morning, showing expanses of wet sand reflecting light, often with beached boats waiting for the tide.

He has exhibited regularly at the Royal Society of Marine Artists since 1974.

Marine painting calls for great accuracy of detail concerning ships and their rigging, and Desoutter painstakingly researches his subject before he paints it. His works have been sold internationally, in Canada and America, where the demand for historical marine subjects is high; a work depicting a wartime convoy has been acquired by the US Merchant Marine Academy in New York.

Two of his paintings have been reproduced in the book *20th Century British Marine Painting*, and a number of his works have been reproduced as greetings cards and fine art prints, one entitled *Hove-to off the Needles* achieved seventh place in the top best-selling prints organised by the Fine Art Trade Guild, of which Desoutter is an Artist Member.

JOHN STEPHEN DEWS
born 1949

Dews comes from a seafaring family that dates back to the seventeenth century. He studied at the Hull Regional School of Art before launching himself on what was to be a successful painting career as a marine artist who painted in oils and watercolours, many of them merchant and sailing vessels. He has held several one-man exhibitions in this country, and his work has been represented in a number of galleries in California. His work is also to be found in the San Francisco Maritime Museum.

DAVID J.J. DIPNALL

Born in Scotland of English parents in the early war years, he received his education at Portsmouth Grammar School.

He pursued engineering design as a career, and held various positions in product design until 1968, when he and his wife Audrey decided to travel the world. He left England in September 1968 and drove overland to India, then on by various means, to arrive in Australia in January 1969.

Australia became their home for the next five years, dur-

ing which time he worked initially in product design, but later joined the teaching staff at Geelong Grammar School. He remained there until early in 1974, teaching design, art and craft, photography, etc. He returned to England in the summer of 1974 with his wife and son after deciding to become a professional artist in response to the demand for his work as an amateur.

Examples of his work may be found in collections in Germany, the United States, Canada, Australia and Tasmania.

CHARLES DIXON, RI
1872-1934

Dixon was born in Goring-on-Thames on 8 December 1872, the son of Alfred Dixon, who painted genre and historical subjects and exhibited at the RA and elsewhere between 1864 and 1891. Charles was also interested in historical subjects, though these were always of a naval interest. He became an illustrator, first working for such important magazines as *The Sphere* and *The Illustrated London News*. The main bulk of his contributions to this field of art were done for *The Graphic* for which he worked from 1900 to 1910.

He began exhibiting at the Royal Academy from 1889, and from then on his work was represented regularly for many years.

He became a friend of Sir Thomas Lipton, whose provision shops were scattered all over England and Scotland, and who had made something of a name for himself in 1897, the year of Queen Victoria's diamond jubilee, when he gave £20,000 to provide many of the London poor with dinners. He was to become even more famous for his repeated attempts to win the America's Cup races. Dixon went out to record Lipton's five attempts to win the cup with his *Shamrocks*, off Sandy Hook, an assignment that Dixon must have greatly enjoyed, as he was a keen yachtsman himself.

He died in Itchenor, Sussex, on 12 September 1934.

Examples of his work can be seen at the National Maritime Museum, Greenwich, and at the Merseyside County Museum.

MARY ELIZABETH DUFFIELD, RI, NWS
1819-1914

A member of the Rosenberg family of flower painters, Mary Elizabeth married William Duffield, who also painted flowers, sometimes in collaboration with his wife. She exhibited her flower studies, most of them of a high quality, from 1848 until 1912, ten of them at the RA. In 1856 she published a book, *The Art of Flower Painting*.

An example of her work can be seen at the Victoria and Albert Museum.

SIR ALFRED EAST, RA, RI
1849-1913

This English artist was born at Kettering, Northamptonshire, on 15 December 1849, and in his time was considered to be one of Britain's leading landscape artists. He received his training at the Glasgow School of Art and at the Ecole des Beaux Arts in Paris, where he studied under Robert Fleury and Bougerau.

He began to exhibit at the Royal Academy in 1882, and from then on continued to show there until the year of his death. He was elected an RA in 1913, after being an associate for many years. Previously, in 1906, he became the President of The Royal Society of British Artists, the same year that he published a useful and instructive book on landscape painting entitled *The Art of Landscape Painting in Oil Colours*.

East travelled widely in France, Spain, Italy and Morocco. He spent six months in Japan carrying out a commission from the Fine Art Society, which had asked him to do a series of Japanese landscapes that were subsequently shown in an exhibition of great critical success, and added further lustre to his name.

Such was his fame in those days that, when he died, his body was placed in his home at Kettering. Nearly 8,000 people came to pay their respects over the three days that he lay in state. It was quite an exit from this life for a man who had started off by working in his brother's shoe factory before he managed to override parental opposition to his becoming a painter. East was knighted in 1910 and also brought out another book called *Brush and Pencil Notes in Landscape*, which was published posthumously in 1914.

JOHN EMMS
1843-1912

Emms was born on 21 April 1843, at Blofield, Norfolk, the son of a minor artist named Henry William Emms.

Nothing is known of his early years except that he eventually found his way to London, where he began exhibiting at the RA and the SS from 1866. At that time he was living at 16 Earls Court Gardens, Old Brompton.

In 1872 he settled in Lyndhurst, Hampshire, where his work as a painter of dogs and hunting scenes soon attracted the attention of the local gentry who already knew him as a promising newcomer to the hunting field. In 1888 he married a woman some fifteen years younger than himself, who was to share the hardships of his tragic later years (see page 81 in the colour section).

He died on 1 November 1912, and was buried in the local cemetery.

ALAN FEARNLEY
born 1942

Alan Fearnley is a Yorkshire artist with a positive feel for that part of the country and its inhabitants. The charm of his figure subjects is immediate.

He is an artist who finds pleasure in portraying a great variety of subjects from racing cars to boats, from small boys fishing, to beautiful landscapes. He has that special ability to be able to capture anything he paints with realism and charm.

Alan Fearnley has exhibited with the RSMA and the ROI. He is also a member of the Guild of Aviation Artists and a past chairman of the Guild of Railway Artists. He has paintings on permanent exhibition at the RAF Museum, the Fleet Air Arm Museum and the National Railway Museum.

SIR WILLIAM RUSSELL FLINT, RA, PRWS
1880-1969

In company with Sir Alfred Munnings and Montague Dawson, Russell Flint was one of the most important British artists of the twentieth century. In the field of pure watercolours he remains supreme as an artist who was capable of obtaining the maximum effect with the utmost economy of brushwork and the way he laid down his gentle washes of colour.

He was born in Edinburgh on 4 April 1880, and was educated at David Stewart's College and at the Royal Institute of Art. In 1900 he went to London, where he studied at Heatherley's, the famous art school that came into existence in 1845 and was run for twenty-seven years by Thomas J. Heatherley, a venerable looking gentleman with long white hair and a flowing beard, who was in the habit of wandering through the classroom dressed in a crimson velvet dressing-gown. He was known to be a superb art teacher and many of his pupils were to become famous artists.

After he had completed his training, Flint joined the staff of the *Illustrated London News*, where his early work came under the influence of Arthur Rackham, a foremost Edwardian illustrator who was capable of creating a bizarre and mystical world of his own, which must have been quite frightening to many young children. About this time Russell Flint began to supply colour plates for such books as Rider Haggard's *King Solomon's Mines*, Matthew Arnold's *The Scholar Gypsy*, Charles Kingsley's *The Heroes*, Chaucer's *The Canterbury Tales* and many others.

However, he was to make his name with his watercolour paintings of sun-drenched beaches and semi-nude studies of Spanish ladies framed against Moorish backgrounds, which have rather overshadowed his excellent landscape scenes. He was made An academician in 1933 and knighted in 1947. He travelled widely on the Continent, but for many years he spent much of his time at Whitstable in Kent.

SIR WILLIAM RUSSELL FLINT
(Courtesy of Frost & Reed Ltd)

ROBERT GALLON
1845-1925

Gallon was a landscape painter who exhibited at all the major galleries between 1868 and 1903, and at the RA, where fifteen of his pictures were hung. He portrayed various beauty spots all over England, Scotland and Wales; some of them were broadly executed sketches, while others were finely painted. In some respects his work resembles that of George Vicat Cole, whose work is also represented in the colour section of this book.

Although he was chiefly a landscape artist, Gallon also painted a number of coastal scenes, including a fine oil, *A Glimpse of the Sea*, in which he combined his talents for painting landscapes and marine paintings with a distant view of barges unloading their cargo on to a jetty.

He lived for some time in London at 12 Tavistock Row, Covent Garden and at 32 Alma Square, St John's Wood. He was last known to be living at Evelyn Place, Deptford.

ALFRED AUGUSTUS GLENDENING
fl. 1861-1903

The son of the landscape oil painter, Alfred G. Glendening, Alfred Augustus was born in Southwark and began his working life as a railway clerk until he took up painting as a landscape artist in oils. Many of his subjects featured cattle grazing beside a river, though he painted many other subjects such as *Coniston Lake*, *On the Thames*, *Twickenham*, *Moonlight Among the Mountains, N. Wales* and *A Pine Wood – Autumn*.

He began to exhibit at the RA in 1865, and by 1893 had exhibited forty-one paintings there, as well as seventy-seven at the SS. After living for a while at 12 St George's Road, Southwark, he moved to the Old Kent Road area, where he lived at a number of addresses, including 192 Old Kent Road, 15 Clarence Street, and 161 Oxford Terrace, Commercial Road. He seems to have disappeared from sight after he visited New York in 1901.

HEYWOOD HARDY, ARWS, RE, PE, RWA
1842-1933

A painter and etcher of animal, sporting and coaching subjects, Heywood Hardy was born in Chichester on 15 November 1842. He studied in Paris and Antwerp before settling in North London in 1870, although he had started to exhibit in London before that, in 1861. As well as painting many pictures he also contributed etchings for *The Illustrated London News* and the Christmas colour edition of *The Graphic* of 1880.

Much later in his life he moved to East Preston, near Littlehampton, where he died in February 1933, at the fine old age of ninety.

CLAUDE HAYES
1852-1922

Claude Hayes was the son of Edwin Hayes, the well-known marine painter, who exhibited more than 150 paintings in his time. He had been determined to make his son a businessman, an idea that Claude detested so much that he ran away to sea and served on *The Golden Fleece*, a transport ship used in the Abyssinian Expedition of 1867-68, which had been sent out from England to rescue the British prisoners who had been put in chains for reasons too complicated to go into here. On his return he spent a year in America before returning to study at the RA schools in London and at Antwerp under Verlat. (See biography of Tatton Winter.)

Under the influence of Verlat, Hayes started his career as a portrait painter in oils. He changed course to become a landscape painter, mostly in watercolours, working in the traditions of David Cox and Thomas Collier, two of the most important landscape artists in the history of watercolour painting. He exhibited regularly at the RA and at the Suffolk Street Galleries between 1873 and 1893.

In his time he was extremely successful, though he claimed that he never earned more than £700 a year from his paintings, even during his most successful period.

Examples of his work are to be found in the art galleries of Brighton and Eastbourne, and at the Newport Art Gallery and the Leeds City Gallery.

CHARLES NAPIER HEMY, RA, RWS
1841-1917

Although Hemy was also a landscape and still-life artist, his reputation rests on his work as a marine artist. His paintings of fishermen and yachtsmen have placed him in the top rank of maritime artists.

He was born on 24 May 1841, in Newcastle-upon-Tyne, and studied under William Bell Scott, the painter, illustrator, poet and friend of Rosetti and the Pre-Raphaelites. When the family emigrated to Australia on the *Madawska* he had the first opportunity to study all the many ships that passed, which fuelled an interest already awakened by his upbringing in a large port where shipping was constantly going to and fro. When the family came back to England five years later Hemy immediately signed on with a merchant brig as an apprentice.

For reasons which have never been explained, he decided to enter the priesthood, only to abandon the idea after he had spent three years in a Dominican house in Newcastle and a monastery in Lyons. He took up painting and studied for a while in Antwerp under Baron Leys, a historical and genre artist whose work was so popular at the time that he was to have a statue erected in his honour in the local park. On Hemy's return he began to exhibit at the RA, and continued to do so for many years.

In the 1880s he settled in Falmouth, Cornwall, where he bought his own yacht, the *Van der Meer*, on which he took painting trips, gradually building up for himself a reputation as a major marine painter. He died in Falmouth on 30 September 1917.

Apart from his work in the Tate Gallery and the National Maritime Museum at Greenwich, his paintings can also be seen at the Walker Art Gallery in Liverpool, the Laing Gallery in Newcastle and the city art collections in Birmingham, Bristol and Leeds.

JOHN FREDERIC HERRING, JNR
1820-1907

John Frederic Herring, Jnr has sometimes been accused of copying the work of his famous father, John Frederic Herring, Snr, possibly because the son assisted his father before becoming a painter in his own right, and there are rumours of a rift between them. Actually, Herring, Jnr painted in a vastly different style, and it is highly unlikely that he tried to pass off any of his own paintings as his father's work. If that had been the case, Frederic Roe, RI, would never have bothered to approach him and ask to be taught horse painting, only to be told that 'love of a horse was not within him'.

Despite their differences, the father became very worried when he learned at one time that his son was in danger of losing his sight owing to his habit of smoking six pipes of tobacco one after another. It seemed that he was worrying for nothing, as John Frederic, Jnr lived until he was ninety-one, still in possession of his faculties almost until the last. He lived at Fulbourne, near Cambridge, and spent much of his latter years personally building extra rooms to his house.

DAVID JAMES
fl. 1881-1897

An interesting artist who painted mainly along the coasts of Devon and the Scilly Isles, David James has now become well known for his paintings of ships sailing on blue seas. His work has been likened to that of the marine painter, Henry Moore, who tried in his paintings to capture the restless and unpredictable movements of the sea, and is considered to be one of the finest marine artists of his period.

Very little is known about James, except that he lived in Plymouth for a couple of years before moving to Bowden, Devon, where he stayed for less than a year, and then moved on yet again to Dalston in Cumberland. He is known to have exhibited at least four times at the RA.

JOHN YEEND KING, RI, RIO, RBA
1855-1924

King was born in London on 21 August 1855. His work as a landscape and genre painter was very much in the style of so many Victorian artists of the period who specialised in painting the same sort of subject matter. Which is to say that King liked to paint charming rustic scenes, often set in some country garden. Any leanings towards the sentimental and over-pretty were, however, mitigated by his vigorous *plein air* technique and bold colours that show something of his art training in Paris.

A London artist who had started inauspiciously by working in a glass works before making his name as an artist, he began his training under William Bromley, who was employed for many years by the British Museum in engraving studies of the Elgin Marbles. After a thorough grounding in the precision line work needed for this type of engraving, King went on to study painting in Paris.

His growing reputation in the 1890s was further consolidated in 1898, when his painting, *Milking Time*, was bought by the Tate Gallery. He exhibited at the RA from 1874 to 1924.

His work is represented at the Walker Art Gallery in Liverpool, and in the art collections of Reading, Rochdale and Sheffield.

WALTER LANGLEY, RI, RBA, RWA
1852-1922

Langley was born in Birmingham on 8 June 1852, the son of a humble tailor, and Ann Langley, an illiterate but hard-working woman, who was to be the driving force behind Langley in his struggle to become an artist. The family lived at Irving Street, and it was from there that he was

launched at the age of fifteen into the fringes of art by being apprenticed to a local lithographer.

In those days he seems to have been more interested in designing jewellery than in a career as an artist, for during that period he designed a number of pieces in the Egyptian style. At the age of twenty-one he won a scholarship to the South Kensington Art Schools, where he did some watercolour and pen-and-ink designs for a jewel casket, a tea service and some other pieces, which were drawn with a wonderfully skilled technique.

After completing his studies, Langley returned to Birmingham to take up the offer of a partnership he had been offered in the business in which he had served his apprenticeship. Having joined the business, Langley decided, rather belatedly, that his real forte lay in painting, which he had started to do in his spare time.

By 1882 much had happened that was to change the course of his career. He had married, was already an established artist, and during a visit with his wife to the tiny Cornish fishing village of Newlyn he painted five views that he sold in 1880.

He liked Newlyn so much that he returned there in 1882 and settled at Pembroke Lodge, a house that no longer exists. His arrival coincided with the foundation of the Newlyn School of artists, and he became one of its first members, together with Frank Bramley and Stanhope Forbes and an old friend of his, Edwin Harris, who was to make something of a name for himself for his studies of pretty girls posing decoratively against simple cottage backgrounds.

Langley was an artist of considerable merit whose best period was at Newlyn, where he painted some very fine watercolours. But for all that, none of his work seems to have sold well until he exhibited his oil, *Shadow and Sunshine* at the RA in 1892, and *Never Morning Wore to Evening but Some Heart Did Break*, which goes to show that artists should never title their own pictures. It was shown in 1894 and brought forth a rather mean-spirited comment from Stanhope Forbes: 'Langley is only commencing in oils so he comes prying in here to see how my work gets done.'

In 1893 Langley moved to Penzance, where he married again after his first wife died. He exhibited at the RA from 1890 until 1919 and is represented in several public galleries, including the Leicester Art Gallery.

He was one of the best of the Newlyn artists whom H.S. Tuke, the Newlyn painter of boys and boats, was to refer to as, 'I should think the strongest watercolour man in England.' But he was certainly not the most successful, although he had been commissioned by the Uffizi Museum to supply a portrait for inclusion among their portraits of great artists, a painting which they received from Langley two years later.

BENJAMIN WILLIAMS LEADER, RA
1831-1923

A landscape artist from Worcester, Leader has the distinction of having had three of his paintings exhibited at the RA in 1922 when he was aged ninety-one. It was the climax of a distinguished career that had started when he had begun to show at the RA in 1857, with pictures painted under the influence of the Pre-Raphaelites.

He found many of his subjects in the Midlands and Scotland, although he was especially fond of painting around Betws-y-Coed, the Welsh beauty spot that was also a favourite haunt of the great watercolour artist David Cox.

No other artist since Leader has caught so well the 'feel' of the British landscape as he did, which no doubt accounts for the enormous popularity of his work during his lifetime.

He was born in Worcester on 12 March 1831 and lived near Guildford, Surrey, for some years. He died on 22 March 1923. He seems to have been a particular favourite of the Selection Committee, which chose 158 of his pictures for hanging during his lifetime.

THOMAS JAMES LLOYD
1849-1910

Lloyd was a landscape and genre artist who lived in London during three separate periods: first at 10 Fitzroy Square and then at 9 Duke Street, Portland Place, and subsequently at 6 Primrose Hill Studios, Fitzroy Road. At other times he lived at Walmer, Kent, and at Yapton in Sussex. Like several other artists of his period he seems to have been fond of changing his address.

He began to exhibit in 1870 and early on in his career was recognised as likely to be one of our great landscape artists. Time has not dimmed that early assessment of his talents.

Examples of his work may be seen at the Shipley Art Galleries and at the galleries of Gateshead, Glasgow and Cardiff.

THOMAS MacKAY
1893-1913

MacKay was a watercolour artist whose work only began to come to the fore in the early 1980s, when a few discerning art dealers began to buy his work in the auction rooms. Not a great deal seems to be known about him. He was a Liverpool artist who enjoyed a small measure of fame in his own area for his watercolours, which were painted in a way that is immediately recognisable to anyone once they have seen a few of his pictures. He exhibited three times at the RA and showed another twenty-eight pictures at the Walker Art Gallery in Liverpool.

He had a studio for a while at Littleton in Cheshire, and was living in Chester in 1911.

SIR ALFRED MUNNINGS, KCVO, PRA,
RWS, RP
1878-1959

The names of George Stubbs and Sir Alfred Munnings are linked as being two of the greatest masters of English art in the field of horse painting. Born in Mendham, Suffolk, the son of a miller, Munnings studied at the Norwich Art School and in Paris. He began exhibiting at the RA in 1898, and in the following year had the misfortune to lose the sight of one eye. During the war he was commissioned to do several pictures for the Canadian Government, which he painted while he was attached to the Canadian Cavalry in France between 1917 and 1918. Immediately after the war he moved to Dedham, Essex.

Munnings was an artist who painted mostly in oils. A superb draughtsman who never used photographs as a painting aid, he was an uncompromising opponent of modern art, and one of his speeches attacking it at an RA dinner caused something of an uproar in art circles.

He was made an RA in 1925 and was knighted in 1944.

Needless to say, with an artist of this stature, his work is to be found in many of the major art galleries in the country. For further information on this artist, see page 15 in the introduction.

JAMES NOBLE
born 1919

James Noble was born in 1919 into a family of craftsmen who were builders and decorators. While working in the family business he attended evening classes in London for drawing under Ian McNab. But it was during the war, when he was an assault engineer with the infantry, that he really learnt to draw. All his spare time was spent making pen-and-wash drawings of barrack-room scenes and drawing charcoal portraits of his comrades. Many of these drawings were shown in wartime exhibitions of the RBA London Group and the Royal Society of Portrait Painters.

After the war he was given a grant to study painting. Unfortunately, at that time, students were either falling under the influence of Picasso and the School of Paris, or of Sickert and the Euston Road tradition. His teacher, being a pupil of Sickert, obviously left the mark of that great painter on the young student. He was showing his Sickertian-style paintings in a number of London's top galleries while still at art school, but he never felt quite right with this assumed style.

For the next few years he earned his living by making picture frames for other artists, and for galleries and art shops. It was at this time that he discovered the Dutch seventeenth-century still-life painters, and above all, Vermeer. He spent hours in the National Gallery wondering at the rendering of textures, the colour so pure even today, after more than three hundred years. Deep inside these

paintings by the master of masters were beautiful little still-life pieces, so solid, and sparkling with life and colour. Here was sown the seed of James Noble's life's work.

Noble began to paint flowers, expecially roses – the most difficult flower of all to paint. Without doubt James Noble is today the leading painter of the modern rose.

New work was accepted by a number of leading galleries in London and sold very well. He also exhibited in the Royal Academy and the Paris Salon. In 1957 he held his first one-man exhibition in a Bond Street gallery — it sold out in the first few days. Since then he has shown his work exclusively in the gallery of Stacy-Marks Ltd at Eastbourne. With the exception of the few paintings he has given his wife, every picture he has painted in the past twenty years or so has been sold. His paintings are in private collections all over the world – some even behind the Iron Curtain.

James Noble now lives in a cottage in Sussex he converted with the aid of his wife, from a near ruin into a comfortable home. He has just begun to plan a new garden in which he will feature many of his favourite roses.

G. BENNETT OATES
born 1928

Bennett Oates was born in London. He has a broad interest in painting, and examples of his portraiture, landscape and animal paintings can be found in many private collections, but it is his flower paintings that have made his reputation.

Now acknowledged worldwide as one of the finest artists working in this genre, his draughtsmanship and technique bears comparison with the best of the Dutch School. But it is his use of the gentler English hues, where strong colours are used 'jewel-like' in conjunction with white and pastel shades that produce the subtle quality and restrained taste that make his paintings unique.

Those knowledgeable in the English School will notice the influence of Gerald Cooper, with whom he studied after leaving grammar school, at Wimbledon College of Art. When he was fifteen years old his first flower painting was accepted at the Royal Academy, and he went on to win a scholarship to the Royal College of Art.

His daughter, Michelle Bennett Oates, was apprenticed to her father, and is now working professionally in the Norfolk Fens as a wildlife artist.

HENRY H. PARKER
1858-1930

Henry Parker was a Midlands landscape artist whose work is sometimes reminiscent of Thomas Collier, one of the most important of the landscape artists who followed in the great tradition of David Cox. It is known that he painted frequently on the Thames and also in Kent, Surrey and Wales.

FRANK PATON
1856-1909

As a painter in oils and watercolours, Frank Paton was best known for his studies of dogs until his oil of a kitten regarding itself in a mirror caused a small sensation when it was sold at auction in 1988 (see page 73 in the colour section).

He worked in London and Gravesend and exhibited from 1872 to 1890 at several London galleries and at the RA, where he exhibited twenty paintings. Much of his time was spent in engraving sporting subjects, both from his own work and from others, which were published as sepia prints. He also contributed illustrations to a number of magazines before his death in November 1909.

HENRY MEYNELL RHEAM, RI
1859-1920

Rheam was basically a genre painter. He was born in Birkenhead on 13 January 1859, and he studied in London before completing his training in Paris under William Adolphe Bougeureau, an artist who specialised in portrait painting. He began to show his work at all the leading galleries from 1887, as well as exhibiting twenty paintings at the Royal Academy before his death in 1920. Although he was far from the best of the Newlyn artists, his work is always interesting and highly varied in its subject matter.

EDWARD SEAGO, RWS, RBA
1910-1974

One of Britain's most famous landscape artists, Seago's name is one that will always be associated with Norfolk. He was born in Norwich on 31 March 1910, the son of a local coal merchant. During his early childhood he was struck down with a heart complaint, and on the advice of his doctors was confined to bed for several years. During that time he began to be interested in art, spending many hours painting watercolours of the view from his bedroom window. By the time he was up and about again he had already decided that he had to become an artist.

He was fortunate at this stage to have met Bertram Priestman, a landscape artist whose flamboyant brush strokes and free use of colour had shocked many art critics in the early 1900s. Priestman saw Seago's potential as an artist and agreed to give him some instruction, which was always carried out at Priestman's house in Walberswick in Suffolk.

The next important stage in Seago's career came when Bertram Mills' Circus came to Norwich. Although Seago had held a successful one-man show in London by then, and should perhaps have been thinking of consolidating his position on the London scene, the tinsel and glitter of the circus so attracted him that he asked Bertram Mills to allow him to follow the circus and paint. Permission was given, and was to lead in time to Seago's experiences with the circus being recorded in a book, *Circus Company*, which he wrote and illustrated himself. Before the book appeared in 1933, Seago had spent further time travelling with circuses around Britain and on the Continent, which was to result in another book by him, *Sons of Sawdust*, published in 1934.

By then he had transferred his interest to the equally theatrical but vastly different world of the ballet, spending many hours at Sadler's Wells and Covent Garden, trying to absorb all he could from the performances. But by 1938 his relationship with ballet was over and he was seeking something else to engage his interest.

By then, however, World War II was approaching. When it did come, Seago joined the Royal Engineers, where he came to the attention of Lieutenant General Alexander, who conceived the idea that Seago should act as Alexander's unofficial war artist, and paint the whole of the Italian campaign. These paintings were eventually exhibited at the Norwich and Bristol municipal galleries.

Anyone who is interested in Seago and his work should read Ron Ransom's highly illuminating book, *Edward Seago*, illustrated by ninety examples of his oils and watercolours, and Jean Goodman's book, *Edward Seago, The Man Behind The Canvas*. Both are revealing studies of a highly complex man who managed to cram a great deal into his life, despite often being laid low by a heart condition that made it impossible for him to paint.

ARTHUR WINTER SHAW
Exh. 1891-1936

A watercolour artist who was fond of including cattle in his landscapes, Arthur Winter Shaw was born in 1869. A London artist who studied at Westminster and the Slade School of Art, he was one of the many artists who seemed frequently to be on the move to various addresses; in his case, to places in Kent and Sussex. Little else is known about him except that he exhibited at least fifteen times at the RA.

ANTHONY SHEATH
born 1946

'Tony' Sheath was born in London, and from an early age he showed an aptitude for drawing and painting, and when at school easily passed his art examinations.

Sheath married in 1968 and moved to Hullbridge, Essex, where he continued to paint as a hobby until the end of 1975, when he decided to paint professionally and resigned from his job in London.

DAVID SHEPHERD, OBE, FRSA
born 1931

From the time when he first went to Africa, David Shepherd has had two consuming passions — to paint wildlife and to do everything in his power to assist in its conservation.

When he was twenty his one ambition was to become a gamewarden — an ambition that was greeted with derision when he took himself off to Africa and presented himself to the warden as a prospective candidate. 'If we had a vacancy we wouldn't give it to you,' he was told. 'You don't even know one end of a lion from the other.'

Deflated, he went away and found a job as a receptionist in an hotel on the Kenya coast; his salary was £1 a week.

While there he started painting — something he had only done before when he had gone to art school merely to escape from the rugby field. This time he did it to pay his passage home. He sold seven of his paintings and promptly left for England.

Back home again, he approached the Slade School of Art and showed them examples of his work, only to be told that he wasn't worth teaching. He was about to give up the idea of making painting his career and become a bus driver instead, when he met the marine painter, Robin Goodwin, who agreed to take him on as a pupil. Shepherd still considers that it was Goodwin who was responsible for where he is today.

In the years following his training with Goodwin, Shepherd began to paint aviation pictures. He became so successful at it that in 1960 the Royal Air Force commissioned him to do a number of paintings in Kenya. During this period he had a traumatic experience that was to lead to his devoting so much ofhis life to the conservation of wildlife (see page 15 in the introduction).

In 1962, Shepherd painted his now famous elephant picture, *Wise Old Elephant*, which was made into a print that has already sold more than a million copies. It marked another turning point in his career, as it made him famous. Today, a Shepherd exhibition, whether it is held in Britain, Africa or the United States, is expected to sell out within the first day.

In more recent years, Shepherd also acquired a passion for steam locomotives, and has painted several extremely fine studies of steam engines. Appalled by the way that the old steam engines were being scrapped and wanting to save at least something of a bygone age, he bought two steam engines and founded (and became Chairman of) the East Somerset Private Railway at Cranmore, which has become one of the best private railways in the country.

He has painted a large variety of subjects, such as *Shires on Holiday*, executed at the Whitbread hopfields at Paddock Wood; a village farrier at work in *The Old Forge*; soldiers patrolling the streets of Northern Ireland, called *Ardoyne Patrol*; and *The Lunch Break*, a scene of farm workers in the fields, which could have been painted by Birket Foster. He has also painted a range of landscapes.

BENJAMIN D. SIGMUND
fl. 1880-1904

Although Sigmund's work is familiar to all those who attend art auctions, very little seems to be known about his private life, except that he lived in Maidenhead and flourished for only a relatively short period before dropping out of sight, like so many of the late Victorian artists seem to have done.

From the old catalogues we know that he exhibited several times at the Royal Academy, and at some of the major English art galleries, as well as at the Royal Hibernian Academy, the Royal Scottish Academy, and at the Society of Painters in Watercolours. He painted mostly in Devon, Cornwall and Wales. In 1888 he brought out two books, *Among the Reeds and Grasses* and *By the Sea Shore*.

THOMAS JACQUES SOMERSCALES, RA,
RBSA
1842-1927

Somerscales was born in Hull on 30 October 1842, the son of a local shipmaster. Like so many of the nineteenth-century marine artists, his life was an interesting one, and is covered at some length in the introduction on page 11. His style is said to have some affinity with the work of Edouard de Martino, whose painting brought a new kind of realism to marine painting. Unlike Martino though, Somerscales's paintings were much more simple in their choice of subject matter, often showing no more than a single ship in the foreground with others seen in the distance.

He exhibited twenty-five pictures at the RA and at a number of the London galleries before his death in Hull on 27 June 1927. One of his sons, Thomas J. Somerscales, became a landscape painter who exhibited from 1900 until 1938.

THOMAS SPINKS
Exh. 1880-1907

Spinks was a London landscape artist who lived at 33 Princess Street, off Stamford Street, London, SE1, before moving to Glenavon Cottage, Betws-y-Coed, Wales. Although he exhibited only four times at the RA, he painted quite a number of very pleasant landscapes, many of them around where he lived in Wales.

HENRY STACY-MARKS

HENRY STACY-MARKS, RA, RWS
1829-1898

A genre artist and a masterly painter of animals, Stacy-Marks was born in London on 13 September 1829, and was trained at the RA Schools. For all its faults, the Royal Academy was one of the best schools for a trainee artist to attend. In addition to the regular masters, a certain number of selected Academicians went into the classrooms to show their personal interest in the students and to give them practical advice.

His training finished, Stacy-Marks studied for a few months in Paris in the company of one of his friends, Philip Calderon. After his return he began to exhibit at the RA from 1853. His best work was as a bird painter and a designer of stained glass. He also supplied illustrations for several magazines and a number of books, including *Legends of the Cavaliers and Roundheads*, and Dickens' *A Child's History of England*.

HENRY JOHN SYLVESTER STANNARD,
RBA, RSA
1870-1951

Stannard was born in London on 12 July 1870, the son of Henry John Stannard (see next entry). Primarily a watercolour artist who specialised in painting rural landscapes

with rustic cottages, his work resembles that of Birket Foster, though his is far less sentimental. He began exhibiting at the RA, where at least thirty-five of his paintings were hung, and another seventy were shown at the RBA. He is known to have used the split brush technique from time to time, where the brushes are split to achieve a more precise look to the details in a painting.

He studied at the Kensington School of Art and spent most of his working life in Bedford. He had a studio in Flitwick and was an enthusiastic member of the local opera and dramatic societies as well as taking a large part in other local activities. He died on 21 January 1951.

His work is represented in many public art collections, including those of Dudley, Luton, Kettering and Wolverhampton.

HENRY JOHN STANNARD, RWS
1844-1920

Henry Stannard was born in Woburn, Bedfordshire, the son of John Stannard, a Bedford landscape artist, and became the father of Henry John Sylvester Stannard in 1870.

Henry Stannard was essentially a sporting artist and illustrator who became almost as well known as Henry Thorburn for his studies of game birds and small wildlife. He studied at the South Kensington Schools, and eventually set up his own Academy of Arts in Bedford in 1887. He exhibited fifteen paintings at the RA and another 182 at the RBA. He spent much of his life in Bedford, where he died on 15 November 1920.

HAROLD SWANWICK, RI, ROI
1866-1929

Swanwick was born in Middlewich in Cheshire, and studied under Alphonse Legros, a French painter who became a naturalised Englishman in 1881 and had a reputation for being a severe and exacting teacher at the Slade School in London, where he worked. Swanwick then finished off his training at the Academie Julien in Paris. His training could therefore be said to have been of the best, and it shows in his work.

Swanwick began to exhibit at the RA in 1889 and he was to show thirty paintings there before he died on 13 April 1929, at Wilmington, Sussex, his home since 1907.

ARCHIBALD THORBURN
1860-1935

Thorburn was born on 31 May 1860, the son of Robert Thorburn, RA, a miniaturist painter. He was educated at Dalkeith and at Edinburgh, and first exhibited at the RA in 1880, which must have been about the time he was living at 25 Stanley Gardens, Belsize Park, London.

He was an animal artist who specialised in painting game birds, and like Henry Stannard (see page 14) did many illustrations for such publications as *The English Illustrated Magazine*, the *Pall Mall Magazine* and *The Sporting and Dramatic News*, supplying illustrations for all of them between 1896 and 1898. Later, at the turn of the century, he began writing and illustrating his own books, all of them with titles that were indicative of their subject matter, including a definitive book on his favourite subject, *Game Birds and Wild Fowl of Great Britain and Ireland*, which was published in 1923.

He led a busy, hardworking but rather uneventful life, which may have been enlivened when he married the daughter of Charles Mudie, founder of Mudie's Lending Library, the first of its kind, which came into existence in 1842 at a little shop off Bloomsbury Square. It was a marriage that would undoubtedly have led him into an entirely new circle where books, rather than birds, were the main topic of conversation.

He lived for some time at Godalming, Surrey, and died on 9 October 1935.

LOUIS WAIN

THOMAS NICHOLSON TYNDALE
fl. 1891-1910

Thomas Nicholson Tyndale was a watercolour artist who painted very much in the style of his time in the traditions of such artists as David Woodlock, Thomas MacKay and Helen Allingham. At his best he was a watercolour artist of considerable merit and is well known for his colour plates in the book *Worcestershire*, one of a series published by A.C. Black. He was a friend of Helen Allingham and went on several sketching expeditions with her.

LOUIS WILLIAM WAIN
1860-1939

Louis Wain was born in London on 5 August 1860, and studied at the West London School of Art, where he later taught. He stayed in that post during 1881 and 1882 and then joined the staff of *The Sporting and Dramatic News*, where he stayed for four years before changing to *The Illustrated London News* in 1886.

By then he had already made a name for himself as a humorist cat artist whose paintings were often made into prints to adorn the bedroom walls of countless children.

In 1906 he went to New York, where he produced a couple of strip cartoons 'Cats About Town' and 'Grimalkin' for the Hearst newspapers. Wain does not seem to have enjoyed himself very much in New York. Always one for rushing into print, he wrote several articles complaining about the weather, about the money-grubbing attitude of the New Yorkers, and about the great mass of emigrants struggling to find a foothold in a city that had little time for compassion. Needless to say, none of this went down too well with the New York newspapers, which began sniping at him through their columns. To cap it all, Wain made the mistake of investing in a new form of oil lamp, a project that eventually foundered on the rocks of his own gullibility.

He returned to England broke, and at a time when his

work seems to have dried up. To add to his sorrow, while he was away his mother had died from the first wave of the Spanish influenza that was to kill 20 million people worldwide, — the 150,000 in this country alone included his eldest sister, who succumbed in 1917.

During the war Wain fell off a bus and was knocked unconscious. This was given as one reason for his mental breakdown in later years, but is extremely unlikely, as the first serious signs of his schizophrenia did not appear until 1924.

The rest of Wain's life was all downhill. He was admitted to the pauper's ward in the Springfield Mental Home in Tooting. After being moved to the Bethlem Royal Hospital in Southwark, now occupied by the Imperial War Museum, he ended his days at Napsbury Hospital, St. Albans, where he died on 4 July 1939.

His two surviving sisters continued to live in Brondesbury Road, surrounded by an enormous quantity of his drawings and watercolours, and countless models of cats, until Felicie, the youngest sister, died in Willesden Hospital in 1940. The remaining sister moved to a flat in Dulwich, where she died May 1945, bringing down the final curtain on a harrowing story in which the sisters had always hoped that one day Louis would return home, until it became evident that he never would.

ROBERT THORNE WAITE
1842-1935

Waite was born in Cheltenham, where he was educated at the local grammar school and where he first developed his interest in art. He went on to study at the South Kensington Museum in the Science and Art Department, and began exhibiting at the Royal Academy in 1863. His early reputation was founded mainly on his watercolours, culminating in his membership of the ARWS in 1876 and the RWS in 1884.

HARRY WATSON, RWS, ROI, RWA
1871-1936

Harry Watson, a well-known landscape and figure artist during the early decades of the twentieth century, was born on 13 June 1871 at Scarborough, but spent much of his childhood in Winnipeg, Canada. He returned to Scarborough in 1884 and received his initial art training at the local art school where he won a scholarship to the RCA. He studied there from 1889 until 1894 and two years later was beginning to exhibit at the RA; he was to have eighty-one pictures in all shown there.

He became Life Master at the Regent Polytechnic in 1913, the same year as his oil, *Across the River*, was bought by the Chantrey Bequest.

Watson painted mostly in Scotland, Wales and France, and was married to Barbara Christian, the landscape artist and wood engraver who exhibited between 1923 and 1940. He died in London in September 1936, where he had been living at 37 Guildford Road, off the Lambeth Road.

Examples of his work are in the Maidstone Art Gallery and in the Tate Gallery.

JOHN TERRICK WILLIAMS, RA, RI, ROI, RWA
1860-1936

Although Graves' *Dictionary of Artists* (1760-1893) refers to Terrick Williams as being an artist who painted domestic subjects, he also painted a large number of landscapes and seascapes in Europe, the Mediterranean and Cornwall, both in oils and watercolours. Many of his marine paintings were of harbour and quay scenes.

He was born in Liverpool on 20 July 1860. His father forced him, upon leaving school, to go into the family soap business, even though he knew his son spent every spare moment painting, and dearly wished to be an artist. When the stress involved caused Terrick Williams to have a physical and nervous breakdown, his father relented and he was allowed to go to Antwerp to study under Verlat. As Verlat's name crops up several times in this book, it might be worth digressing briefly to give some idea of why so many artists went to him for tuition. His name is mentioned in a number of reference books without any mention of his background.

Initially Verlat (1824-1890) was a portrait painter and director of the Academy of Weimar. He gained a considerable reputation, even at that stage in his career, by painting several notables of the time, including Franz Liszt. After returning to Antwerp, he visited Palestine and brought back with him a number of paintings of biblical subjects that were highly popular at the time, and eventually ended up in the Antwerp and Brussels galleries. All this added to a reputation which also embraced his renown as an excellent art teacher.

After studying under Verlat, Terrick Williams went for a couple of years to the Academie Julien in Paris. He began to exhibit at the RA in 1890 and later won a silver and then a gold medal at the Paris Salon.

He was an artist of considerable talent who was equally at home working in oils, watercolours and pastels. He was elected a full member of the RA in 1933, and died three years later in Plymouth on 20 July 1936.

FREDERICK A. WINKFIELD
fl. 1873-1920

Winkfield was a landscape and marine artist who exhibited sixteen pictures at the RA and another twenty-three at the RBA, as well as many other important galleries. A talented artist who originally came from Manchester, he moved to London in 1877, where he lived at 59 Britannia Road, Fulham. His RA paintings include *Misty Morning*, *Oyster Boats Getting Under Weigh*, *A Coasting Collier* and *The Upper Pool, River Thames*.

FRANK WOOTTON
born 1914

Frank Wootton is a leading artist in the field of equestrian painting, as well as being a well-known landscape artist. He was born in Hampshire on 30 July 1914, and studied at the Eastbourne School of Art, where he won a travelling scholarship and a gold medal.

During World War II he was invited by the Commander-in-Chief, Allied Forces, to become one of the country's war artists, and in this capacity saw service in Normandy, India and Burma. Many of the paintings he did during that period are now in the Imperial War Museum and in the Royal Air Force Museum.

Since then he has carried out several important commissions, including some for various members of the Royal Family. He has also exhibited at the RA and in America, and produced the book *How to Draw Aircraft and Cars*, two other subjects that have always interested him.

He now lives in Alfriston, Sussex.

WILLIAM TATTON WINTER, RWS, RBA
1855-1928

Tatton Winter was a landscape painter who worked both in oils and watercolour. He was born in Ashton-under-Lyne, just outside Manchester, where he attended evening classes at the Manchester Academy of Fine Arts, working by day for a business company in the city. After deciding to abandon a career in business, he went to Antwerp to study under Charles Michel Maria Verlat.

Winter exhibited at the RA from 1889, and also at the Paris Salon and in Munich. He lived at Reigate and much of his painting was done in Surrey, Sussex and Kent.

Examples of his work are to be seen in the City Art Gallery, Manchester, and at Cartwright Hall, Bradford.

JOHN WORSLEY

JOHN WORSLEY, RSMA
born 1919

Worsley was born on 16 February 1919, in Kenya and spent his early years on his father's coffee farm. His early schooling was at Gilgil School, Kenya, and then, from the age of nine, he was educated in England, first in Seaford and then at Brighton College, before going on to study at Goldsmith's School of Art.

Upon leaving art school he plunged into the highly competitive world of freelance illustrating, where he survived until war broke out, when he joined the RNVR. Some of his colourful wartime activities and later adventures are covered in some detail in the introduction on page 12.

In 1946, before being demobilised, he completed his work as a war artist by painting many senior naval and military officers, including Field Marshal Viscount Montgomery of Alamein, and Admiral Sir John Cunningham; these paintings now hang in the Imperial War Museum.

Since then, as well as painting a large number of important marine pictures, he has also done portraits in oils of many well-known figures of our times such as Edward Heath, Dr. Runcie the Archbishop of Canterbury, Basil Boothroyd the writer, Walter de la Mare at the age of eighty, and Arthur Askey, to mention only a few of his many 'sitters'.

A man of many parts, he has also sculpted several busts, including one of Sir Francis Chichester, illustrated a number of books, and has produced several television programmes.

Examples of his work are in the Imperial War Museum, the National Maritime Museum at Greenwich, and in various provincial art galleries. His work is also in the permanent collections of Imperial Oil of Canada and the Hong Kong & Shanghai Banking Corporation.

GEORGE WRIGHT
1860-1942

Wright was born near Leeds, the son of a manager of a local carpet shop and was one of at least five children who were brought up at Victoria Villas, Victoria Road, Headingley, near Leeds.

He was living in Rugby in 1901 and then moved to Oxford, by which time Ackermann & Son were guiding his career and obtaining commissions for him, as well as holding the occasional exhibition of his work. He also exhibited at the RA from 1892.

He was a superb artist whose sporting and coaching scenes have seldom been bettered. In 1939 he retired to Seaford, Sussex, where he died three years later. He was the brother of Gilbert Scott Wright, a self-taught artist who had also become a sporting and coaching artist, and in the earlier part of George Wright's career, the two had combined their talents in the painting of a number of pictures. Some of their work was reproduced on calendars.

WILLIAM LIONEL WYLLIE, RA, RI
1851-1931

Wyllie was born in London on 5 July 1851, the son of Morrison Wyllie and the elder brother of Charles W. Wyllie, both of whom were professional artists. He studied for a year at Heatherley's Art School before joining the RA Schools, where he studied from 1866 until 1869, winning the Turner Medal in the last year of his training.

By 1873 he had bought his first yacht, *Ladybird*, and had converted it into a studio. Then he began to paint a whole series of pictures of the River Thames, culminating with his famous *Toil, Glitter, Grime and Wealth on a Flowing Tide*, which was purchased from the funds of the Chantrey Bequest and handed over to the Tate Gallery in London.

Moving to Hoo Lodge on the Medway estuary in 1885, he widened the scope of his subject matter by beginning to paint merchant steamships. This brought him to the attention of the steamship companies, which commissioned him to paint 'portraits' of some of their best ships. This often meant that he had to travel on cruise liners. Wyllie must have found this much to his liking as it sometimes meant going on an extended luxury cruise, from which he generally returned with many watercolours which he then exhibited at the London galleries. He was also an outstanding painter-etcher and became very well known for his prints. In 1906 he bought the Tower House in Old Portsmouth, overlooking the harbour, another splendid vantage point that allowed him to paint many of the vessels that went in and out of the harbour.

Throughout his working life, Wyllie was an industrious and prolific artist who still found time to enter yacht racing competitions with his wife and they often found themselves racing against such formidable opponents as Uffa Fox. Wyllie died in London on 6 April 1931.

His paintings may be seen in many museums besides the National Maritime Museum. These are to be seen in the city art galleries of Glasgow and Manchester, as well as in the town art galleries of Bridport and Maidstone, the Towner Gallery, Eastbourne, and the Fitzwilliam Museum in Cambridge.

THE PAINTINGS

Lamorna Birch

Lamorna Birch is one of our landscape artists whose reputation has grown steadily over the years. For many people, including myself, his studies of Cornish woods and, in particular, his many studies of Lamorna stream which flows to the sea from Lamorna Valley, are the best paintings he ever did. He painted this stream in all the seasons, capturing its every mood, when its waters sparkled in the sunlight and when they had turned grey and dull with the snow lying deep on its banks.

He was the most English of artists, whose love of the area where he had chosen to spend his life was reflected in every picture he painted around Lamorna, where his freshness of vision was never dulled by repetition.

He was himself a very English figure. An ebullient man who was never happier than when holding a fishing rod in his hands, he became a familiar sight when dressed for his fishing expeditions in plus fours and a well-worn hat adorned with a variety of fishing flies. His fanatical devotion to fishing and to his art, almost to the exclusion of everything else, caused Alfred Munnings to comment: 'When he was not painting, he was fishing. When he was not fishing, he was painting.' His love of fishing may have been a trifle obsessive, but he really loved his art more. He is said to have died in mid-sentence when describing to someone at his bedside how he would tackle his next picture.

Although Lamorna Birch travelled widely during his life, Lamorna was always something of an earthly paradise to him – a view that seems to be shared by his eldest daughter, Lamorna Kerr, who still lives in Flagstaff Cottage, which her father bought in 1903.

This painting of Lamorna stream, playground of a piper bird, is one of Lamorna Birch's many works that captures entirely the magic of this beautiful area.

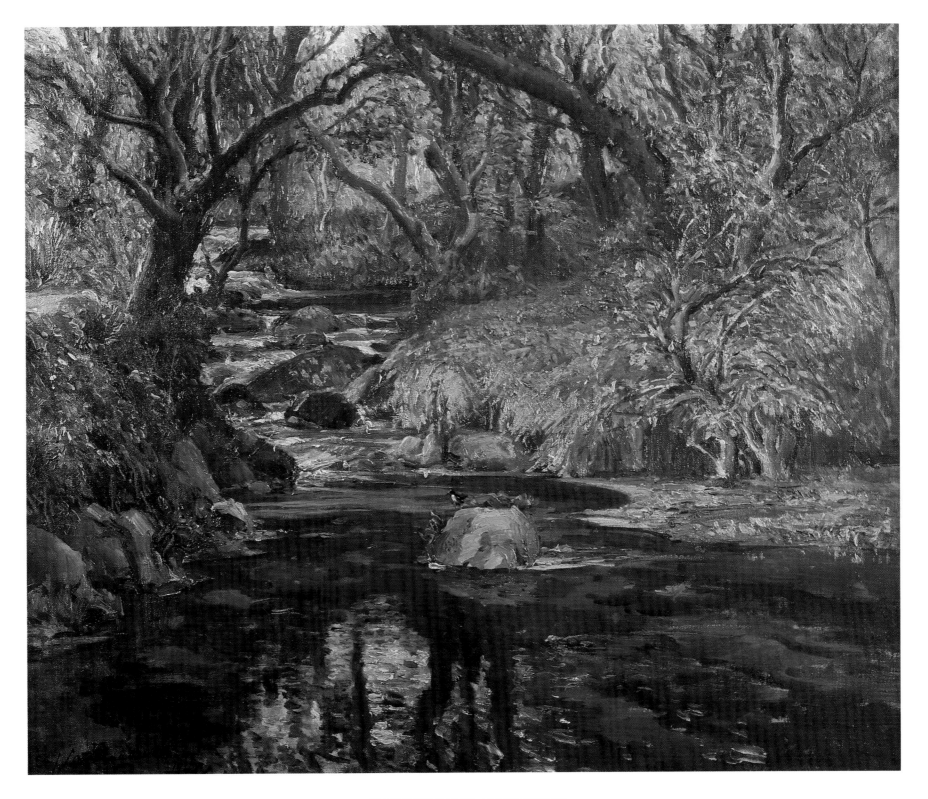

THE PIPER'S PLAYGROUND
(RA Exhibit) signed oil. 20in x 24in, Priory Gallery. Courtesy of Mrs Lamorna Kerr.

Henry H. Parker

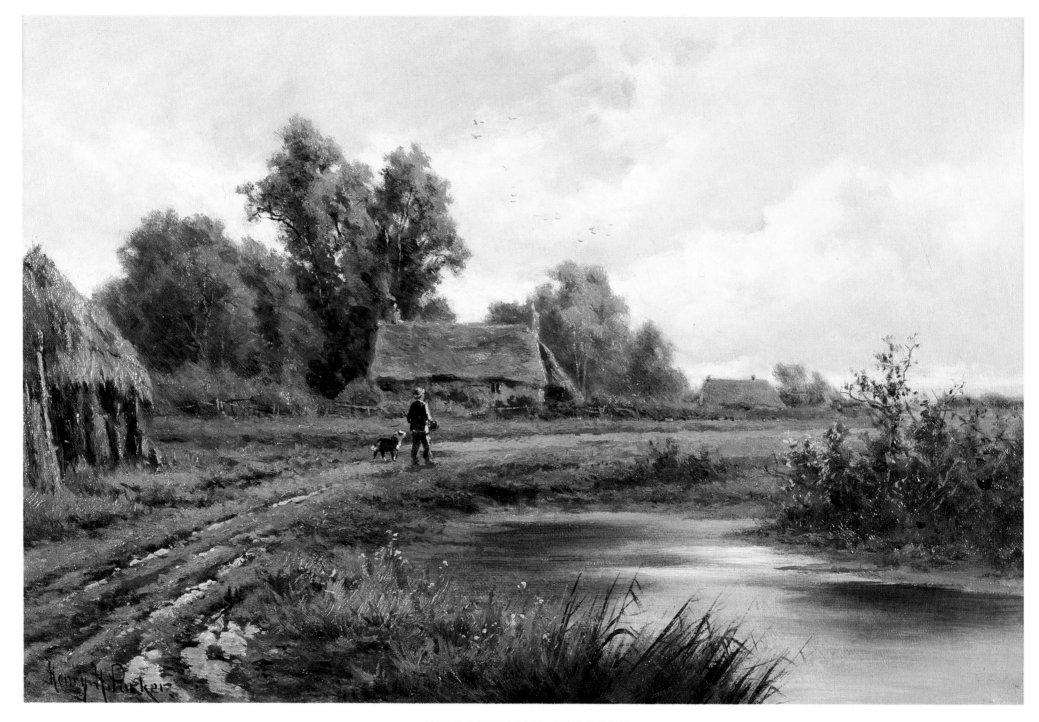

COUNTRY LANE BY A POND
signed oil. 12in x 13in, E. Stacy-Marks Ltd.

Nothing could be more traditional in style and treatment than this oil by the Midlands artist, Henry H. Parker, painted in an unspecified place and merely titled *Country Lane by a Pond*. Parker was an oil and watercolour artist of considerable merit, whose work has been neglected for some time but is now getting the attention it deserves. This painting gives some idea of Parker's style and the way he uses a fairly restricted palette to capture, in this case, the atmosphere of a dull and wet day in the country. The pearly white of the pond waters is particularly well done and obliquely underlines the point already evident – the country is just as dull and depressing on a bad day as any urban scene.

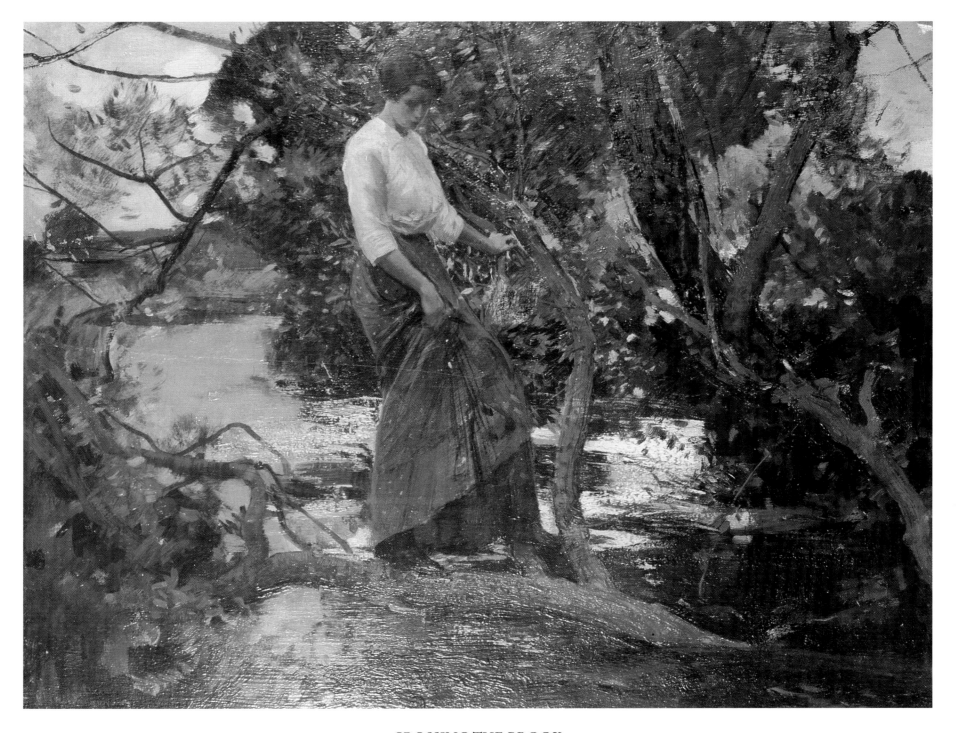

CROSSING THE BROOK
signed oil, dated 1913 on panel. 11¾in x 16in, Sotheby's, Billingshurst, Sussex.

This oil was painted in 1913, the same year that one of his paintings was bought by the Chantrey Bequest, a sale which did much to enhance his reputation and no doubt helped him to obtain his post as an art teacher at the Regent Street Polytechnic. The model in this painting may well have been his wife, who herself painted and was to exhibit twenty-two pictures at the RA before her death in 1940.

It is a well-organised painting in which the artist has made effective use of white to show the reflection of the light as it falls on the waters swirling around the lower reaches. Considering the quality of his painting, it is surprising that his work seems to have fallen slightly out of favour these days.

Kenneth Denton

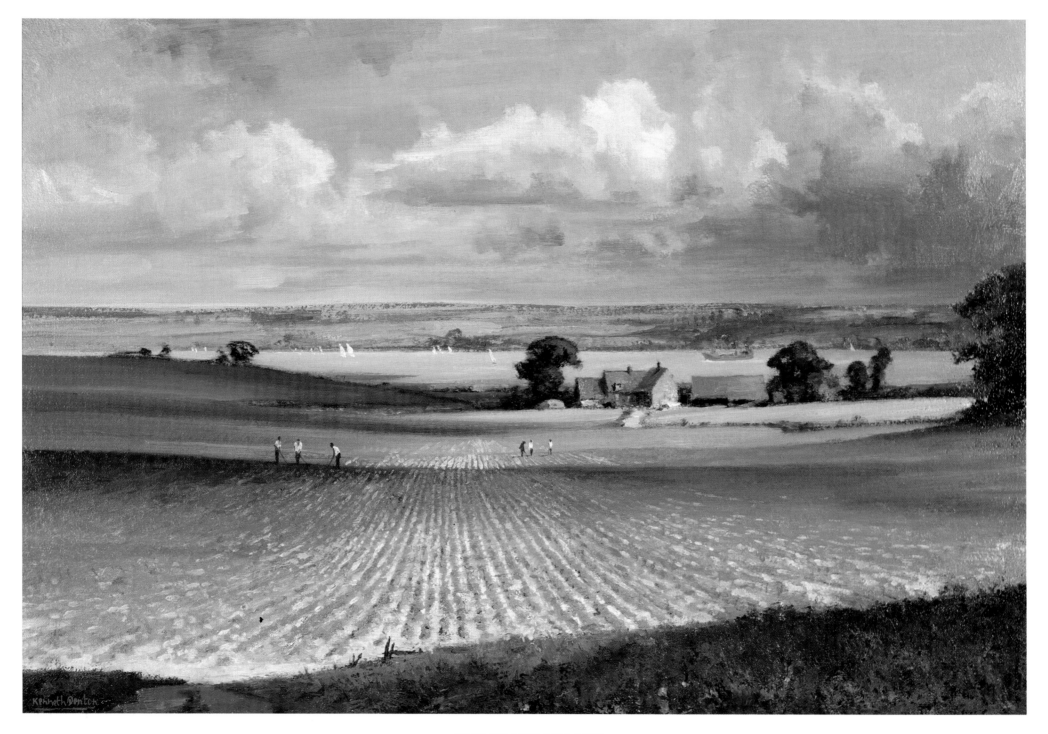

THE STOUR VALLEY
signed oil. 24in x 36in, E. Stacy-Marks Ltd.

When one sees examples of Kenneth Denton's landscapes, and others of a similar quality by some of the other artists included in this book, one wonders why so much attention is given to the Victorian artists at the expense of latter-day painters.

The first of Kenneth Denton's splendid landscapes, shown on this page, is a view of the Stour Valley, which the artist has painted from a vantage point where he was able to obtain the maximum effect with his masterly use of perspective. It embraces a fore-

ground view of a field of growing vegetables that are being tended by several farmhands. Beyond, we see a large farmhouse, and beyond that yet again, a view of the river flowing through the Stour Valley. On the other side of the river the eye is taken onwards over

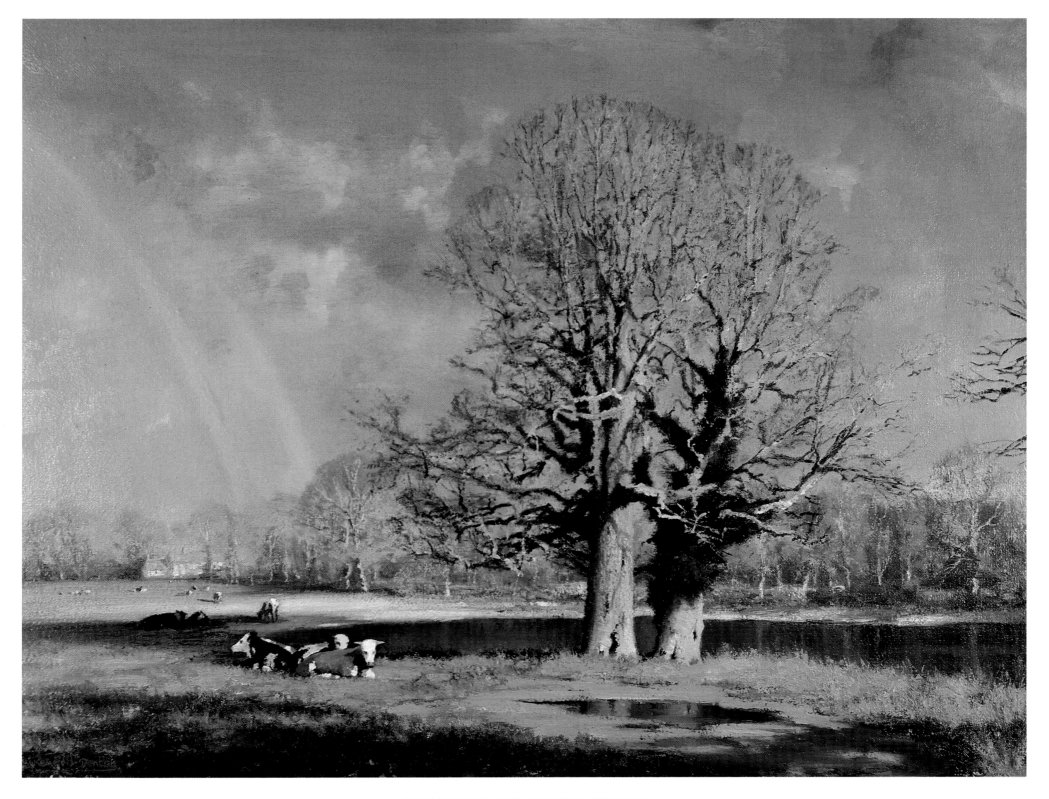

ELM TREES AND CATTLE: SPRING
signed oil. 24in x 36in, E. Stacy-Marks Ltd.

another vista of more fields, with grey clouds lowering over them. All in all, it is an incredible display of painting a scene in depth.

His other oil *Elm Trees and Cattle: Spring* is quite different in subject matter, but just as striking in its way. It is a finely executed study of a pair of stripped elm trees standing off centre in a field, with cattle reclining nearby. A reflected rainbow is seen in the far distance, following a downpour of rain that has left puddles on the ground. It epitomises the timeless quality of the English countryside, which has always been Kenneth Denton's forte.

Robert Thorne Waite

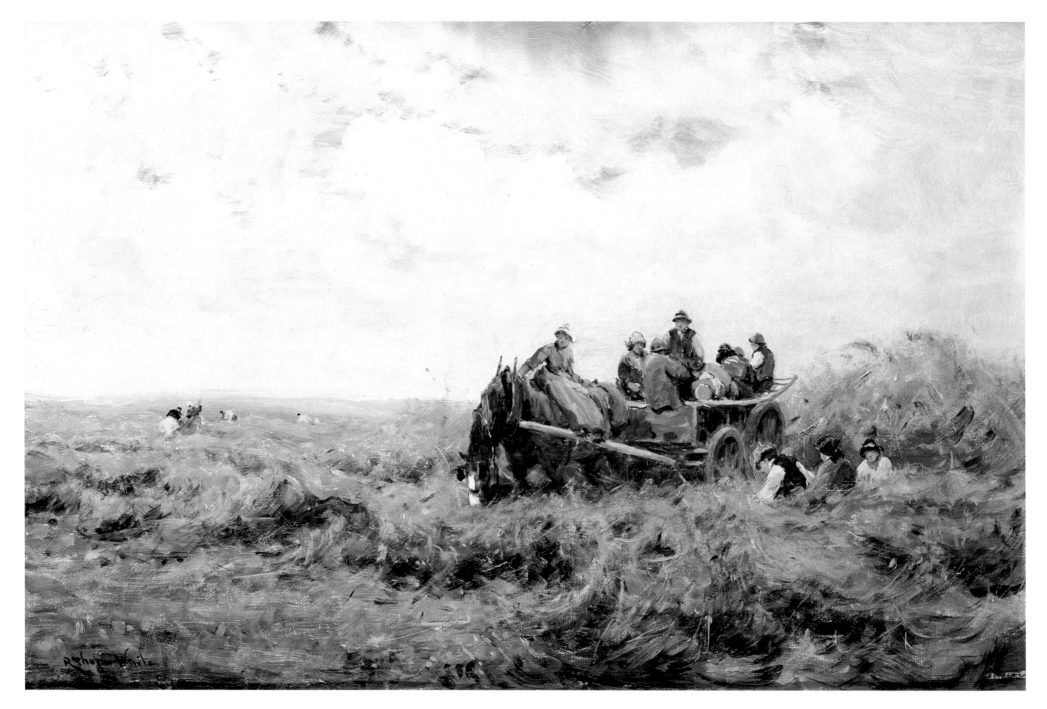

NEW MOWN HAY
signed oil on canvas. 12in x 18in, one of a pair, Priory Gallery.

Although primarily a watercolour artist, Waite did occasionally paint in oils. He was an excellent draughtsman whose early work resembled that of the great Victorian genre painter, Myles Birket Foster, with his idealised studies of children playing in a rural landscape. Later, however, his style began to change, probably to meet the growing demand of a public that now wished for something a little less sentimental to hang on their walls. His work became more Impressionistic, though still maintaining its basic feel for the English countryside.

His oils, though rare, are of a particularly fine quality, such as his *New Mown Hay*, which epitomises his flair for interpreting a country scene. It is a striking composition in which his use of perspective is evident, with farm workers resting in and around the cart after their labours, while others are tidying up in the background, with a mass of low-lying hills seen in the far distance. Obviously, great care was taken in capturing the look of newly turned hay which lies in untidy clumps waiting to be gathered.

RESTING
signed oil on canvas. 20in x 36in, Priory Gallery.

The constant theme running through nearly all of Sigmund's work is that of village and country life, but it is seen through the eyes of an artist who was concerned only with depicting the more pleasant side of rural life – as indeed were nearly all the other artists of his time. Despite this, his range of subject matter was quite varied, as can be gathered from the titles of some of his paintings, such as *Waiting to be Hired,* *The High Street, Cheltenham, A Group of Game, Sea Drifts by the Sea, Where the Nibbling Flocks Do Roam, Stepping Stones on the Conway,* and *The Fuel Gatherer.*

He generally preferred working in watercolours and gouache, so his oil *Resting* shown here is something of a rarity, although he did exhibit a number of oils at the RA. Unlike his rather 'pretty' watercolours of rural scenes (which are occasionally a little too charming for their own good), *Resting* is a more ambitious piece of painting in which light and shade play an important part in a way that is not often seen in his watercolours.

Due to the recent swing around in public taste, this sort of painting by Sigmund has now become highly collectable.

William Tatton Winter

GATHERING BRACKEN
signed watercolour. 12¾in x 29in, Sotheby's, Billingshurst, Sussex.

The watercolour on this page is very typical of Tatton Winter's work. Its delicate, atmospheric style is reminiscent of Corot, with its peasant figures trudging home through a landscape in which the trees have been stripped bare and even the river waters look cold. His work is at its best when his own poetic vision of a scene is brought into play; when he strives to catch the effect of light at dawn on a landscape, or portrays a scene that is bathed in the light of a dying day, as with his *Gathering Bracken*, which is the sort of subject with which he was most at home. Some of the paintings he exhibited at the RA show his leanings towards this type of subject, such as *When the Trees Are Bare*, *The West Wind* and *A Breezy Upland, Sussex*.

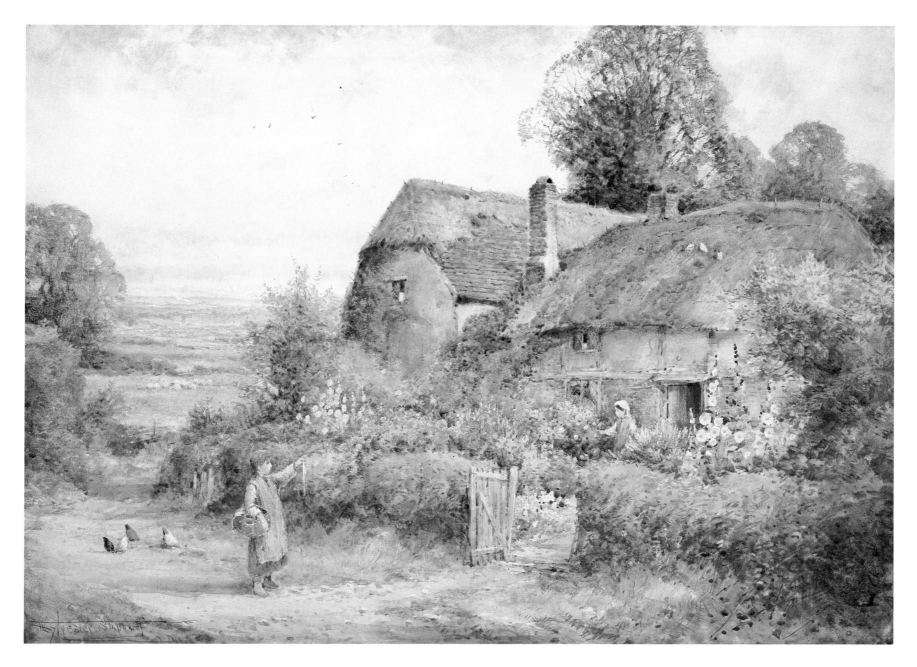

WOOL FOR SALE
signed watercolour. 14in x 20½in, E. Stacy-Marks Ltd.

Stannard's watercolour here is more attractive than most of his paintings around. Generally he gave his countryside scenes a rather desolate and unattractive look, with country cottages shown in varying degrees of decay. Set within rural surroundings that seem to have gone to seed, the cottagers occupying his pictures appear to be struggling to make ends meet, and are probably only two steps away from the workhouse.

This watercolour is far more in keeping with those highly popular Victorian paintings of a rural England where everything looks cleaner than it actually was. With a pretty thatched cottage, made even more attractive by a garden full of wild flowers and set in a sylvan glade with a distant view of the countryside where sheep peacefully graze, it is a picture of the sort of place that would appeal to any urban dweller who dreams of getting away from it all. The only intrusion on this idyllic scene is the poorly clad child trying to sell skeins of wool to the householder – a reminder that all was not perfect in Arcady, after all.

Thomas Spinks

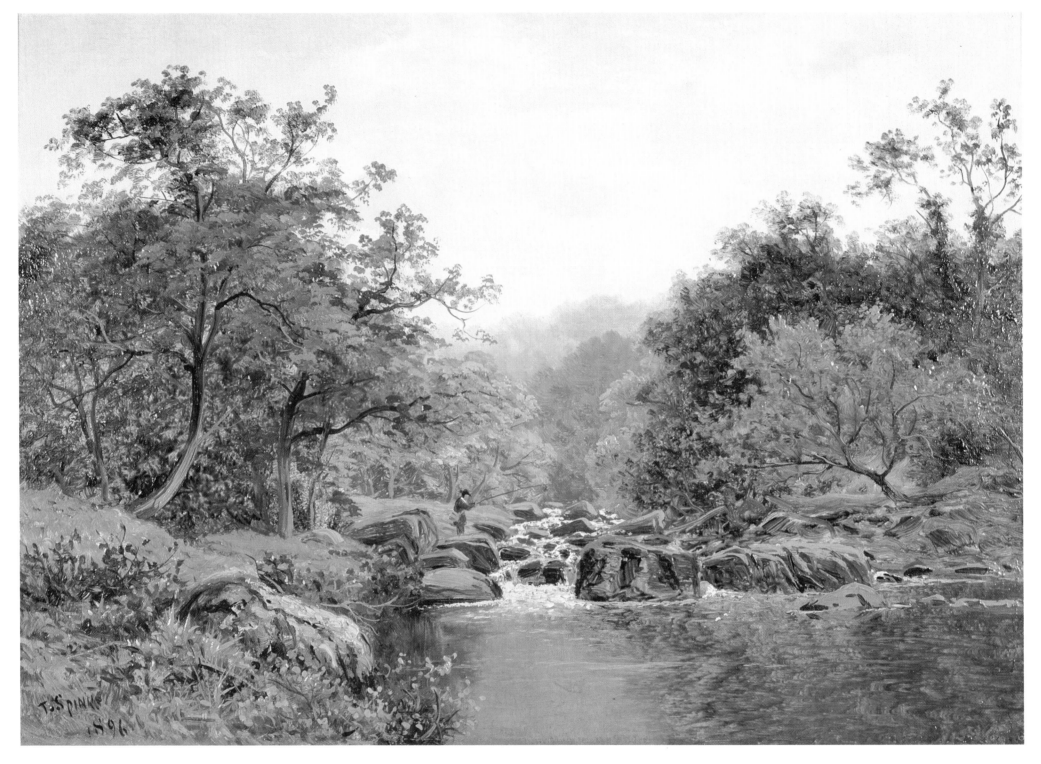

IN THE LLEDR VALLEY
signed oil, dated 1886. 14in x 20in, E. Stacy-Marks Ltd.

This painting by Thomas Spinks was done around one of the famous beauty spots near Betws-y-Coed, a popular haunt for artists. They were lured there by the beauty of the wild scenery in the vicinity of the village itself, whose name means chapel or sanctuary.

This little village and its surroundings were first popularised by David Cox in the early part of the nineteenth century.

One has only to look at this painting of a stretch of river in the Lledr Valley, where the waters cascade through a wooded countryside, to see why the place was so popular with artists. It is a highly competent piece of work, which captures much of the charm of this largely unspoilt area.

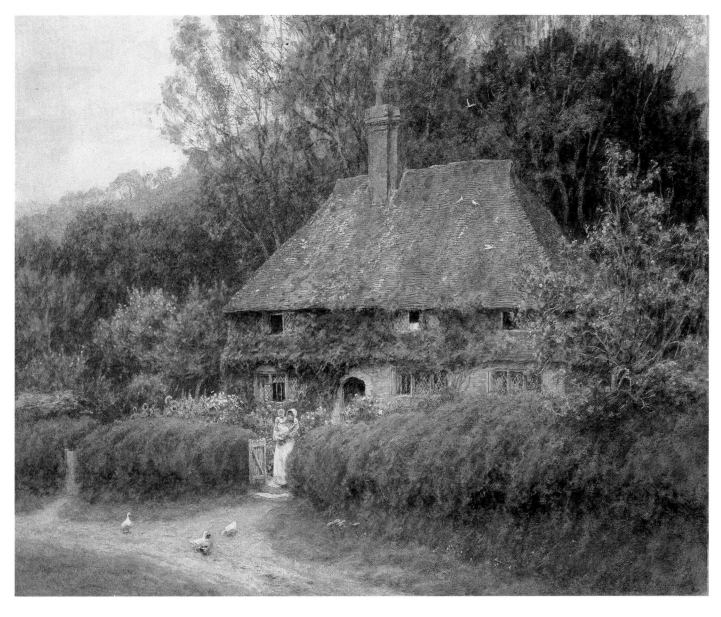

VALEWOOD FARM, UNDER BLACKDOWN, SURREY
signed watercolour. 11½in x 13¾in, Priory Gallery.

Next to Birket Foster, Helen Allingham has become one of the most famous of all the watercolour artists who specialised in painting rural scenes in watercolours, with the emphasis on country gardens where flowers always bloom and the houses are occupied by little girls and cats who always seem to be on hand to pose together by the garden gates.

John Ruskin, who was a close friend and a great admirer of her work, linked her name with that of Kate Greenaway, the famous illustrator of children's books whose pictures for *Under .the Window* achieved great success when it was published in 1879.

When Ruskin liked the work of an artist he always said so in no uncertain terms. In the case of Allingham he went on to praise her painting of 'the gestures, character and humour of charming children in country landscapes'.

Ruskin's praise was well-deserved. Many artists have tried to emulate her techniques, but she remains unsurpassed in her field. Her work appealed to several generations, though sadly most of it is now out of reach of many, owing to the fantastic rise in prices for her paintings.

This watercolour, *Valewood Farm, Under Blackdown, Surrey*, is a fine example of her work and is more tightly executed than many of her other watercolours. Although it features the almost inevitable mother and child, it is to the house, with its tiled roof laden with lichen and its mullioned windows, that one's attention is drawn most. As with many houses and cottages belonging to the period, it has been built under the shelter of a hill and is further protected from the elements by bushes and a large silver birch. Its faintly dilapidated air seems to be fairly common to most of the country cottages that were painted by the Victorian artists.

Henry Meynell Rheam

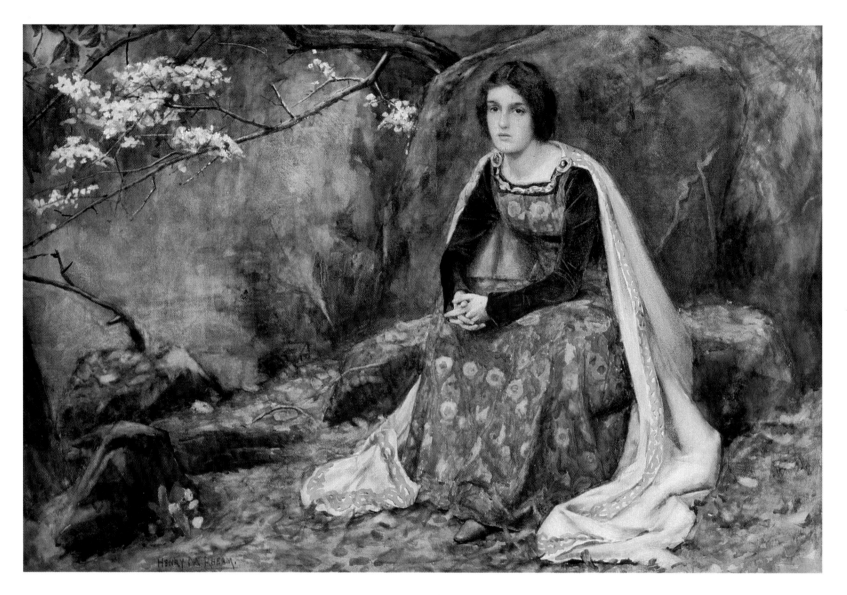

A MAIDEN IN THE GLADE
signed watercolour. 19¾in x 29in, Sotheby's, Billingshurst, Sussex.

Rheam was a member of the Newlyn School of painters, who became one of their fraternity for a reason quite unconnected with art. Stanhope Forbes, the leader of the school, was to explain the reason for Rheam's arrival in Newlyn in a paper that he read at the Passmore Gallery:

The annual cricket match between the artists of St Ives and Newlyn was one of the chief sporting events of the year and about the time I speak of, St Ives had acquired two notable batsmen and Newlyn seemed likely to endure defeat. But in a fortunate moment the situation was saved, for Harry Rheam, the notable

cricketer, was imported at great expense from Polperro. He remained with us ever after . . .

No doubt Rheam would have preferred to have been invited to go to Newlyn because of his talents as a painter rather than for being the formidable batsman he seems to have been by all accounts. But having gone there, he stayed until his death in 1920, long after his best days as a cricketer were over.

Rheam was primarily a watercolourist, and, like a number of the artists of the school, he did not confine himself entirely to painting the local scene and its fisherfolk. His watercolour *A Maiden in the Glade*, shown here, is an example where he sought a subject

to paint but executed it entirely from his imagination, although he probably used a model for his figure work. He was beginning to paint fanciful subjects at that time and was under the influence of the current vogue for art nouveau, a movement that dominated the poster scene and had come about with yet another wave of artists who were trying to break away from the styles of the past.

His watercolour here has more in common with the Pre-Raphaelites, at least with its choice of subject matter, although the colours are far more subdued. On the other hand, the face of the girl could have belonged to one of their models.

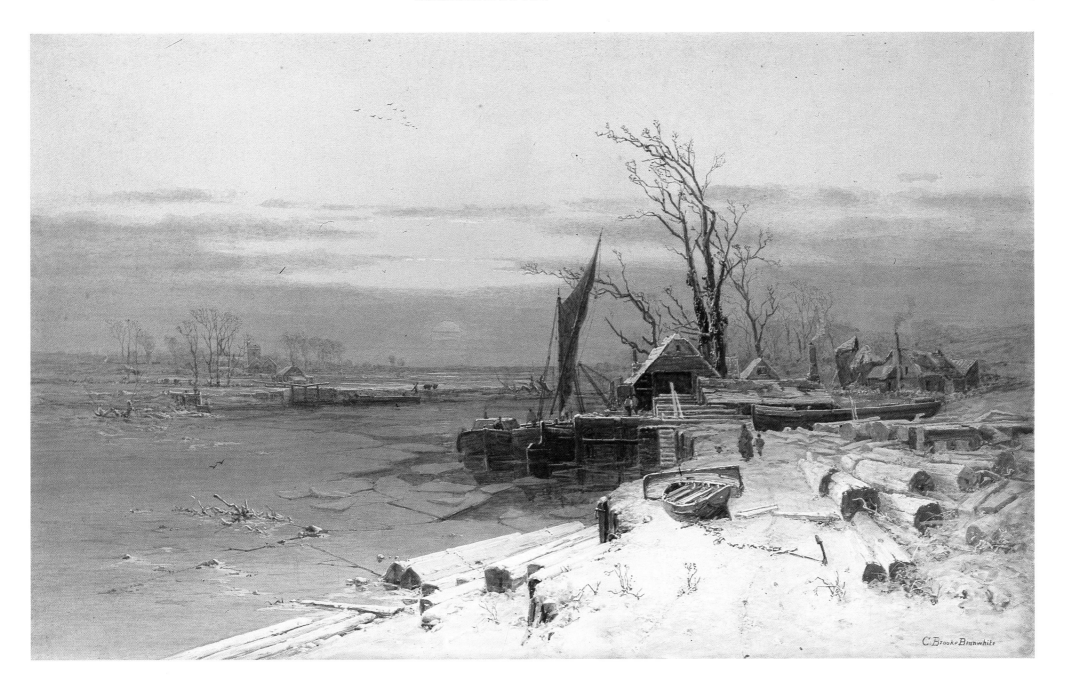

signed untitled watercolour. 20in x 30in, Bourne Gallery.

This Bristol-born artist who painted in the West Country is known for his atmospheric watercolours. In this excellent example of his work, he has painted a barge locked in a canal by snow and ice. The painting is well composed. The blood-red setting sun, which is reflected over a large expanse of frozen water, sharply contrasts with the white of the snow-covered near-side bank of the canal. The scene has an air of desolation and almost eerie stillness. There is hardly a soul about except for a woman and her son who trudge through the snow towards the few men idling their time away by the barge. Although it was painted in appalling weather conditions, the watercolour has an almost poetic quality to it.

Alan Fearnley

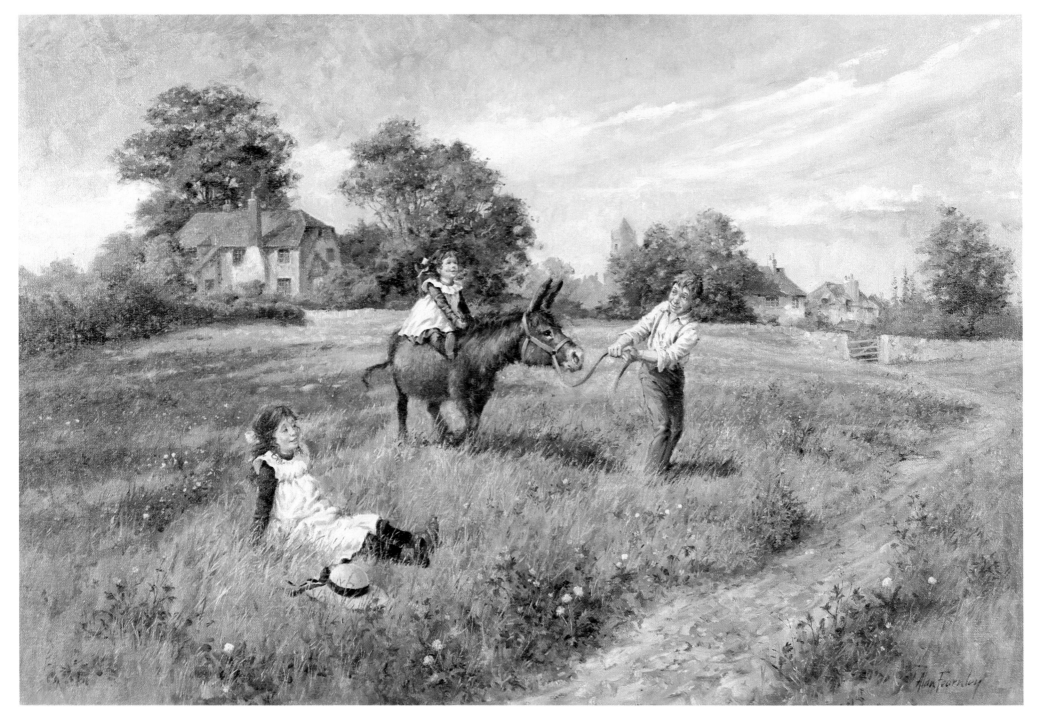

PLAYING WITH THE DONKEY
signed oil. 20in x 30in, E. Stacy-Marks Ltd.

The work of Alan Fearnley, like that of Gerald Coulson, which is discussed elsewhere in this book, includes cars and aeroplanes as well as landscapes.

His painting here depicts a rural scene with three children and a donkey. It is a charming oil that could have been painted by any of a number of Victorian artists, such is its subject matter. Like many modern painters of the countryside, Fearnley's grass is a more vibrant colour than the shades normally used by Victorian artists, and it brings the painting to life. The treatment of the grass, incidentally, is finely done and in such a manner as to make it appear that every blade has been carefully picked out. The same attention to detail has been given to other elements in the painting, down to the girl's bonnet lying on the grass. Even with the cottages the artist has not succumbed to the temptation of fudging the work merely because they are seen only in the far distance.

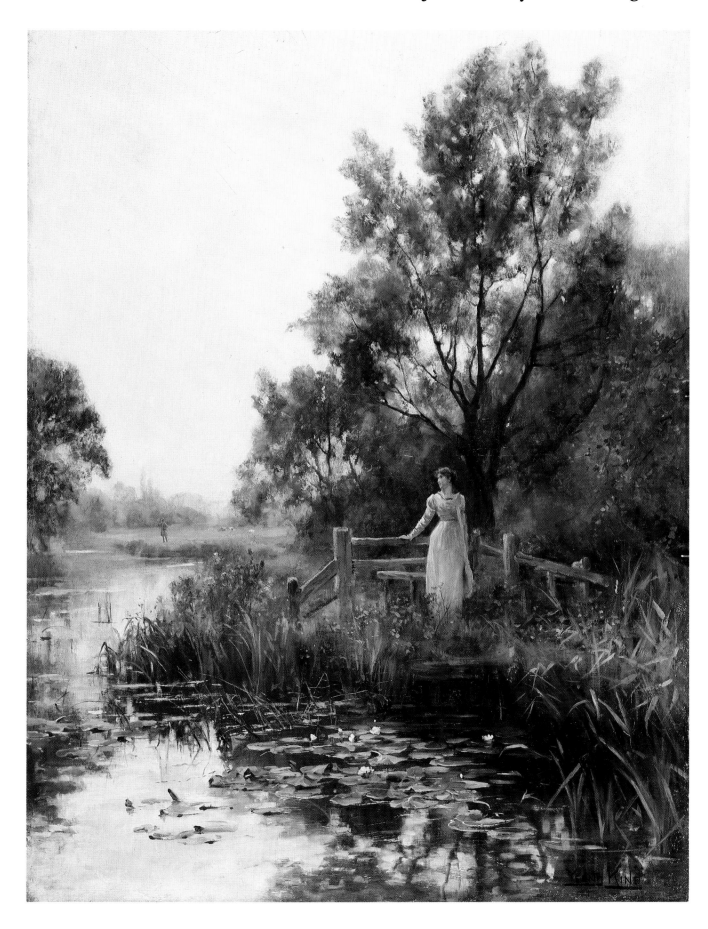

If there was one thing that Yeend King preferred to paint more than anything else, it was a pretty young Victorian woman posed against a rural setting. The painting illustrated here is no exception. Posing gracefully against a fence, this young woman gazes sadly into the distance while she waits to keep her last tryst with her lover. Nearby, a sluggish stream bedecked with water-lilies meanders into the distance, where the sun is beginning to set behind the trees.

What makes this more than just another pretty Victorian painting is the artist's *plein air* treatment, in which great play is made of the last full light of a late afternoon of a summer's day, seen reflected on the slow moving waters.

THE LAST ASSIGNMENT
signed oil. 40½in x 31¾in, E. Stacy-Marks Ltd.

Benjamin Williams Leader

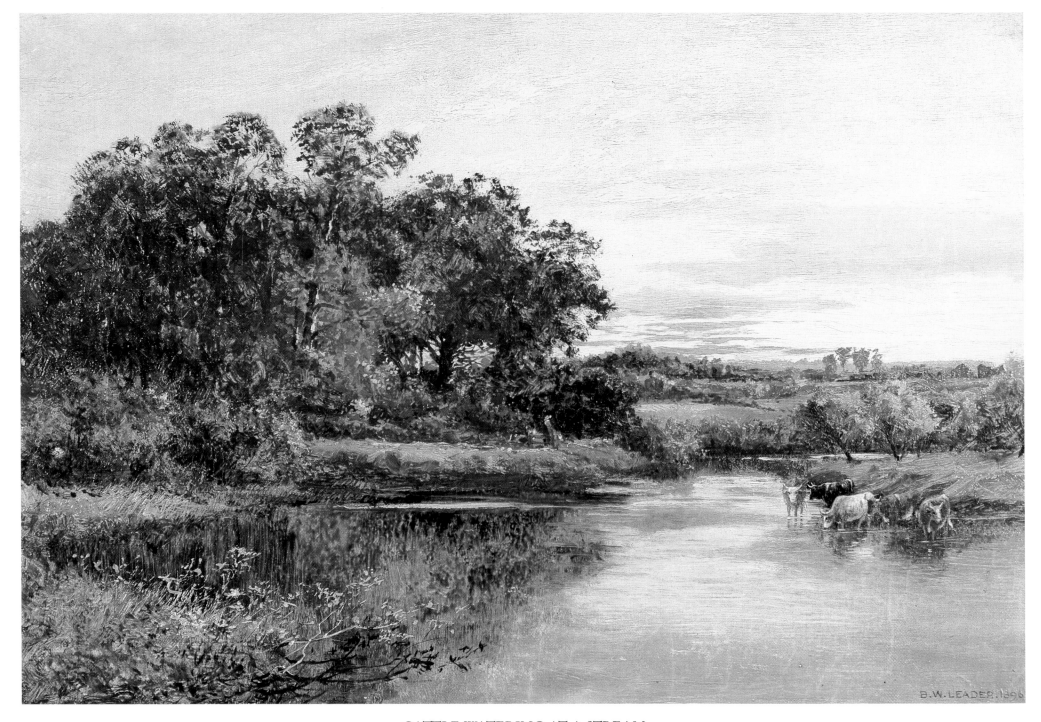

CATTLE WATERING AT A STREAM
signed oil dated 1896. 12in x 18in, E. Stacy-Marks Ltd.

Leader, who died in 1923 at the age of ninety-two, is best known to the knowledgeable for his painting of *February Fill Dyke*, which is now in the Birmingham Art Gallery. It is most representative of the work of an artist who was one of the best landscape painters of his age and whose work has always been admired for its truthfulness to nature.

The oil shown here belongs to his best period, when his painting had developed a more broad and realistic style. He painted this picture in 1896, but there is no indication of where it was painted, though it seems likely that it was done somewhere in Worcester, one of his favourite places for putting up an easel. It is a pleasing, atmospheric painting with the late afternoon sun already setting behind the distant hills, and casting a chill sheen on the river, where cattle have come to drink.

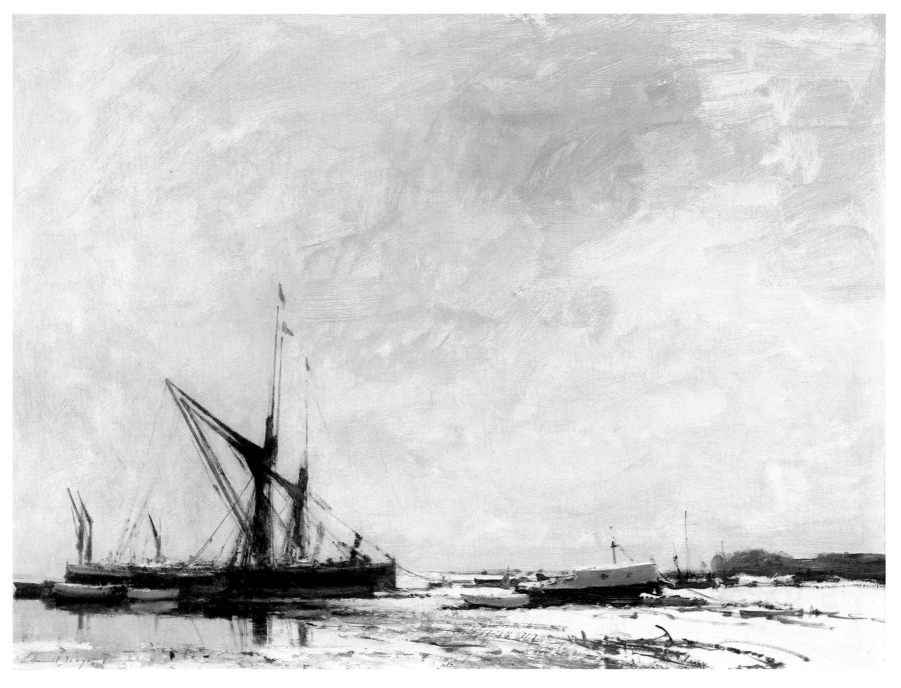

BARGES IN THE SNOW - PIN MILL
signed oil. 25in x 36in, Stacy-Marks. Copyright: Thomas Gibson, Fine Art Ltd.

Seago has always been fond of incorporating in his paintings the barges, yachts and local sailing vessels that are seen along the East Anglian coast, so that they become an integral part of the landscape, rather than marine subjects in a coastal scene. His *Barges in the Snow – Pin Mill* is a case in point. The barges may be the first thing to capture the attention, but they are placed firmly on the left-hand side of the painting to allow the beach and what lies beyond to be equally important factors in this oil, which still manages to look like a typical landscape, rather than a coastal scene. As a painting that evokes one of those icy cold days that are all too familiar to those who live in this part of England, it represents some of the best aspects of Seago's work, the best effects of which were achieved with apparent ease. This, of course, is part of the master painter's craft – to make the difficult seem easy.

Gerald Coulson

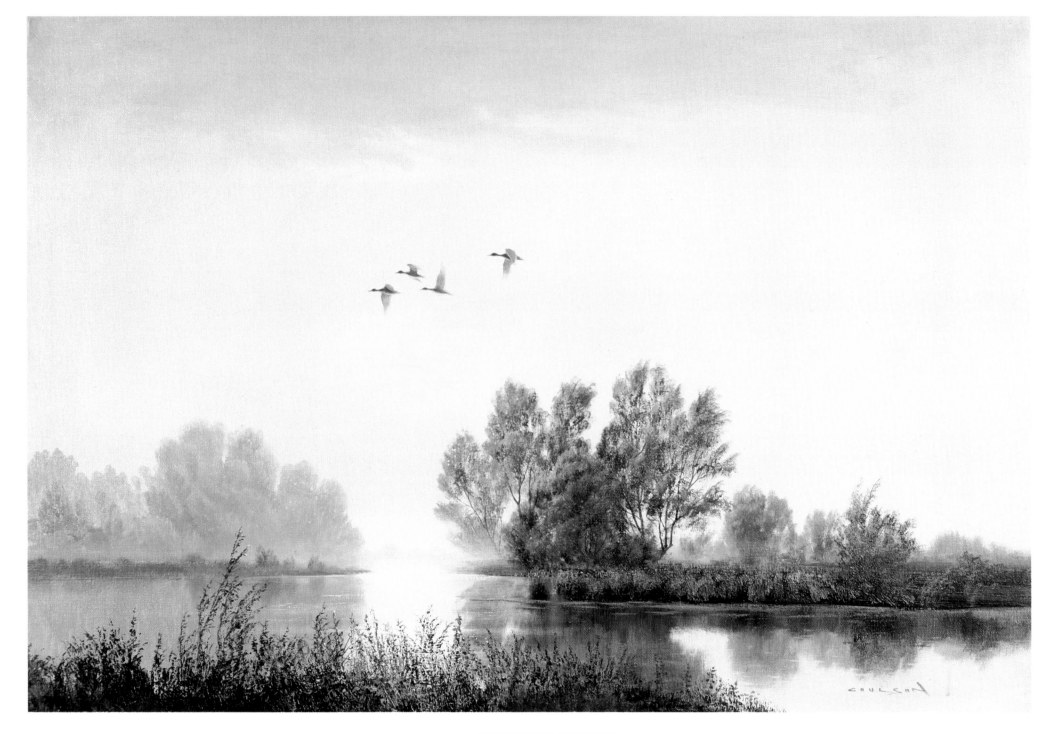

MORNING FLIGHT
signed oil. 24in x 36in, E. Stacy-Marks Ltd.

This is a striking example of the work of the contemporary artist Gerald Coulson who is equally at home painting railway, motoring or aviation scenes, as he is painting evocative landscapes such as the one shown here.

He has made wonderful use of light in this oil painting of wild geese flying over a large stretch of river water in early morning, and has utilised colour in a way quite foreign to any Victorian painter. The rising morning mists still in evidence over sections of the river help to give the painting an almost dreamlike quality. Note also the big expanse of sky, which is common to many of Coulson's paintings.

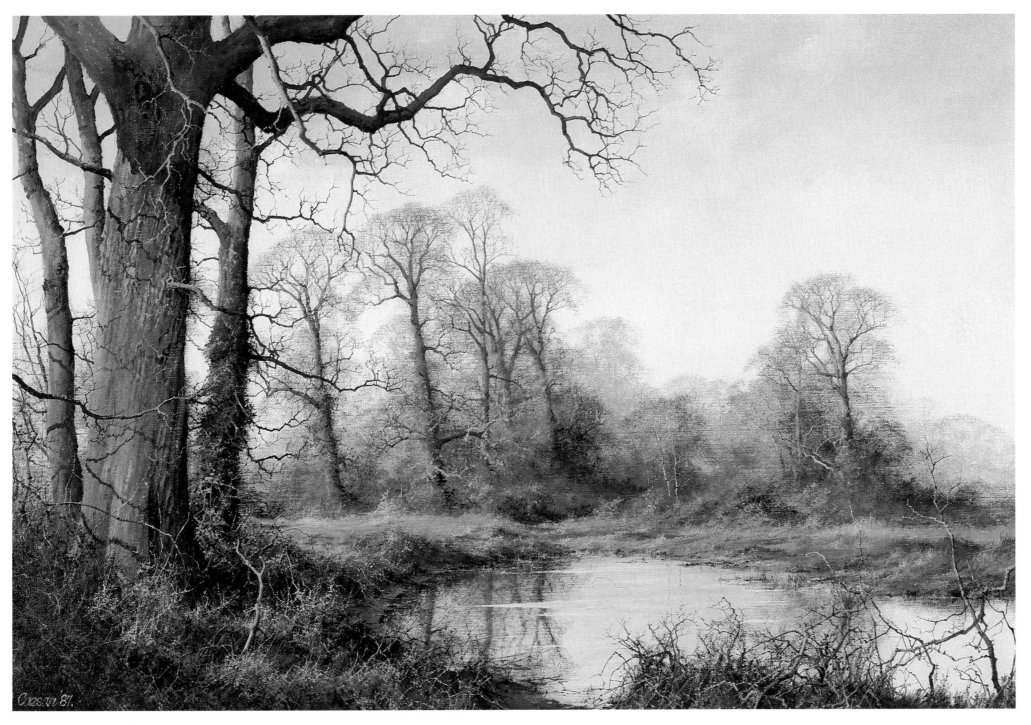

QUIET WATER
signed oil. 20in x 30in, E. Stacy-Marks Ltd.

As an artist who works in oils, Caesar-Smith must rank among the best of our present-day landscape painters, several of whom are represented in this book. He has a special feeling for silver birches and for trees in general, as can be seen from his picture *Quiet Water* shown here.

In this oil, painted on a fine, early winter's morning, the branches of the stripped trees stand out starkly against a sky of gentle blue, with the trees providing a framework for a large pond where the still waters are disturbed only by a gentle breeze that occasionally ruffles the surface.

The delicacy of the brushwork is evident in every area of the painting, from the fine interweaving tangle of branches in the foreground, where every detail is caught by the artist's brush, to the distant trees seen through the early morning haze.

Thomas MacKay

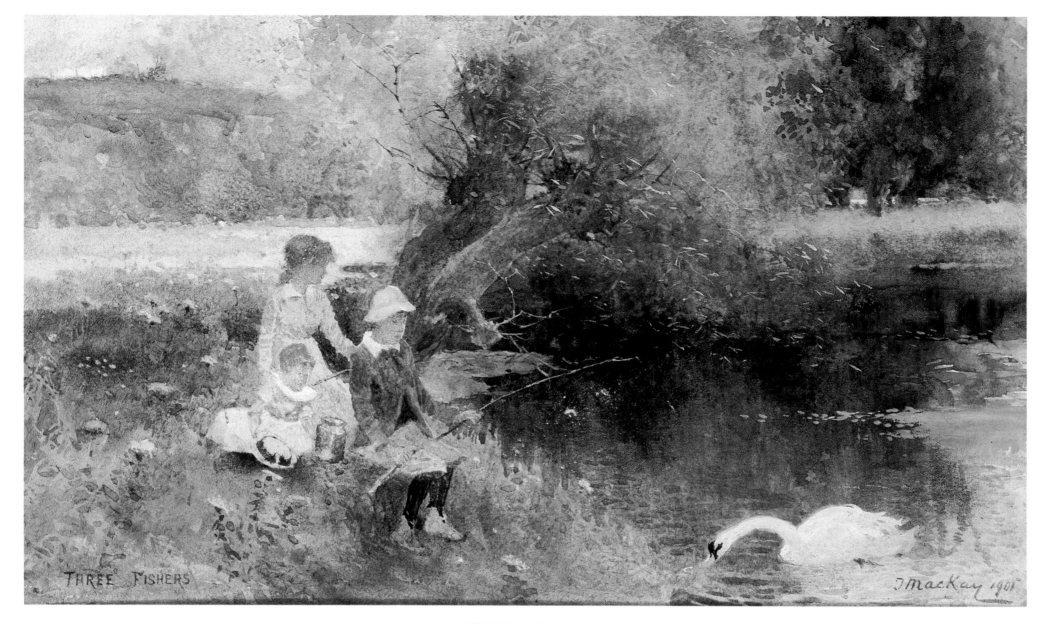

THREE FISHERS
signed watercolour, dated 1901. 6½in x 10½in, Priory Gallery.

MacKay was still painting in the traditional style of the nineteenth-century watercolourist, even when the world of art was changing around him. Many of his watercolours depict people or children fishing on a river bank, often with a predominance of blue in the colouring.

In the watercolour shown here, which is a representative example of his work, he has painted more sun than usual. The painting is a study of three children fishing on a river bank with an inquisitive swan hovering in the water nearby. Nearly all his watercolours are attractive – this one more so than most.

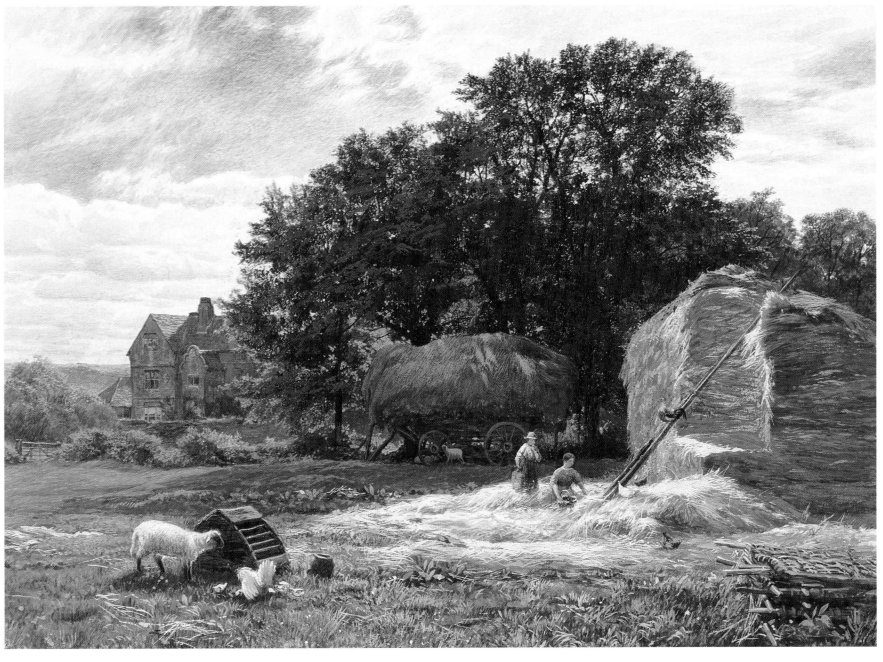

BY THE HAYSTACK
signed watercolour, dated 1866. 10in x 14in, E. Stacy-Marks Ltd.

Much of George Vicat Cole's enormous success dates from 1880, when three of his views of the Thames were exhibited in that year at the RA, and led to his nomination as an Academician. Although Cole was to devote the rest of his career to painting various views of the Thames, his fame rested on his earlier paintings of the English countryside.

His *By the Haystack*, which was probably painted when he was living at Abinger in Surrey, combines all those elements that helped to make him such a popular artist – a straightforward directness of technique, a delicate sense of colour and a close attention to every detail.

Unlike many of the Victorian artists who painted the countryside merely because it was attractive, Cole had a genuine love for rural England.

By the Haystack is a 'sunny' picture that makes no deliberate attempts to beguile with its charm, but merely sets out to portray what Vicat actually saw. Some artists would have highlighted the farm animals, but Vicat places them unobstrusively in the setting so that they merge naturally into the scene.

Thomas Nicholson Tyndale

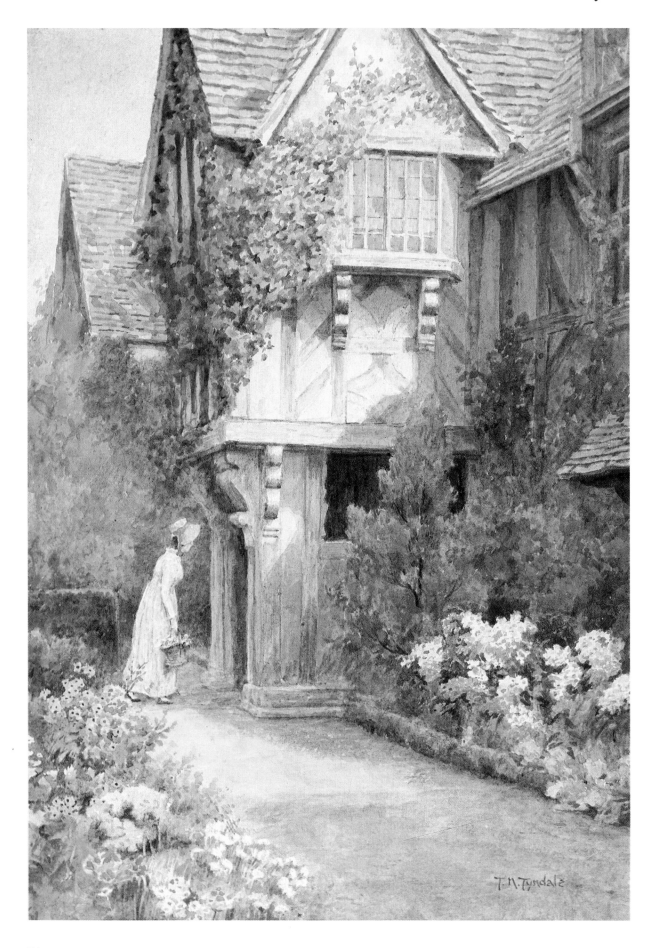

As Tyndale was a friend of Helen Allingham and went on sketching expeditions with her, it is hardly surprising that some of his watercolours bear a resemblance to her work. *The Manor House* is certainly similar in style. The borders of flowers that surround the building attract the viewer's attention first, although they occupy less than a third of the whole area of the painting. *The Manor House* itself is very different from one of Allingham's thatched cottages, but the almost obligatory woman poses on the doorstep, in this case carrying a basket of flowers picked from the garden.

At his best, Tyndale was a very good watercolour artist indeed, as is evident from the technical expertise that has been put into the painting of this picture, especially in the depiction of the manor house.

THE MANOR HOUSE
signed watercolour. 10¼in x 7in, E. Stacy-Marks Ltd.

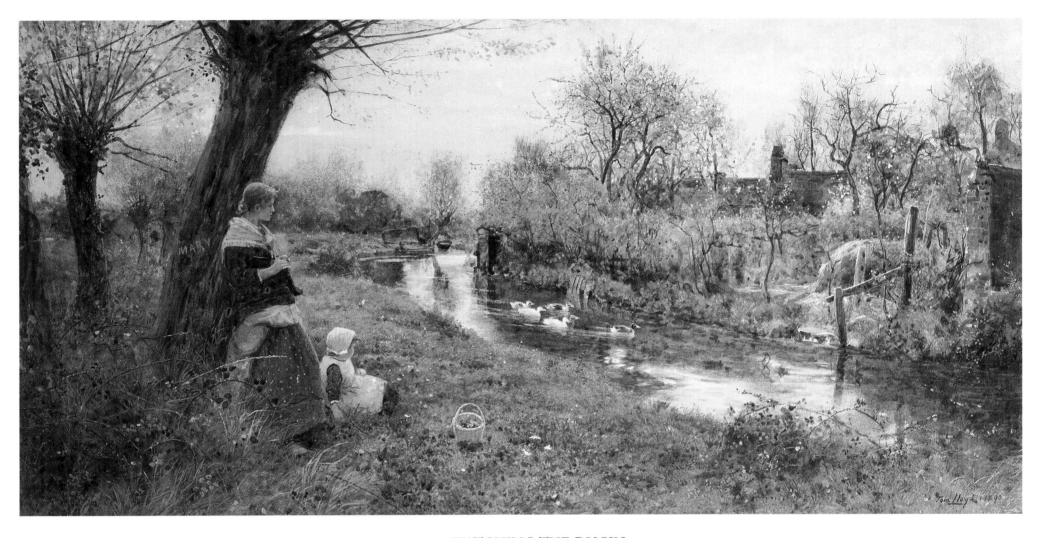

WATCHING THE DUCKS
signed watercolour. 13½in x 28in, Priory Gallery.

In recent years there has been a considerable reappraisal of the work of many Victorian artists. Among those whose work has been more than favourably reassessed is Thomas James Lloyd, the genre and landscape watercolourist who lived until 1910. There is no doubt that he was indeed a superb artist whose use of colour and composition places him in the top rank of the watercolour artists of his period.

Many of his watercolours are river scenes depicting a woman strolling or resting by a river bank, often accompanied by a child, a subject on which Lloyd managed to ring an amazing number of changes, even though many of them were painted in the same locale.

The one shown on this page is no exception.

As with most of Lloyd's work, the picture contains a considerable amount of detail that does not immediately have an impact on anyone looking at it with a casual eye. The blue skein of wool that is used by the girl, the ripples left on the water in the wake of the three ducks and the drake as they proceed on their way, the name 'Mary' carved on the bark of the tree and the boat lying quietly downstream — these are just a few details that have been worked unobtrusively into this picture; all of them add something to what is one of Lloyd's best watercolours.

Anthony Sheath

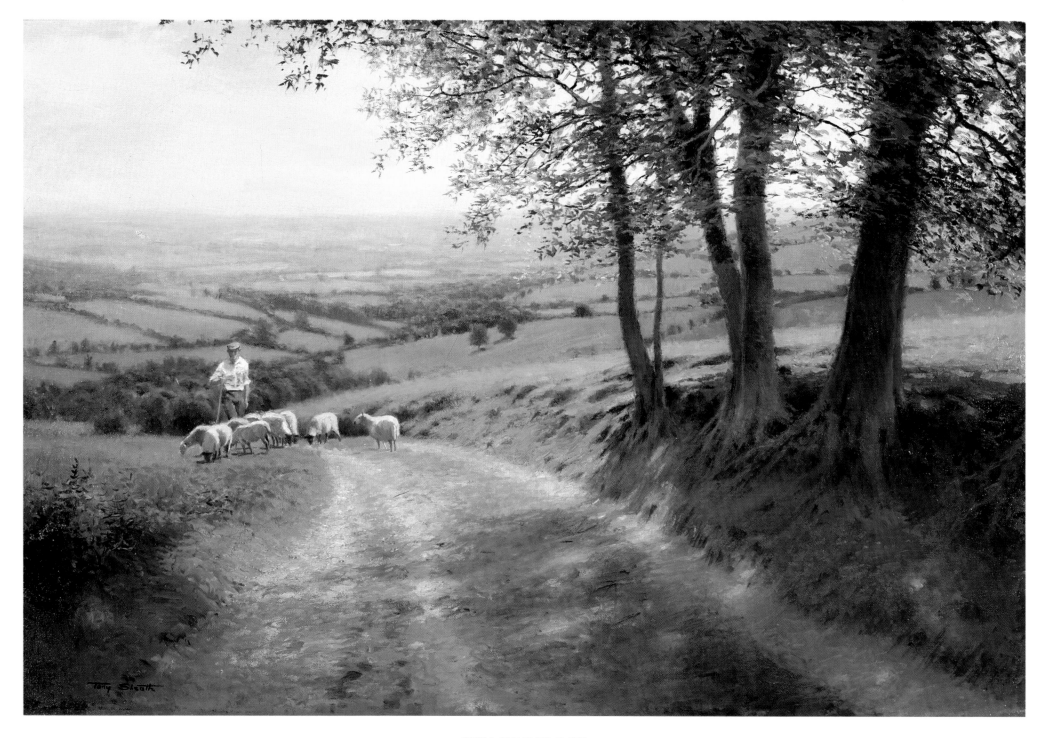

HILLSIDE FLOCK
signed oil. 20in x 30in, E. Stacy-Marks Ltd. Copyright: Venture Prints (Studios) Ltd.

This landscape by Anthony Sheath was obviously painted at the height of summer when the English countryside is looking its best. It is a study of a modern-day shepherd taking his flock up a steep hill from where the viewer can see the vast expanse of rolling countryside below. The shepherd and his flock provide a focal point of interest to the painting.

The artist has also made a point of showing the effect of sunlight on the fleece of the animals, which gives him the opportunity to add further small highlights to the painting, thereby helping to bring into sharp relief the shepherd and his flock against the distant countryside.

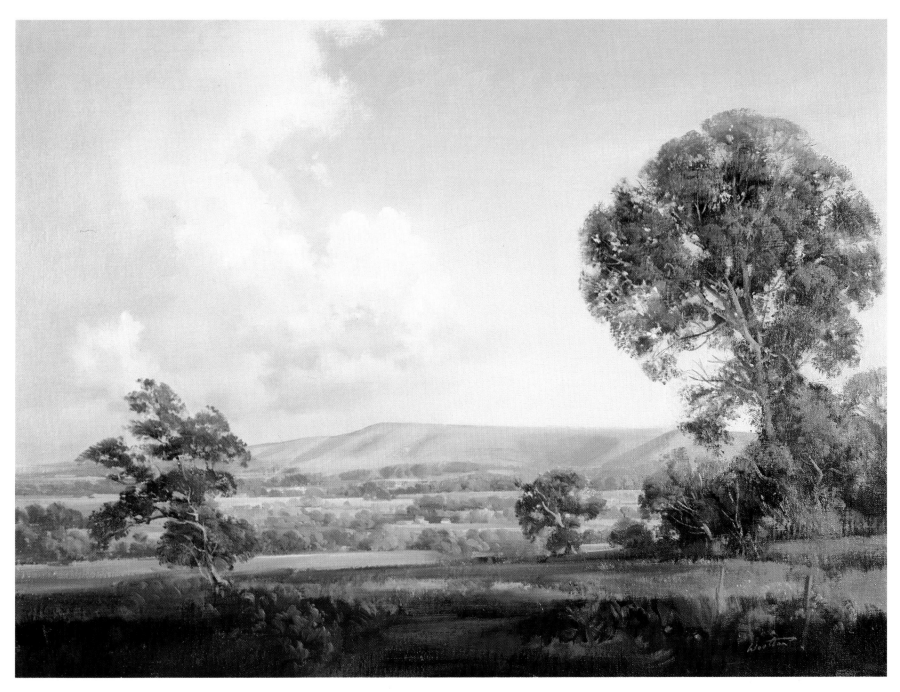

FIRLE BEACON, SUSSEX
signed oil. 16in x 22in, E. Stacy-Marks Ltd. Courtesy of Frank Wootton.

In this landscape Frank Wootton has captured the very essence of the English countryside. In this view of a lush rural scene executed on a summer's day in varying shades of subtle greens, with a view of distant hills, the artist was able to balance his picture on either side with trees, the alder on the right predominating.

It seems a straightforward enough scene until one looks at it closely and realises just how well it has been painted. The faint haze over the hills is created by the scattering of light once described by Leonardo da Vinci as 'aerial perspective', which has long been known to painters. In this case it helps to throw the trees into sharp relief.

David Dipnall

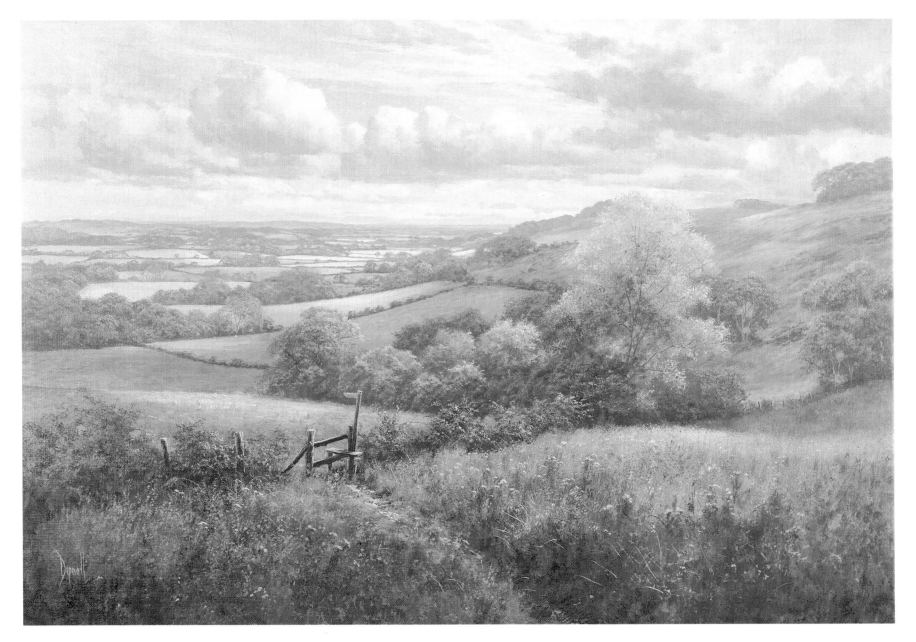

ON THE DOWNS
signed oil. 24in x 36in, E. Stacy-Marks Ltd.

Although the spirit of Birket Foster still lives and has actually been nurtured in certain areas of the English countryside in the cause of commercialism, we must be grateful at least that today's landscape artist has not yet succumbed to giving us Birket Foster's romanticised view of it. Consequently we have been spared pretty postcard landscapes that are false to the actual rural scene. Apart from using a palette with more bright colours than ever the Victorians used, modern landscape artists tend to go no further overboard than choosing the best day and the most propitious moment to paint a scene, as Kenneth Denton did with his cattle grazing beside a tree with a rainbow throwing an arc over the background (see page 37).

Dipnall goes further, painting his scene without waiting to be aided by nature. In this landscape he gives us an unadorned scene of a vast, panoramic stretch of countryside, taken from a high viewpoint among wild grasses and ragwort that overgrows a little-used public footpath leading to a stile. With this oil, Dipnall has managed to paint an attractive landscape without playing to the gallery.

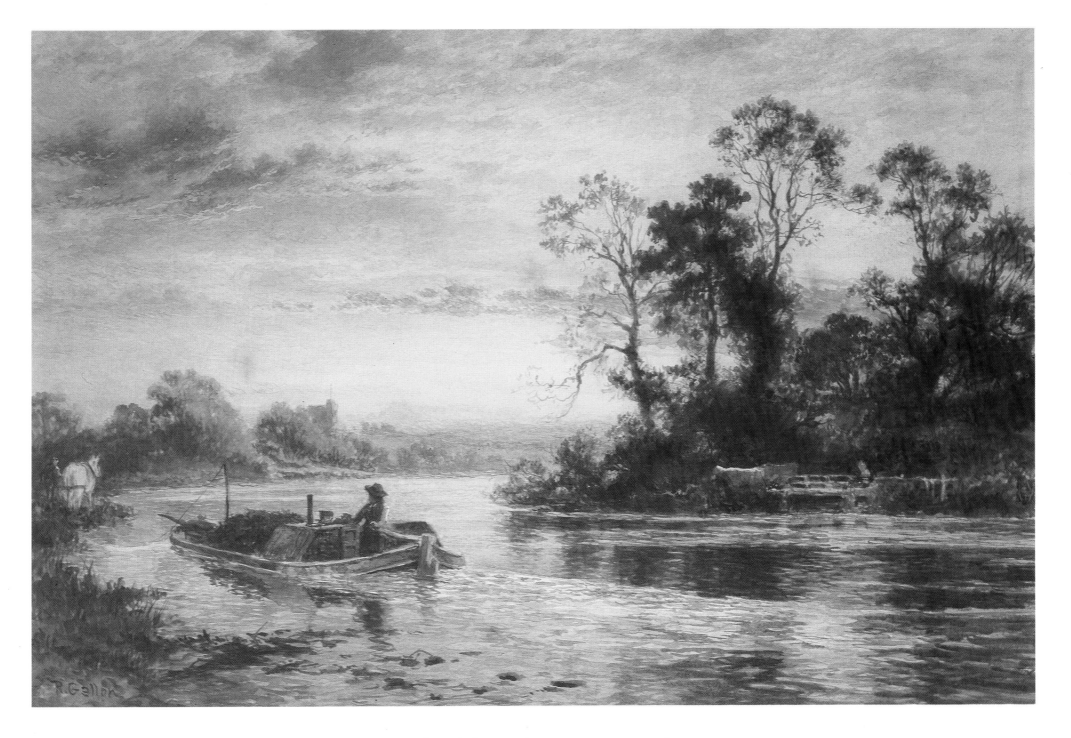

signed untitled watercolour. 9in x 13½in, David James.

Gallon's landscape scenes are always very attractive to look at, with a welcome feeling of space and light about many of them. Although the watercolour on this page was not given a title, it might well be a painting catalogued *Sunset on the Tamar, Devon* and which he sold in 1874 for £63, a sum considerably less than what it would fetch today at auction.

It is a charming scene of a girl on a steam-driven barge that is being towed from the river bank by a horse and man. The glow of the setting sun reflected on the water helps to make it a warm and appealing picture.

Sir Alfred East

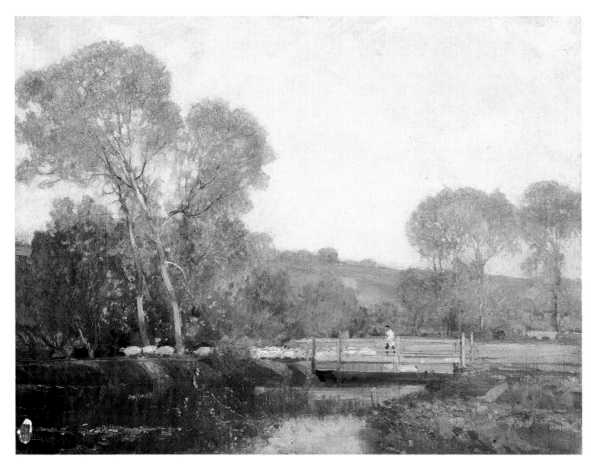

GOLD
signed oil. 30in x 40in, Brian Sinfield.

Alfred Augustus Glendening

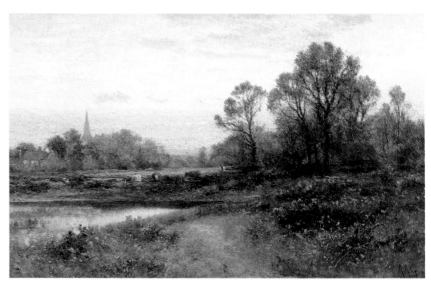

ON CHISLEHURST COMMON
initialled oil. 9½in x 15½in, E. Stacy-Marks Ltd.

East's landscapes are known for their lyrical use of colour and pleasing rhythm of line, which were the result of the careful selection and building up of the essential elements that constitute his scenes. These are invariably arranged with a rare sense of balance, which discards all extraneous details, so that a landscape painting of great compositional beauty and subtle colouring is created.

East may have travelled widely, painting as he went (see biography) but he was essentially an English artist who painted mostly in the Lake District, Cornwall and the Cotswolds. As well as being a painter of oils and watercolours he was also a fine etcher and engraver, and a member of the Royal Society of Painter-Etchers and Engravers.

Trees, which he described once as being 'those peers of the nobility of nature', played an important part in his paintings. That lyrical phrase, which might not have meant much coming from some artists,

meant a great deal when it came from East because he saw in almost every tree a living model whose best attributes he strove to put on canvas so that others could see the same grace and beauty that he did.

This is most apparent in his oil, *Gold*, which we have chosen as an example of his work. Here the trees are clothed in autumnal leaves, making them the focal point of a painting in which everything else, apart from the shepherd chivvying his sheep flock across the wooden bridge, becomes unimportant. East believed in applying the principle of decorative design to his landscape paintings once all the untidy clutter of nature had been removed.

It is a paradox of success that once a popular artist or writer is dead, his work is often completely forgotten. Such was the case with East, whose work was ignored after his death. It is therefore heartening to be able to report that there is now a revival of interest in his paintings.

Alfred Augustus Glendening painted realistic landscapes rather in the manner of Alfred de Breanski, a landscape and river painter who flourished between 1880 and 1919.

Although he was working right up to the very early years of the twentieth century, Alfred Augustus painted in the style of an earlier period when an artist who worked in oils tended to use much darker shades of green to portray trees and foliage. Note in this painting how he has carefully placed the grazing cattle in the background between the clump of trees and the distant church spire, which is a focal point for the viewer and which at the same time emphasises the artist's excellent use of perspective.

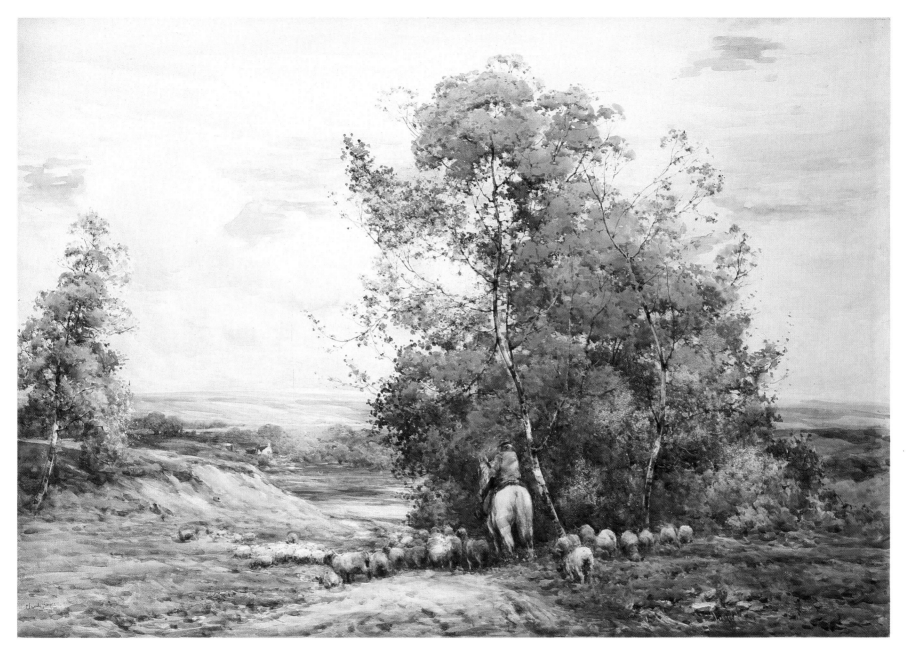

PASTORAL, DORSET
signed watercolour. 28in x 36in, Priory Gallery.

Hayes was a landscape painter who was highly popular in his lifetime, but who fell out of favour until recent years, when his work has come to the fore again.

'Not before time,' the late Martin Hardie might well have thought, who mentions Hayes in Volume III of his *Watercolour Painting in Britain* as being an artist who has 'never quite received the recognition which he deserves'.

Hayes was unfortunate inasmuch as ill-health and

a lack of money in his latter years led him to producing several inferior paintings that may well have led to his sudden rejection after all those years of success.

However, his beautiful watercolour shown here is typical of his best work, its great expanse of sky hanging over, but not dominating, a typical English country scene that has been painted in soft, muted colours.

Sir William Russell Flint

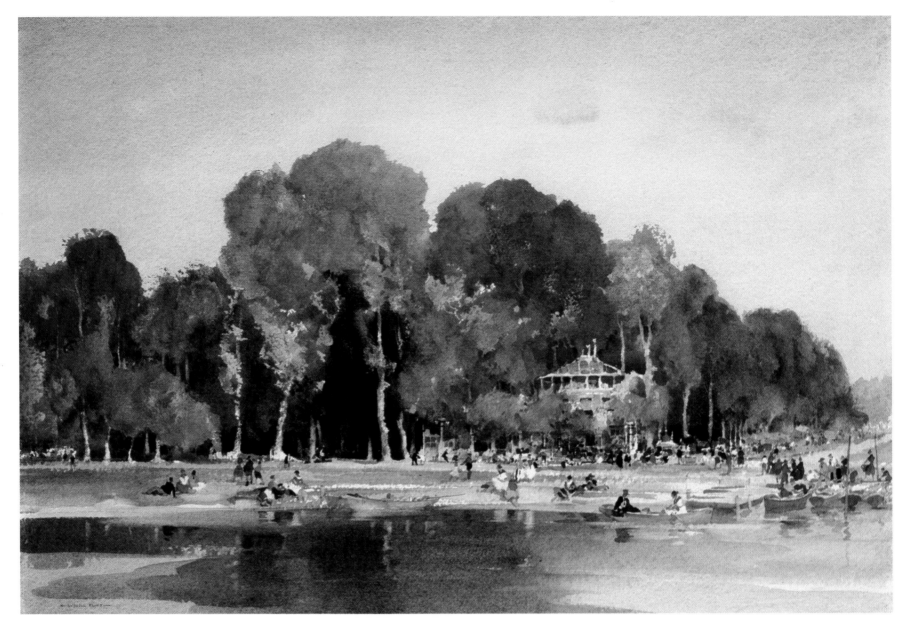

VERSAILLES. A FINE AUTUMN DAY
signed watercolour. 14³/₄in x 22in. Sir William Russell Flint Gallery.

Most people are more familiar with Russell Flint's now famous Spanish semi-nudes than they are with his landscapes. It therefore makes something of a welcome change to come upon a watercolour scene such as the one shown here: *Versailles. A Fine Autumn Day*, painted in 1955. An unquestioned master of the watercolour, a medium to which he turned almost exclusively from 1908, Flint's watercolours had their day before the public became over-fond of his voluptuous half-naked ladies, to the detriment in popularity of his landscape scenes to which far less at-

tention has been given. As examples of landscapes done in pure watercolours, they remain unsurpassed in the way they can catch the mood of a scene with the seemingly casual application of watercolour.

The scene here is very much a case in point, with the trees acting as a backcloth to all the activity going on around the lake, where people are taking advantage of the fine autumn day by going boating, taking a stroll or merely sitting and watching the passing scene, all caught by a few deft strokes of the brush.

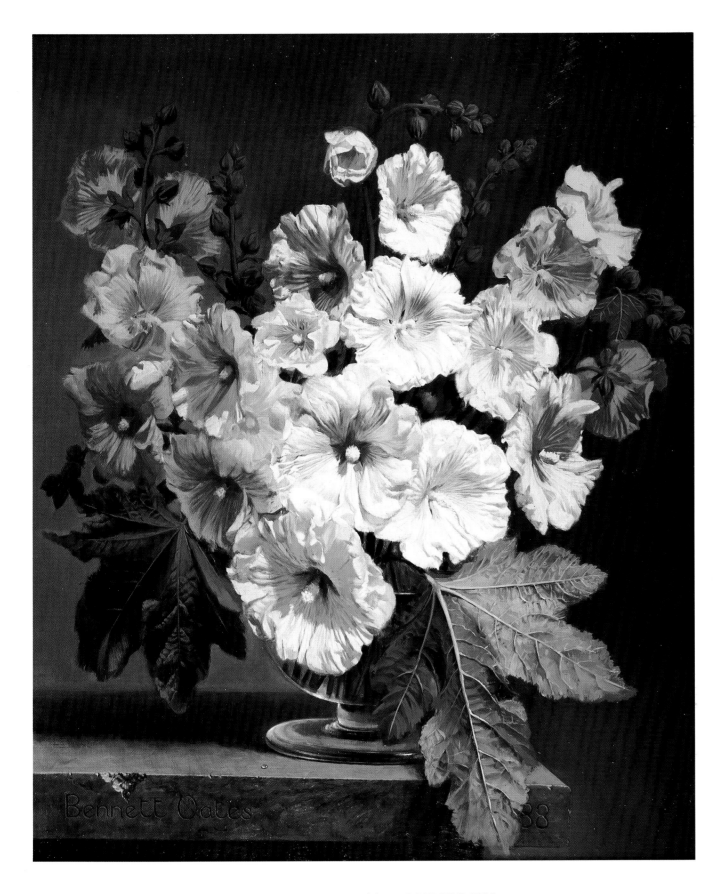

This stunning oil of a bowl of cream and white hollyhocks draws one's eye immediately to the incredibly delicate shades of lemon, cream, white and beige which are within the blooms, all of them enhanced by the large, soft green leaves.

Like Gerald Cooper's painting on page 67, it is done in the Dutch manner of Jan Huysum, whose passion for detail extended to painting in the least drop of water on a leaf. The fact that this style of painting became unfashionable for a long time is attributable to Joshua Reynolds, whose open contempt for still-life painting did much to hold back this form of art until the early nineteenth century, when it began to be popular again.

CREAM AND WHITE HOLLYHOCKS
signed oil, dated 1988. 24in x 30in, E. Stacy-Marks Ltd.

Mary Elizabeth Duffield

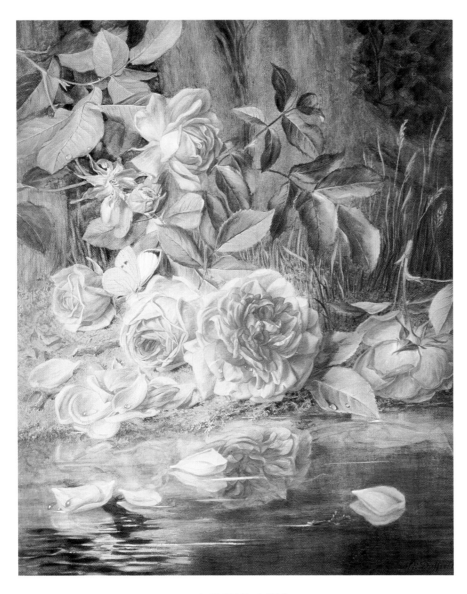

BLAIRIE ROSES
signed watercolour. 17½in x 14¼in. Fine Lines (Fine Art).

As a member of the distinguished Rosenberg family of flower painters, it would be reasonable to expect that Mary Duffield's own flower paintings were never less than accomplished, as her study of Blairie roses most certainly is. Her overblown roses in this watercolour cascade towards a puddle, scattering the fallen petals on the water that reflects the surviving blooms. It is a very different type of painting from that of the Dutch School of flower painting, but it stands in its own right as an excellent example of the late-Victorian style.

Jessy Fairfax Bates

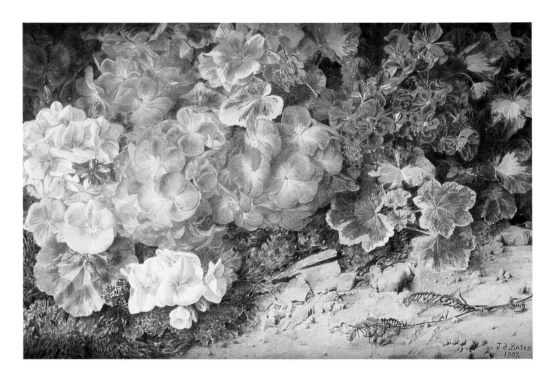

GERANIUMS
signed watercolour, dated 1907. 11in x 18in. Fine Lines (Fine Art)

In this very appealing flower study, Jessey Fairfax has painted geraniums growing in the flower beds, in all the glory of their mixed colours and double and single blooms, as they crowd together at the edge of a path. Apart from the loving work she has expended on the blooms, she has also gone to a great deal of trouble to capture the subtle colouring of their variegated leaves.

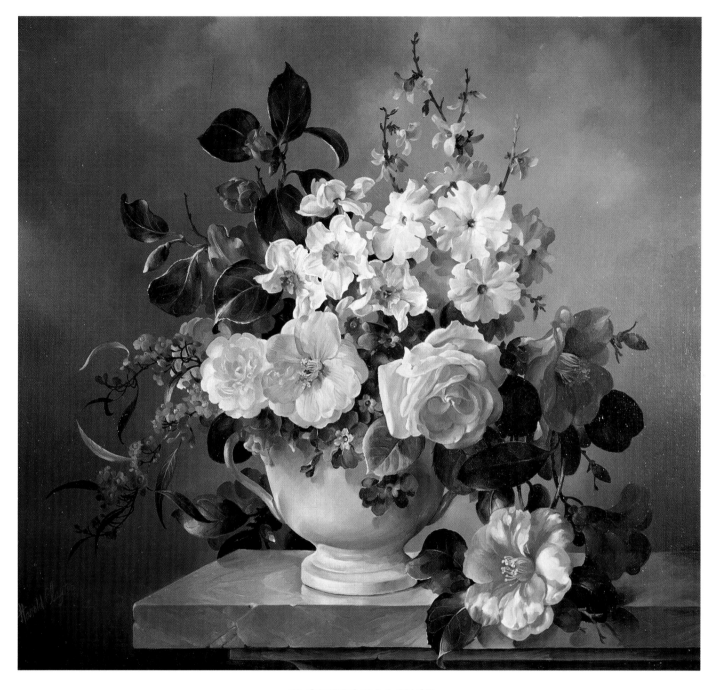

FLOWERS IN A VASE
signed oil. 18in x 20in, E. Stacy-Marks Ltd.

In this lovely, late spring bouquet of mixed blooms painted in oils by Harold Clayton, there are the palest pink phlox, pheasant's eye narcissi, deep pink camellias, blue primula, delicate sprigs of jasmine, some roses in pink, white and yellow, and a spray of orange coloured japonica. The arrangement is offset by the glossy dark green leaves of the camellias.

William Jabez Bligh

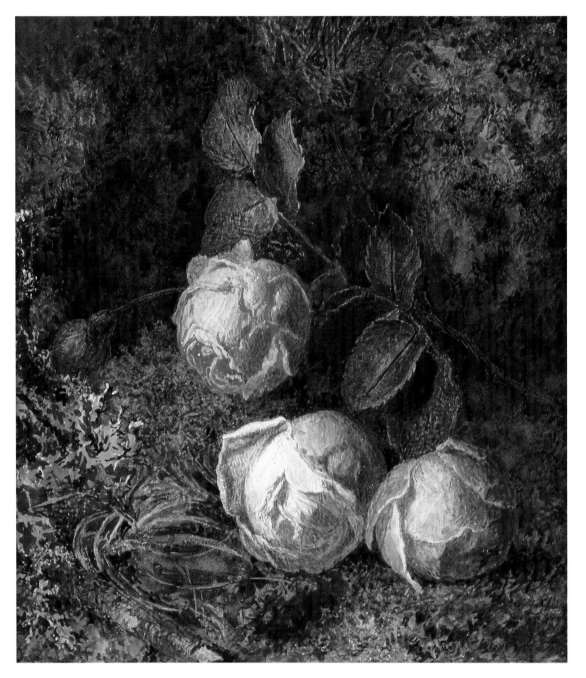

ROSES ON A MOSSY BANK
watercolour, heightened with white. 6¾in x 6in, Fine Lines (Fine Art).

These blush pink roses lying on a mossy bank were painted by the Worcester-born still-life artist William Jabez Bligh who exhibited at least seventeen times in his life at the RA. They embody all that a gardener expects to see in the old type of open cup flower that was grown at the time that this was painted and which still exists today.

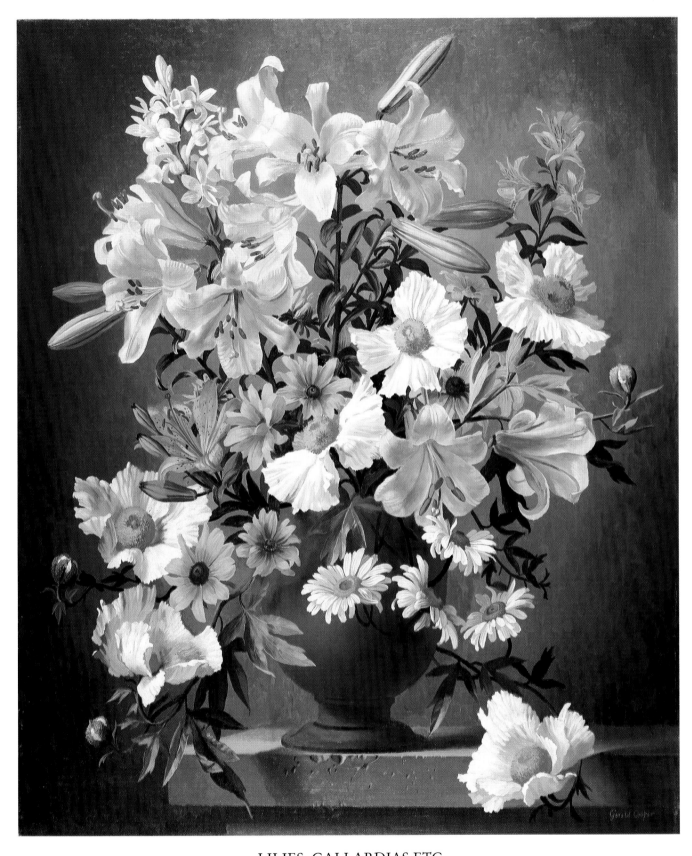

LILIES, GALLARDIAS ETC
signed oil. 29 ⅞in x 25in, E. Stacy-Marks Ltd.

This magnificent flower arrangement of yellow and white flowers in a terracotta vase is painted in the Dutch manner by Gerald Cooper. It is a striking composition of subtle tones, which range from tiny white and creamy yellow lilies to small tawny ones, mixed with magnificent white poppies with crinkled petals and serrated edges, and a number of marguerites and yellow black-eyed Susans. Cooper has blended all together to make a truly beautiful array, worked in oils.

James Noble

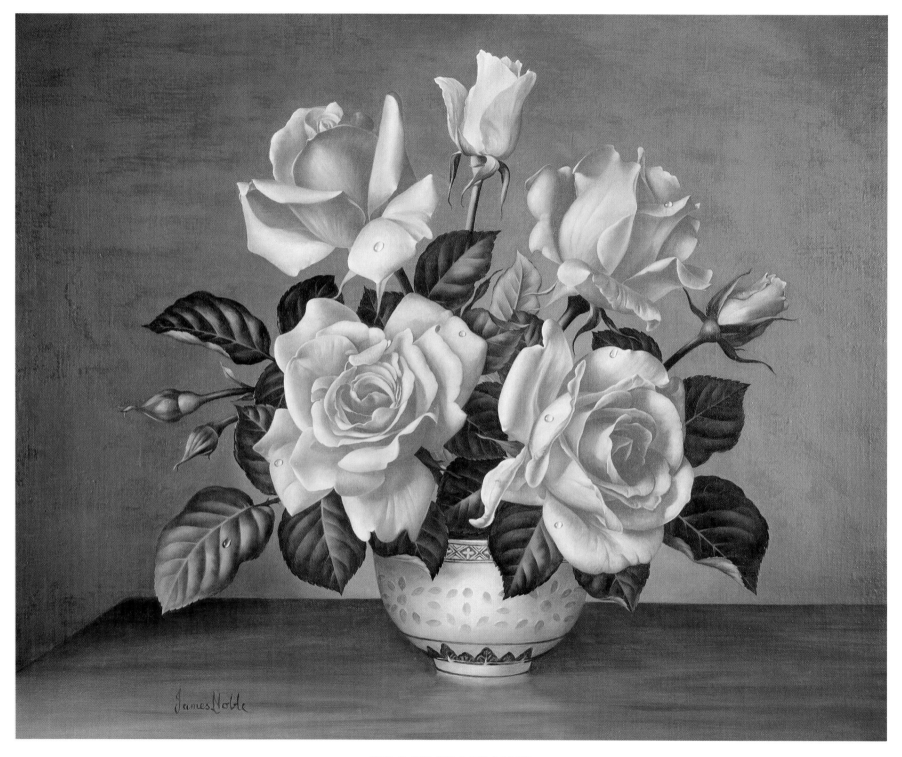

SUMMER FRAGRANCE
signed oil. 29in x 20in, E. Stacy-Marks Ltd.

Although greatly influenced by the seventeenth-century Dutch School of flower painting, Noble's studies of roses are less formalised. He is an artist who specialises in painting roses to the exclusion of everything else, and his love for them is apparent in every brush stroke he makes. The exquisite bowl of fine roses are so wonderfully painted that one can almost smell their perfume. Note how the early morning dew drops still cling to the petals and how the deep colours of the flowers shade out to paler tones.

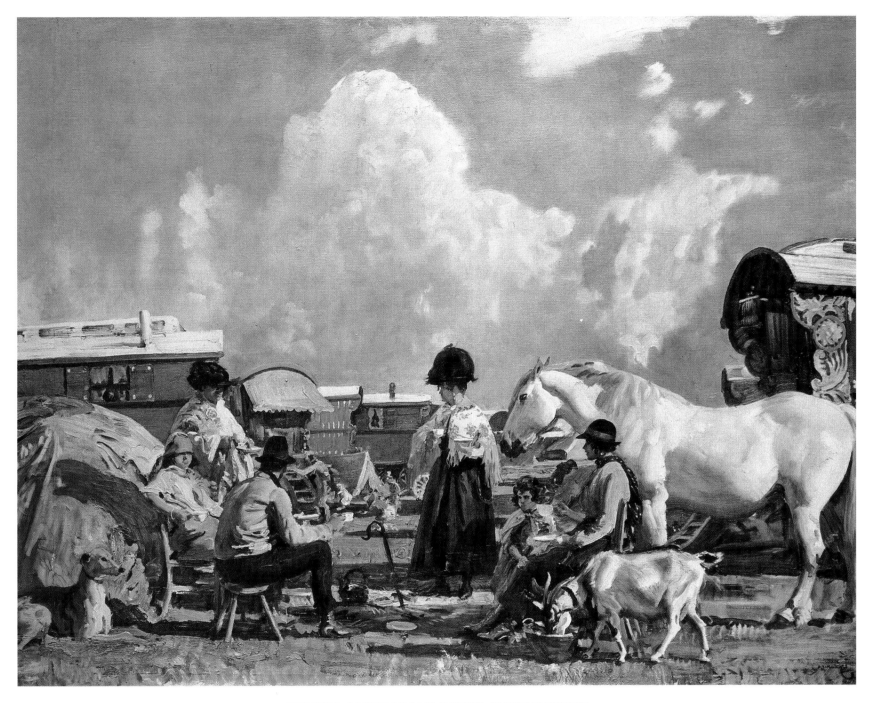

GYPSIES ON EPSOM DOWNS, DERBY WEEK
signed print, published in 1927 in an edition of 250. Courtesy: Frost & Reed Ltd.

Munnings was the greatest horse painter of his time. You do not have to be a lover of horses to enjoy this picture, however, which is of a gypsy encampment at Epsom during a Derby week in the twenties. One can see why the gypsies and their way of life appealed to him so much. There were always plenty of horses around and the gypsies themselves and their caravans gave Munnings the opportunity to use welcome splashes of colour on his painting. The painting has a very twenties look to it, although the subject matter is almost timeless.

Munnings was able to paint a large number of gypsy encampments, as they were quite a feature of life at one time in many of the Norfolk and Suffolk villages, where they gathered to hold one of their horse fairs on the village green or nearby common.

Harold Swanwick

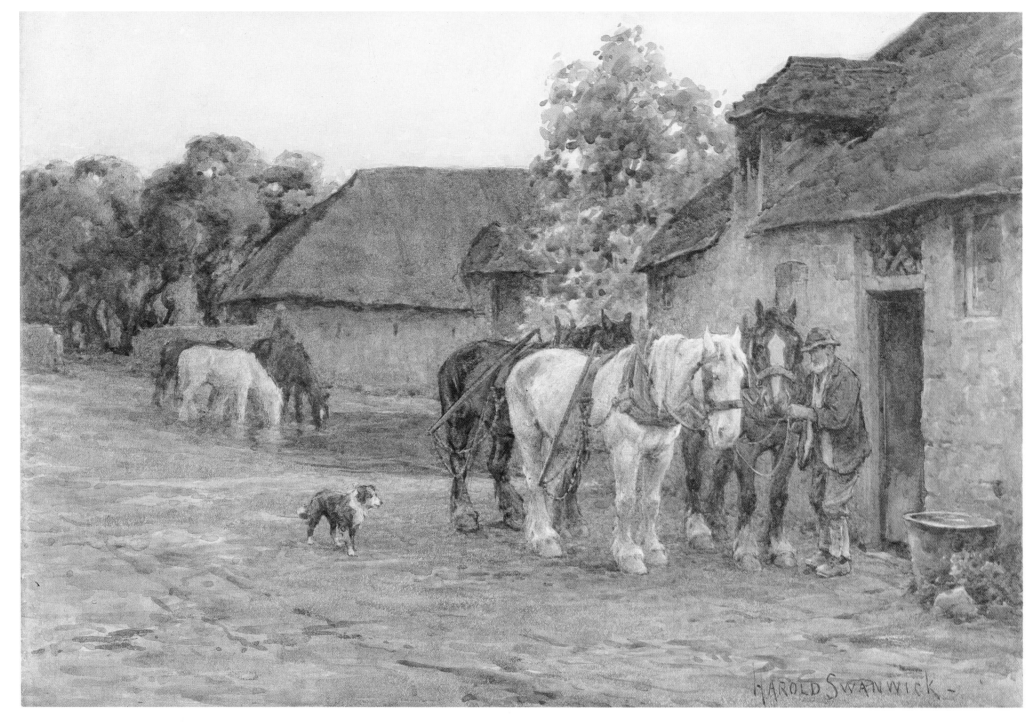

EVENING
signed watercolour. 7in x 10in, Priory Gallery.

When it came to painting heavy horses working on a farm, Swanwick could hold his own with the best. Often he would give his horses an air of sad resignation, which lends his paintings a touch of understated pathos, thereby adding a little something for the sentimental lover of horses, as with the watercolour on this page.

The pair of horses in this picture seem laden with all the cares of the world. In fact the drooping postures and lowered heads indicate the phlegmatic nature of this type of horse, whose working life is spent plodding and pulling heavy loads across muddy fields and asking nothing more than to be able to retire to the stable with a bag of hay when the day is done.

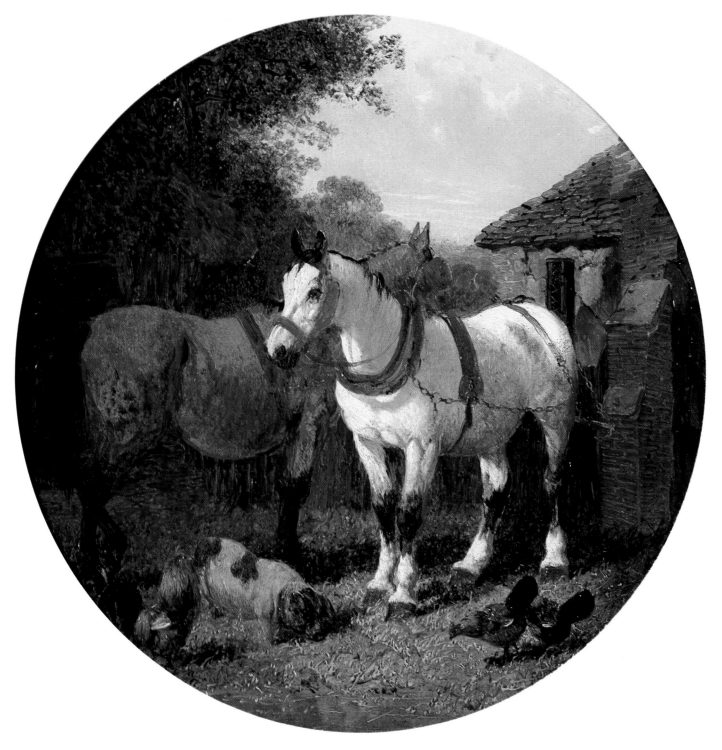

FARMYARD COMPANIONS
oil. 7¾in in diameter, E. Stacy-Marks Ltd.

This charming oil by John Frederick Herring, Jnr is typical of his work, with its highly detailed brushwork used on the straw, where the chickens compete with the Dorset Old Spot pig as they all grub for whatever pickings are on the ground.

No one would pretend that this painting could compare with most of the work by John Herring, Snr but it is still a fine oil painting in its own right that most people would be very glad to own.

Charles James Adams

In a large number of oils and watercolours, C.J. Adams combined his talents as a landscape painter with those of being an animal artist. He has done just that in the charming watercolour on this page. It is a pastoral scene in the true sense of the word, inasmuch as the idealised painting of a rural scene featuring a shepherd at work with his flock captures all the natural charm and simplicity of the countryside.

Adams was always at his best when painting horses, cattle and sheep against this sort of background, though seldom with the same lyrical feeling for the countryside that is displayed here. The watercolour has an unusual, misty appearance which can never be caught in oils, and which adds an ethereal quality not often seen in a watercolour of this nature.

signed untitled watercolour. 15in x 22in, David James.

Arthur Winter Shaw

Although he normally worked in watercolours, this oil, depicting cattle grazing by a pond, is typical of Arthur Winter Shaw's work. Apart from being a very pleasant oil, its real merit lies in the way that Shaw uses the light from the sun to highlight the cattle. The painting is broadly done — almost in an Impressionistic manner.

CHALK PITS AT AMBERLEY, SUSSEX
signed oil. 15¾in x 23½in, Fine Lines (Fine Art).

Until one of Paton's studies in oils fetched the astounding sum of £30,800 (including the 10 per cent buyer's premium), he was considered to be no more than a gifted and popular animal artist, which is still saying a lot, but not enough to make him a top selling artist in the auction rooms. His oil, *Who's the Fairest of them All?*, which Bonhams had thought would not make much more than £6,000, changed all that, although of course the price it fetched may have been a freak one, never again to be repeated with another of his pictures.

The oil shown here is undoubtedly a charming painting, with its study of a kitten regarding itself inquisitively in a dressing-table mirror. The work has an almost photographic quality to it, a great deal of care having been spent on the cat's fur, which is painted in minute detail. It is a painting that belongs very much to its period, while still appealing to a modern cat lover.

WHO'S THE FAIREST OF THEM ALL?
signed oil, dated 1883. 24in x 20in, Bonhams.

Cecil Aldin

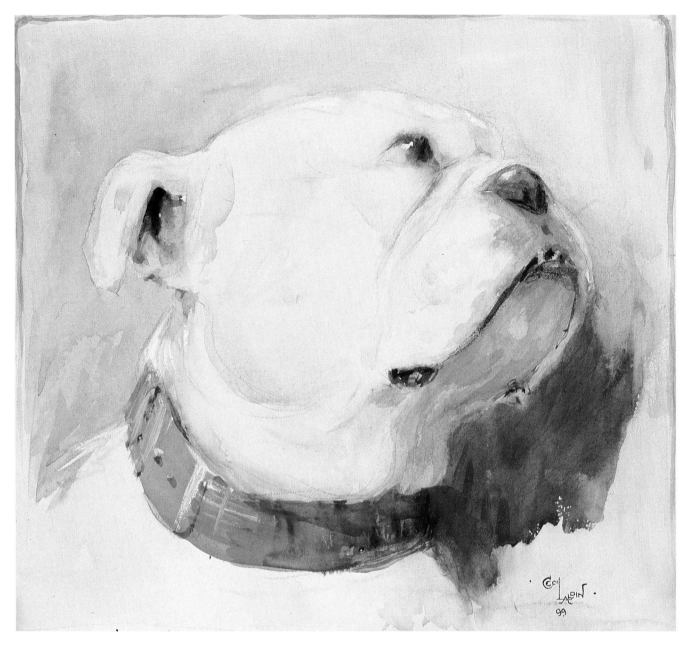

As with so many popular artists, Cecil Aldin's skill as a painter and black-and-white illustrator has always been taken very much for granted. The sheer quantity of work he did in his lifetime has compounded this situation, which has led to his being dismissed in certain quarters as no more than a highly competent artist. This produced a situation where, up to the late seventies, his work could be bought for a few hundred pounds. Fortunately, that situation has now changed and the price of his work at auction reflects more accurately the quality of his work.

His easy and engaging style in watercolours was generally made up of simple washes and outlines, rather in the manner of Randolph Caldecott, a watercolour artist who was a very popular children's book illustrator (1846-1886).

Some interesting work was done by Aldin during World War I, when he was appointed by the War Office to act as a Remount Purchasing Officer, in common with many other Masters of Hounds, as he was at that time. Aldin's drawing of some of the Land Girls who worked in his stables at that time is now in the Imperial War Museum, together with various studies of his bull terrier Cracker, who became the inseparable companion of a woolly lamb.

In his autobiography, Aldin comments waggishly that 'some men are always wanting to change something – nowadays their wives' – words that could not have gone down too well with his own wife. In his case, however, it was the desire to produce something different that led him to doing a series of drawings, a dozen of them in colour, for his book *Old Inns*, for which he also wrote the copy. These were later put out as a set of prints which are now to be found in various print shops all over the country.

A THING OF BEAUTY
signed watercolour, dated 1899. 11in x 12¼in, Sotheby's, Billinghurst, Sussex.

The history of British painting is full of tragic stories of artists who either died in dire poverty or became insane. The story of Louis Wain's slide into madness is such a one. It is a story made more poignant because of the very nature of his art, with all its emphasis on the world of cats, conjuring up an age of innocence far removed from the dark world of schizophrenia inhabited by Wain for so much of his life. As a little of this has been touched on in the introduction on page 13, it would be more fruitful to go briefly into the cause of his madness and the way it affected his painting, which he continued to do long after he had entered a lunatic asylum.

The causes of his madness have been gone into in some detail inRobert Dale's invaluable book: *Louis Wain. The Man Who Drew Cats*, published by William Kimber in 1968. This contains a report by Dr D.L. Davies who examined Wain while he was in Napsbury Hospital. His findings were straightforward enough. Madness was already in the family with one of Wain's sisters, Marie, who displayed a schizophrenic condition when she was twenty-nine and had spent the rest of her life in a mental home. This incipient madness had shown itself in Wain when, as a young man, he had gone around claiming that he had powerful and influential friends with whom he was supposed to have had a high old time in Mayfair. One could have put this down to nothing more than a piece of self-aggrandisement had his behaviour not also shown a pattern of faint eccentricity, burgeoning into his obsession with cats. None of this, however, marred his success as an artist until that last dreadful period in Brondesbury Road, when he became equally obsessed with electrical phenomena. Once his schizophrenia was in full control, he became convinced that the electrical power within his own body gave him magical healing properties. This conviction that his body was charged with electricity may well have led to his drawing cats with jagged outlines to show the supposed bursts of electrical energy that emanated from his hands as he drew. In time these still-acceptable drawings degenerated into decorative designs that recalled elaborate wallpaper patterns through which emerged the outlines of a cat's head imprisoned in the design.

The first stages of his madness can be seen in the head of a cat in picture A, whereas the painting in picture B shows Wain at the height of his powers, painting the type of watercolour that endeared his work to so many people.

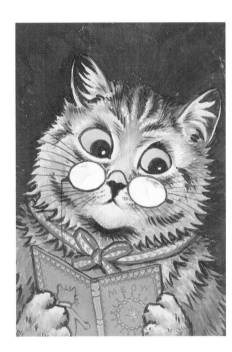

(A) CAT READING
gouache. 8½in x 6in, Bonhams.

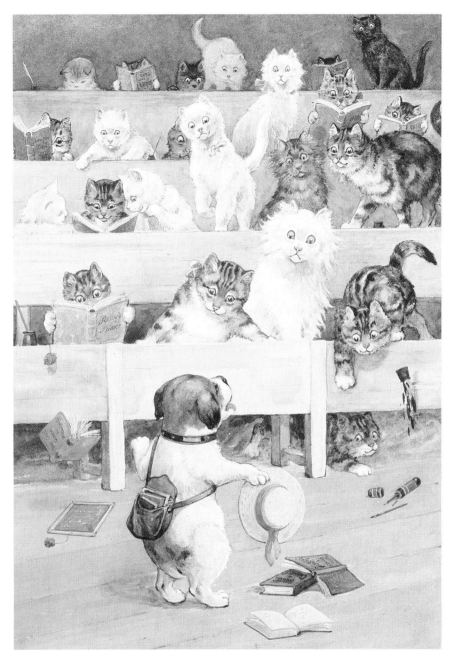

(B) IN THE WRONG CLASS
gouache and watercolour. 20½ x 17in, Bonhams.

David Shepherd

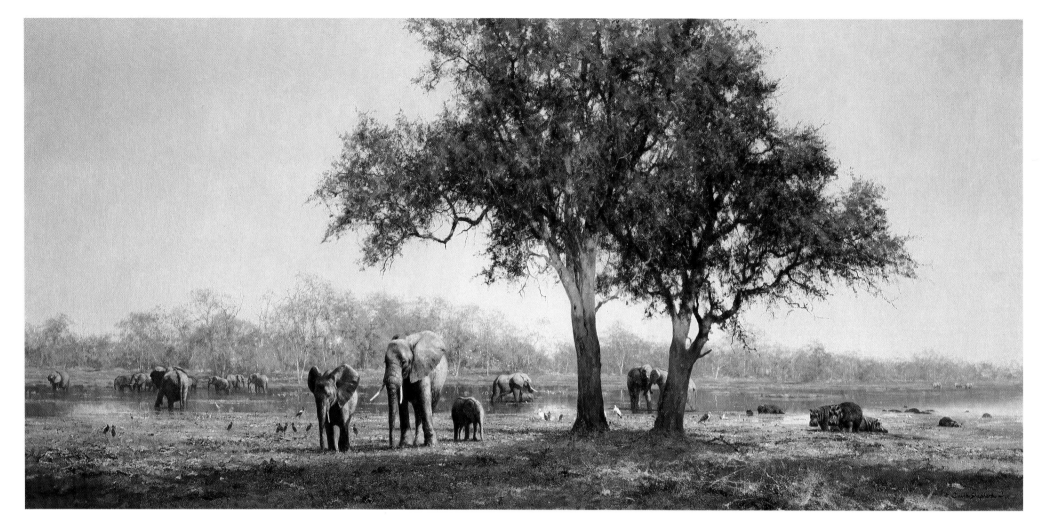

LUANGWA EVENING
signed oil. 80in x 40 in. Courtesy of David Shepherd.

David Shepherd has had a special affection for the elephants of Africa since they first cast their spell on him in 1964, when he first visited the Luangwa Valley National Park in Zambia. Since then he has been back there many times to paint the elephants as they gather round the waters of the lagoon with their young. On other occasions he has gone there merely to sit and watch and listen to the sounds of the African bush while the sun begins to set on this sanctuary which the elephants share with the hippos and impala.

Apart from the elephants which Shepherd handled with his customary skill in his painting *Luangwa Evening*, he also managed to capture something of that magical period when the setting sun throws a golden glow over everything and is the prelude to the swift onset of the African night.

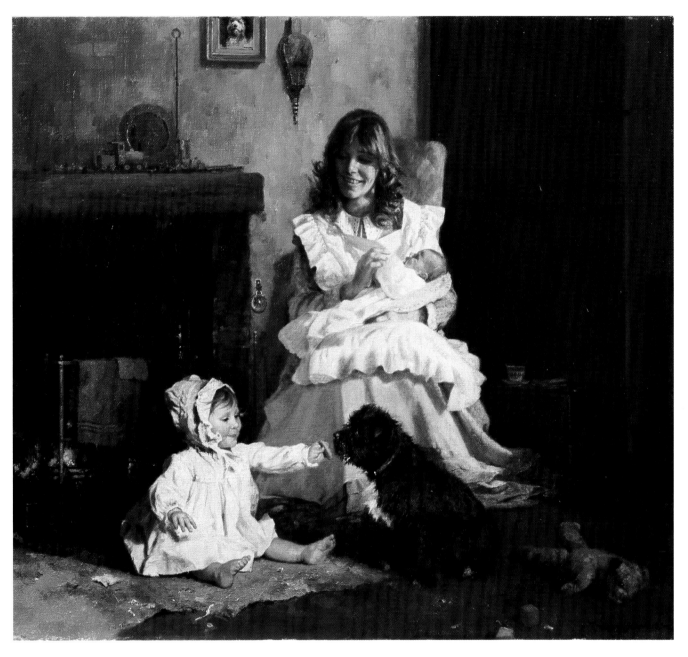

BISCUITS
signed oil. 24in x 21in. Courtesy of David Shepherd.

The picture on this page is one of David Shepherd's more recent paintings, and one that belongs to the old style of genre paintings. The young mother nursing a baby, while the toddler feeds biscuits to the family dog, is near-Victorian in subject matter, even down to the slightly sentimental touch of the painting on the wall of some dear departed pet. But there the resemblance ends. A Victorian painter, more likely than not, would have handled the subject very differently, portraying the interior of a spotlessly clean cottage with brasses gleaming on the mantlepiece, and a large dog hogging the scene and playing on the viewer's emotions by looking soft-eyed and appealing. Shepherd's approach is quite different. What he has given us here is a fresh looking and 'happy' painting of a humble abode, with the mother, child and pet all completely absorbed in what is going on. It is a painting that emphasises the enormous chasm that lies between the old genre painter who strove to prettify everything, when he was not painting a social scene, and a modern painter like Shepherd who avoids all the pitfalls inherent in this sort of subject matter.

Henry John Stannard

Stannard's work was at its most popular during the late Victorian and early Edwardian periods (see page 14 in the Introduction). He was also a frequent contributor of bird studies to the *Illustrated London News*. This phenomenally successful magazine was the brainchild of a Northampton newsagent named Herbert Ingram, who founded a lively magazine for the whole family. It had no political affiliations, it gave all the news of the day and was freely illustrated with woodcuts. As its circulation of 100,000 in 1851 was still rising, any artist who worked for it regularly was assured of becoming well known.

Stannard also contributed illustrations to various sporting magazines such as *The Sporting and Dramatic News*, *Bailey's Sporting Magazine*, and the *Encyclopaedia of Sport*. In addition, he produced several books on the country, illustrated with his paintings, which were not unlike the one shown on this page, but in black and white.

The watercolour, *A Sheltered Corner*, is a characteristic example of Stannard's work, which might have been found on the walls of any of the sporting and gentlemen's clubs of the time.

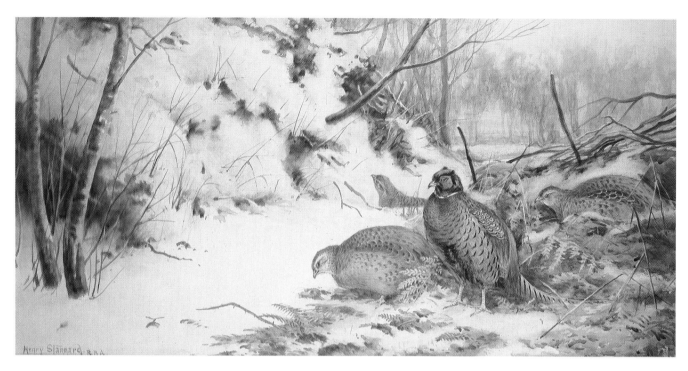

A SHELTERED CORNER
signed watercolour. 19½in x 36in. David James.

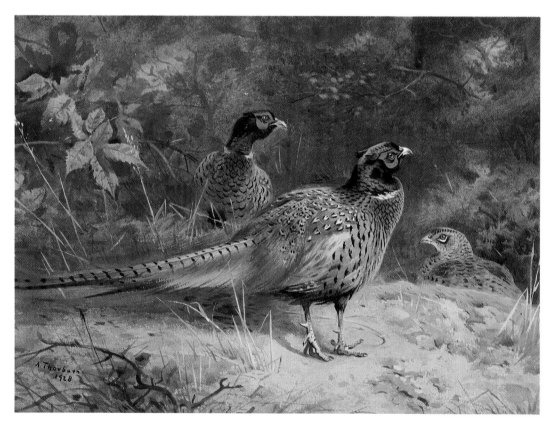

PHEASANTS
signed watercolour dated 1928. 10½in x 15¼in. Bonhams.

Archibald Thorburn

If you like the sort of painting on this page — and a great number of people do, if the prices they fetch at auction are any guide — then this painting by Archibald Thorburn is for you.

He was a painstaking, if rather unimaginative artist, whose studies of bird life and game birds were always painted with a meticulous attention to detail and colouring, and which greatly appealed to the sporting set, who were great admirers of his work.

His watercolour on this page is a fine example of his work, in which the detailed painting of the cock bird and the bright red colouring marking the surrounding area of the eyes all help to make it an attractive study of game birds in their natural habitat.

According to a laudatory article on Stacy-Marks in the 1878 bound edition of *The Magazine of Art*, this painting of *St Francis Preaching to the Birds* was painted in 1870, and was one of his very earliest essays in oils on an ornithological subject.

From all acounts he was a kindly man and this shows indirectly in his sympathetic but unsentimental treatment of the large variety of birds gathered around St Francis. One's eye is so taken up with examining the birds that one tends to overlook the excellent painting of the background scenery, with a distant castle and surrounding houses in the far distance. In subject matter it is a painting that belongs very much to its time — in this case by a master tackling a now unfashionable subject. St Francis and his companion look as though they might have stepped from a painting by one of the Old Masters.

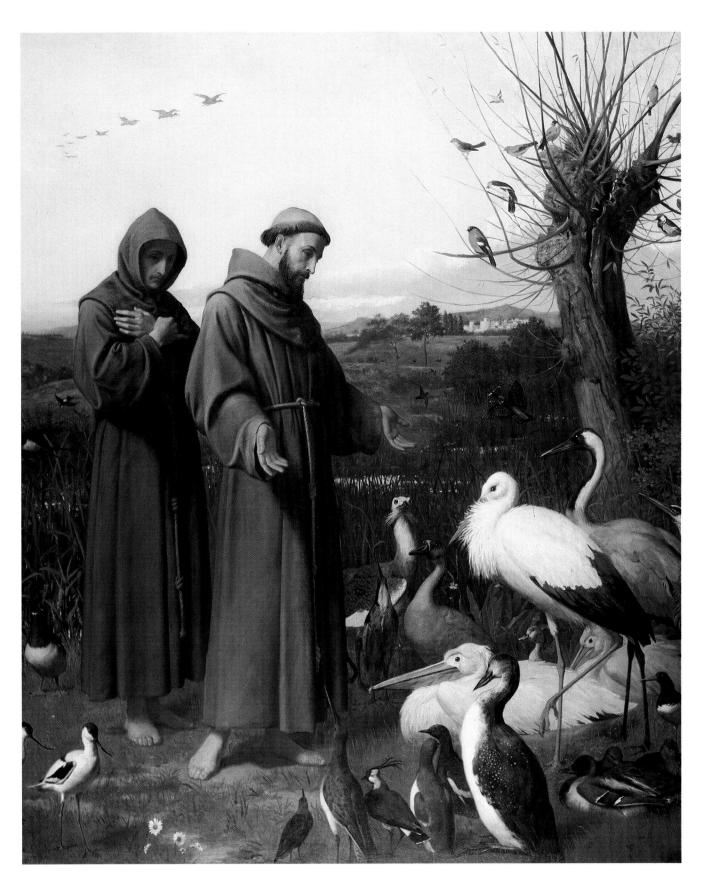

ST FRANCIS PREACHING TO THE BIRDS
oil. 50in x 37in, E. Stacy-Marks Ltd.

Frank Wootton

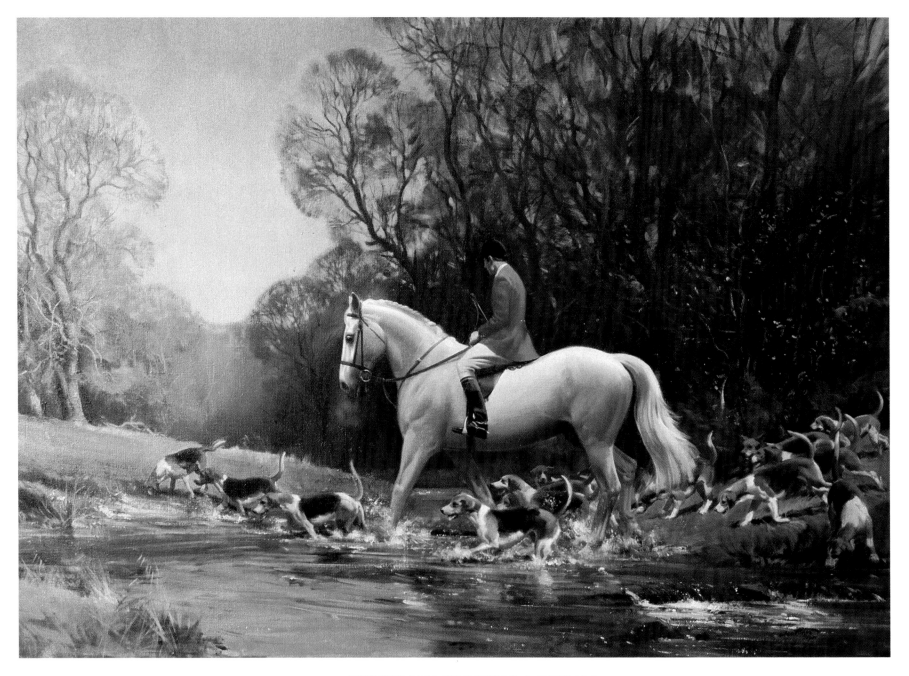

HUNTSMAN CROSSING A STREAM
signed oil. 28in x 40in. Courtesy of Frank Wootton.

In this painting, Frank Wootton really comes into his own as a sporting artist whose work can now rank alongside the best of the artists in this genre. His Irish hunter, carefully picking its way among the hounds as it crosses the stream in their company, is a superb oil in which he catches the exuberance of the chase on a fine but cold morning, with the leading hound picking up the scent again on the other side of the stream.

In common with Munnings, who gave him help and encouragement in his early days, Wootton has always been conscious of the nobility of the horse if his loving treatment of the white hunter is anything to go by. In this painting, the hunter has a noble, almost mythological look to it, as one might find in a horse belonging to the gods.

John Emms

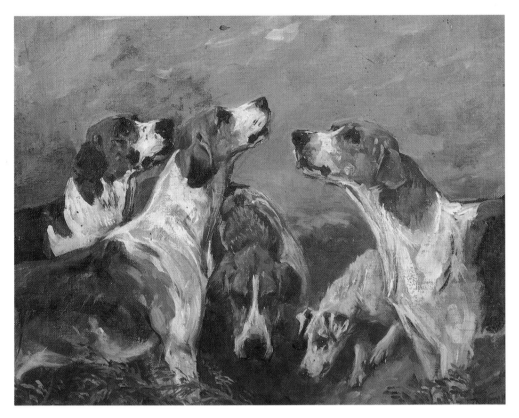

GONE TO GROUND
signed oil on board. 13in x 11in, Sotheby's, Billingshurst, Sussex.

Heywood Hardy

DEPARTING GUESTS
signed oil. 24½in x 36½in, Sotheby's, Billingshurst, Sussex.

John Emms may not have been quite in the same class as the famous sporting artist Lionel Edwards, but he was still a considerable artist whose work has never achieved the popularity it deserves.

He was a prolific painter, mostly in oils, until his health broke down during the early part of the twentieth century and he was no longer able to work. The family were soon in considerable financial difficulty, so much so that the local tradesmen started taking pictures off the walls of Emms' home in lieu of payment. The situation became so bad that the family became destitute and would have been without a roof over their heads had it not been for the kindness of a neighbour who let them have a house in which to live. Somehow, despite their situation, Emms always managed to pay the rent.

His was not the old and sadly all-too-familiar story of the neglected artist forced into penury by the indifference of the public. The truth of the matter with

Emms was that he was far from being provident with his money. Instead, whenever he sold a picture he would take the family to London, where they always checked in at one of the best hotels and then promptly went on a spending spree. This is a familiar story with a number of painters and writers who have been on short commons for a long time and then suddenly find themselves in funds again.

A colourful character, who is said to have walked around in a long black coat and wide-brimmed hat, Emms seems to have been intent on playing the role of a typical Bohemian artist — at least the way the lay public used to think that artists lived. In fact most artists were sober minded and led quiet, unobtrusive lives, with most of the time spent at their easels.

His oil, *Gone to Ground*, is a good example of his scenes of hunting dogs. It is perhaps a little dark, even for an oil painting, but not enough to detract from the quality of the painting.

Hardy was an important sporting artist of his time (1843-1933) and also one of the most popular. His horses were always finely painted, even in his coaching scenes, where they are shown as magnificent examples of horse flesh, as they are in his oil painting *Departing Guests*. Here the steeds are of a quality befitting their obviously wealthy owners, who are about to depart from the inn.

When Hardy painted his coaching house scenes, such as the one shown here, he often dressed his characters in eighteenth-century costume, which gave him an opportunity to introduce several bright colours into the picture. *Departing Guests* is an oil painting which has been done with a fine brush so that it might seem to be a watercolour at first glance. It is a typical coaching scene done in the manner of George Wright, and is an excellent example of a branch of painting that was immensely popular right up to the late thirties.

George Wright

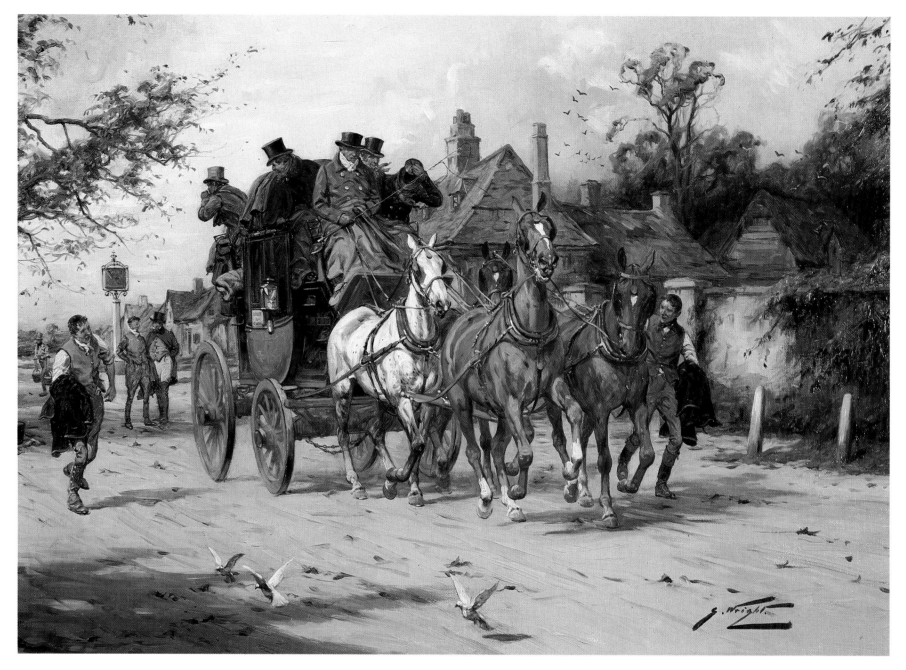

COACHING SCENE
signed oil. 14¾in x 20¼in, E. Stacy-Marks Ltd.

Right up to the 1930s many sporting artists were still painting coaching scenes in which they attempted to evoke the age of eighteenth-century England, when every coach journey was thought to be a great adventure. The reality of those journeys was something quite different. Those alleged adventures on the road were nothing more than a bone-shaking journey in which the only break from the tedium came with a stop at a coaching inn to change horses, when the unhappy travellers were allowed to warm themselves briefly in front of the fire and wash down a quick meal with a tankard of ale.

In this scene, painted by George Wright, the travellers are setting off on their journey again, well muffled up against the weather. He painted many similar scenes, often working with his brother, who was the lesser artist of the two.

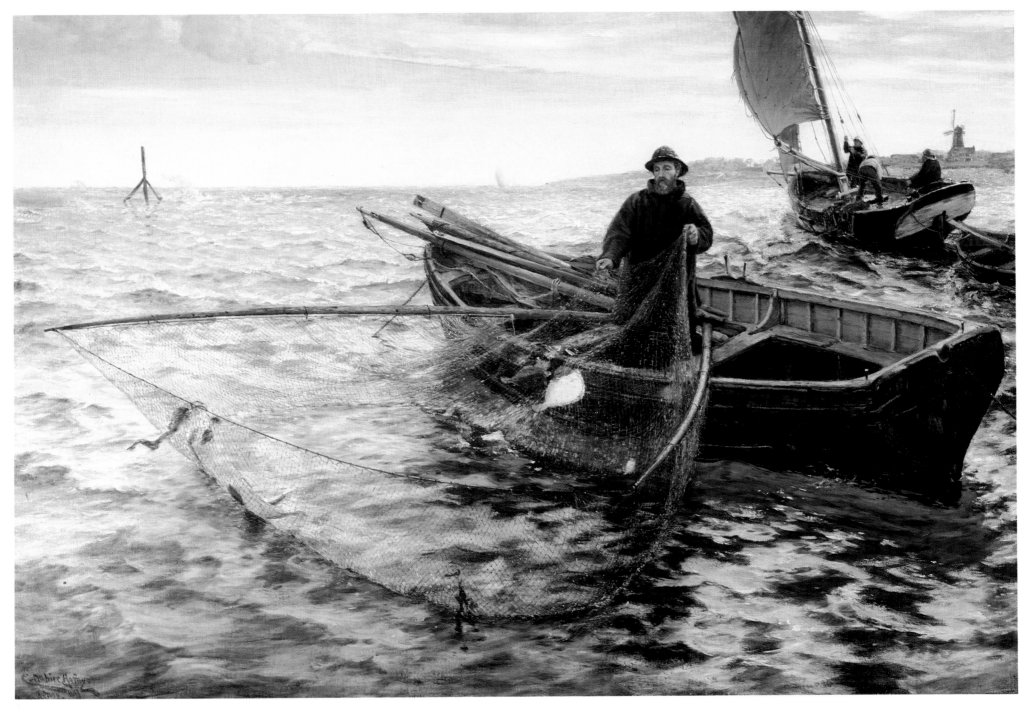

THE FISHERMAN
signed oil on canvas. 36in x 45in, Royal Exchange Gallery.

Some of Hemy's strongest painting can be seen in his oils, where he has painted fishermen and yachtsmen at close quarters, something that was only made possible because he went sailing in his yacht, the *Van der Meer*. He was not the first marine artist to own his own boat, but no one else seems to have used it more effectively than he did in getting near enough to his subjects to paint them as they coped with the problems of nets and sails while at sea.

His oil *The Fisherman*, shown here, is one of the best examples of Hemy's work as a marine artist. The fisherman in the foreground, bringing in his net with a catch that seems a poor reward for all his efforts, must have been caught exactly as Hemy saw him. He then sketched in the essential details for what was to be an oil painting that compares not unfavourably with his masterpiece *Pilchards*, bought by the Chantrey Bequest in 1897 and now in the possession of the Tate Gallery.

Roger Desoutter

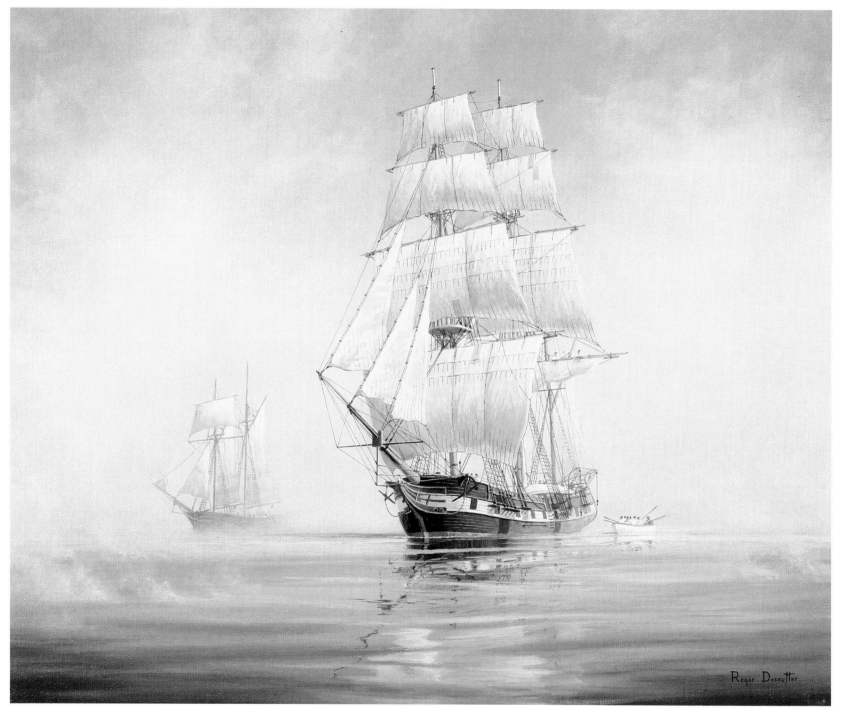

HMS BEAGLE
signed oil. 24in x 30in, E. Stacy-Marks Ltd.

As well as being a talented landscape artist, Roger Desoutter is also an accomplished marine artist, who like Hemy, acquired a boat as an aid to his marine painting.

Desoutter painstakingly researches his subject before he paints it — something that is quite evident from his study of *HMS* Beagle, the ship that took Darwin on his surveying expedition which lasted from 27 October 1831 until 2 October 1836. The painting shows the ship coming forward in full sail and a smaller sailing ship following close behind, with the early morning mists rising from the mirror-like calm of the waters.

From this painting alone one can see that Desoutter's work can hold its own against many famous marine artists of today and yesterday.

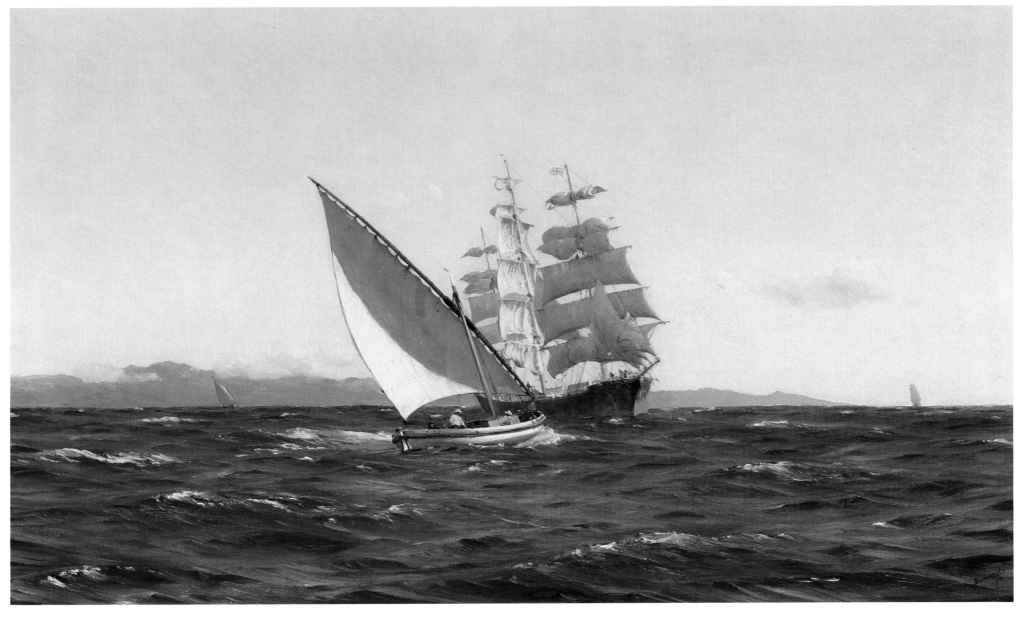

TAKING A PILOT OFF VALPARAISO
signed oil, dated 1900. Inscribed with title on stretcher. 23in x 41in, Polak Gallery.

The Somerscales oil shown here is a splendid example of his work and was painted off the coast of Valparaiso, where he lived for many years (see page 11 in the Introduction).

The small boat coming to collect the pilot and the sailing vessel are both almost entirely dominated by the deep blue sea which, almost imperceptibly, seems to darken as it reaches the horizon — as it always does from a viewer's position because of the angle of the waves against the light. The painting is crisp in every area of the painting, though one has the feeling that Somerscales was really more interested in capturing the look of the sea and conveying the feeling of deep waters. If this was his intention he has succeeded admirably. There is no doubt that if Somerscales had wished to paint pictures of pure sea, he could have been very successful.

Walter Langley

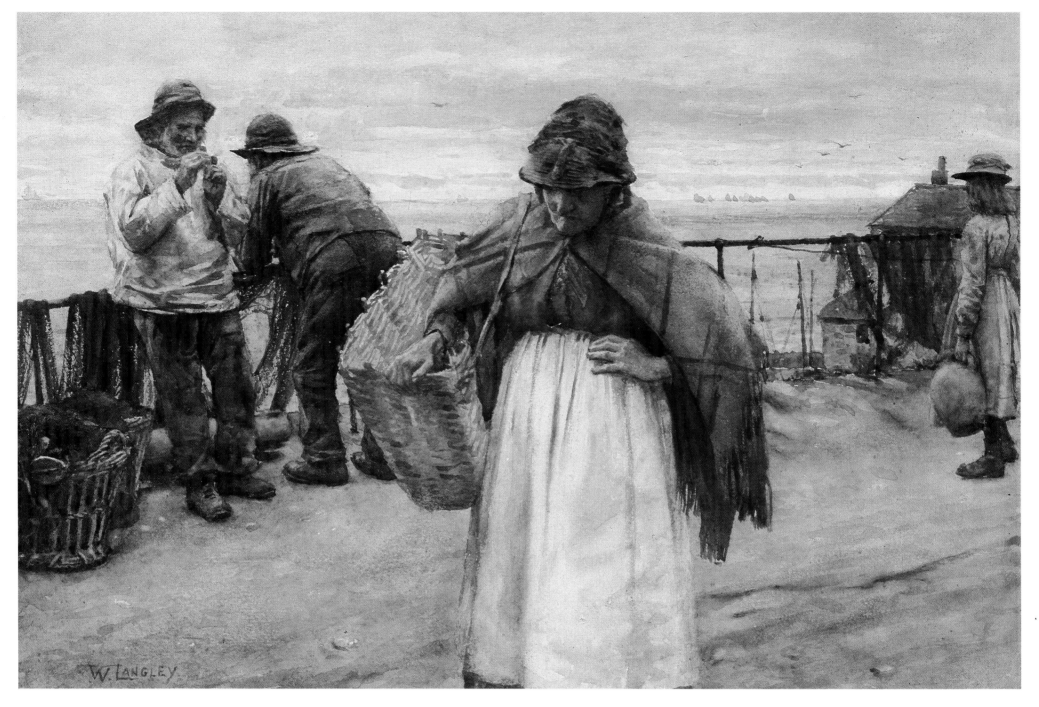

THE HIGH STREET, NEWLYN
signed watercolour. 10in x 14in, Priory Gallery.

Langley has always been well known for his scenes of fisherfolk and their daily lives, which were painted with an uncompromising honesty that made no concessions to popular taste.

His watercolour shown here illustrates the point. No-one could be less endearing than the old fisher-woman who occupies the centre of the stage dressed in a stained white pinafore, battered hat and a shawl probably improvised from an old blanket. Nor are the fishermen by the rail behind her romanticised versions of two rugged 'sons of the sea'. Even the girl looking out to sea is painted exactly as Langley saw her, rather than as Edwin Harris might have depicted her, wearing a pure white bonnet and dressed in a simple but clean dress.

Langley *always* painted his scenes exactly as he saw them. His models were never characters inhabiting a canvas for the enjoyment of those attending a Royal Academy Summer Exhibition, but real people who led hard lives. Their very existence depended on the pilchard, mackerel and herring seasons, and a bad season, when catches were small, could bring them all to the brink of starvation.

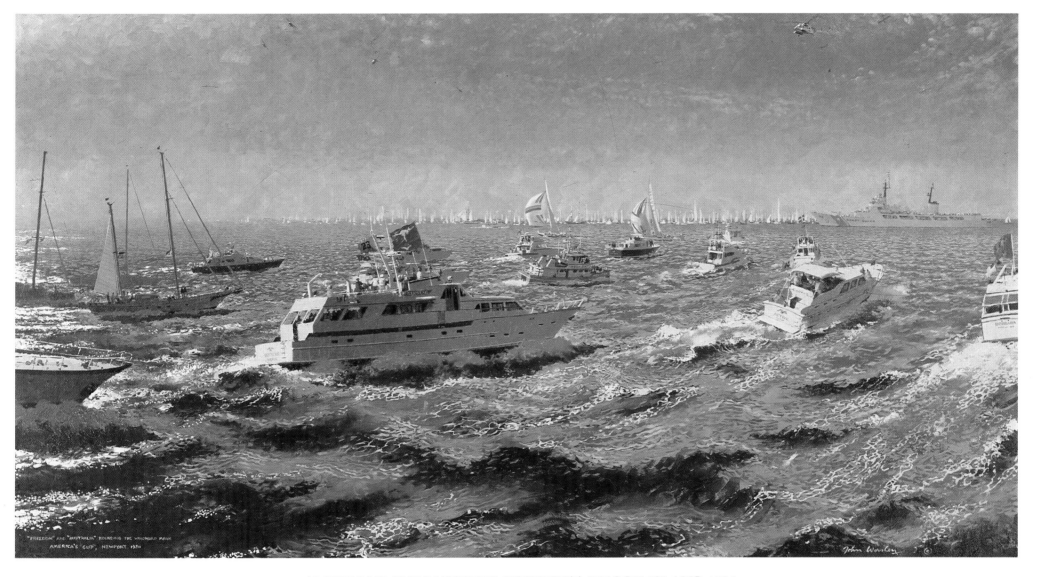

AMERICA'S CUP MATCHES, NEWPORT, RHODE ISLAND 1980
signed oil on canvas. 42in x 66in. Courtesy of John Worsley.

Worsley has always been a marine artist who has gone out searching for new scenes to paint and this has led him to paint such diversified subjects as *Spritsail Barge at Rochester; Rocky Seascape, West of Ireland; Careening Dows, Old Mombassa; Start of the 'Tall Ships' Race; Louisiana Oyster Boat* and *A Sternwheeler Towboat, Ohio River*.

His oil on this page is something different again: a view of the America's Cup races in 1980. It shows the American entry *Freedom* ahead, and *Australia* round the windward mark with the spectator fleet close behind. It was the first time that Worsley had had the opportunity to see the America's Cup races from the spectator's fleet. It was an experience he found tremendously exciting, being able to watch all those racing yachts competing against each other from the deck of what was fondly known to the following spectators as the 'Gin Palace'.

As one would expect with a modern marine artist painting a contemporary subject, Worsley has painted this oil on canvas in bold colours with a predominance of blue in the palette. It is clearly the work of an artist who knows his craft, which is reflected in all Worsley's oils.

John Stephen Dews

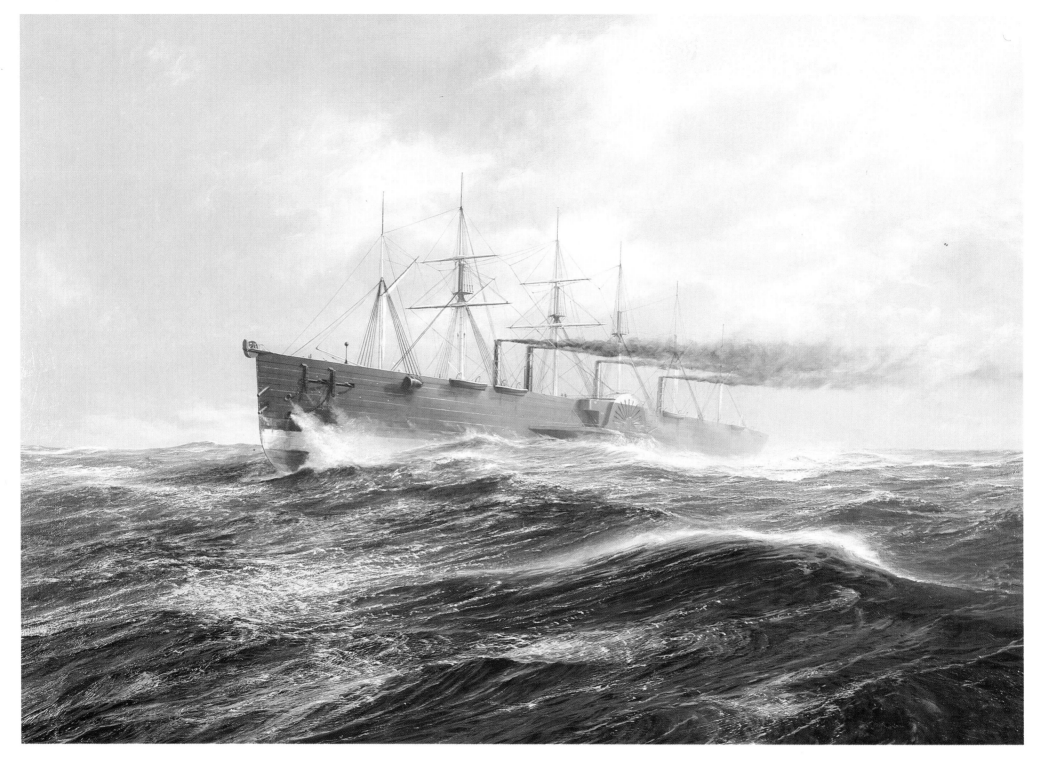

THE GREAT EASTERN BUILT 1859. CABLE LAYING. ATLANTIC 1866
oil. 20in x 30in, E. Stacy-Marks Ltd.

For this excellent marine oil, John Stephen Dews has taken for his subject Brunel's famous sail- and steamship, the *Great Eastern Built 1859. Cable Laying. Atlantic 1866*, as she appeared in that year, after certain modifications had been carried out on her. Originally launched in 1858, she was before her time by some fifty years, but suffered from the disadvantage of being underpowered for her size. At the time shown here she was on the brink of great changes at sea, having been in at the birth of the compound engine, which revolutionised shipping and caused ship owners to think seriously for the first time of competing with the old sailing ships in the carrying of cargo for long distances.

Unlike so many marine paintings, this splendid oil by Montague Dawson has a story behind it.

During the Napoleonic Wars, when the great fleets of the French, Spanish and other nations were contesting the British Navy's supremacy across the seas of the world, the admiral of such a fleet relied heavily upon his 'Eyes of the Fleet' to provide up-to-the-minute information on his enemy. He employed small, fast-sailing frigates and even smaller cutters with the minimum of armaments to act as pickets to prevent surprise attacks and as scouts to range far and wide ahead of the slower main body of the fleet, seeking out, shadowing and reporting back upon an enemy fleet's movements.

The importance of such vessels cannot be sufficiently stressed, as the admiral with accurate and fast information had the maximum time to plan strategies, organise battle lines and ensure a much greater probability of a successful outcome. Usually commanded by a recently promoted captain before he was confirmed in his rank to 'Post', these small craft were the foundation of many a career and reputation, based on the degree of daring shown by the young commanders who welcomed this stage in their careers, when they could enjoy a certain freedom of action away from the immediate eye of the admiral.

The painting shows Montague Dawson at his very best, with the 'scout' ship surging forward and the fleet itself following at a distance. Something of the excitement of the occasion has been caught in this painting, which also gives a feeling of how deep and immense the ocean must have seemed to those who sailed on her in those days.

THE FLEET MESSENGER
signed oil on canvas. 26in x 36in. Courtesy of Frost & Reed Ltd.

David James

SEA FEVER
signed oil. 24⅞in x 50in, E. Stacy-Marks Ltd.

This is one of the many pure sea subjects that David James painted along the coast of the West Country. It is very similar to one he did near Ilfracombe, North Devon, except that this was painted from a different angle. It is a large oil, and is an impressive study of the rolling waves of the ocean with the dark blue of the seas stretching without interruption to a distant horizon. The lack of even a single ship in sight somehow manages to convey the immensity of the ocean as we look at it from the shore.

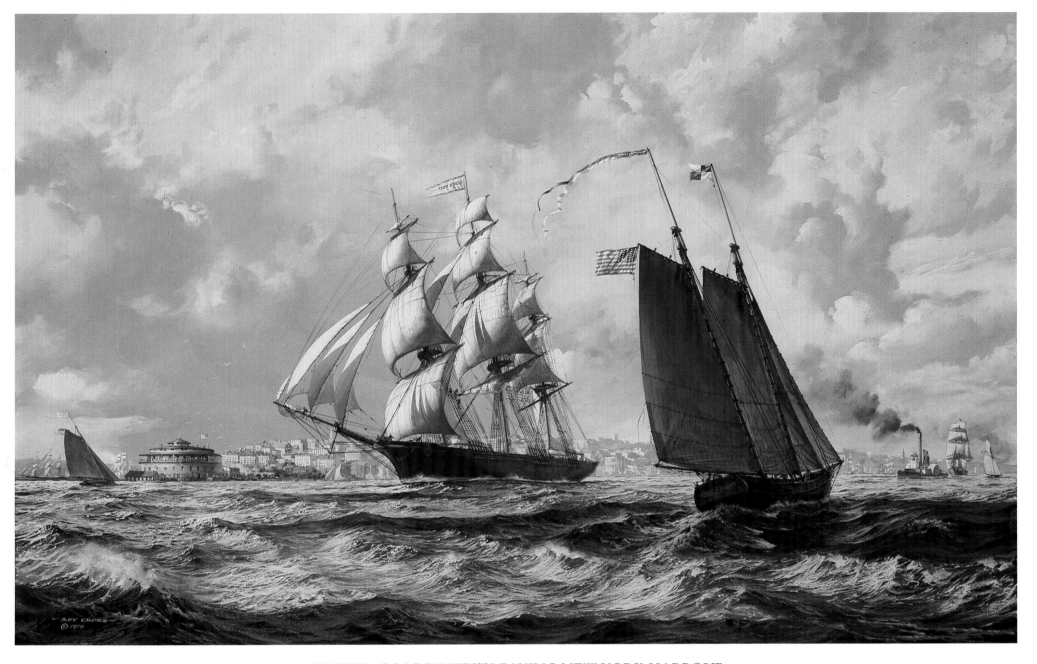

CLIPPER *GOLDEN WEST* LEAVING NEW YORK HARBOUR
signed gouache, dated 1979. 18¾in x 30in. Courtesy of Roy Cross.

Roy Cross places the time when he started to think seriously of painting marine subjects to the occasion when two marine subjects he had painted as a spare time relaxation received fulsome praise from a client's friend. Already a great admirer of the work of Montague Dawson, he decided to study marine painting, which eventually led him to completing half a dozen carefully researched sea pieces.

At this stage he was fortunate enough to meet Malcolm Henderson, owner of a gallery in St James's,

who became his agent and personal friend. Henderson persuaded Cross to take up marine painting full-time, and since then Cross has never looked back.

Cross has always specialised in re-creating the past of the great maritime ports and the enormous variety of vessels that sailed from them, ranging from Mississippi steamers to the great sailing ships of their day.

A fine example of his work is his oil of the *Golden West* leaving New York harbour. This clipper ship

was launched on 16 November 1852, from Boston. She made a series of voyages, some of them under extremely difficult weather conditions, including rounding the Horn in heavy gales, being driven on to a reef in the Gaspar Straits, and having her steering apparatus and her sails split whilst going round the Horn on her third voyage. In 1863 she crossed to Liverpool and was later sold for $25,000. She was last heard of in 1866, transporting coolies from China to Peru.

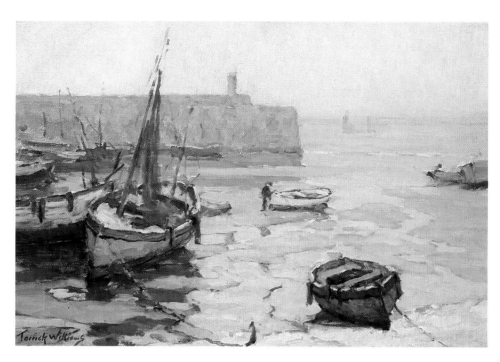

HARBOUR SCENE LOW TIDE
signed oil on canvas. 10¾in x 16in, Royal Exchange Gallery.

John Terrick Williams

Many of Terrick Williams' paintings were of Venice and of French coastal scenes. This one, however, looks as if it might well have been painted in St Ives, Cornwall, where at low water the fishermen could walk across the harbour to work on the boats. The high walls of the quay, festooned with brown sea-weed, form a stark contrast to the many and varied shapes of the boats as they lay heeled over with their masts silhouetted against the sky. Schooners visited the harbour, and between the two world wars the French tunny fishers were frequent and colourful visitors to the town.

As with most of Williams' harbour scenes, the painting shows the influence of the Impressionists while still maintaining the artist's own original and distinctive style.

William Lionel Wyllie

When Wyllie was made a Royal Academician, it put the final seal of official approval on his work, which had been enjoyed by thousands of people who had never even put a foot on a boat or ship of any form, and his popularity has lasted to this day.

Although he worked fast, both in oils and water-colours, he always gave great attention to the rigging, and especially to the sails, so that it was possible to deduce in which direction the wind had been blowing.

Spritsail Barges Under Sail, the oil shown on this page, gives some idea of the care Wyllie took over a painting. In the foreground is a 'stumpy' barge, a nickname given to a barge without a topsail. By contrast, the barge on the right does have a topmast on which a topsail has been set. A stiff breeze was obviously blowing, as all the barges have their mainsails brailed in, which was a form of taking a reef in the sails. The barges are all low in the water with little freeboard, which indicates they were loaded.

It is a fairly straightforward but assured piece of oil painting. The barge in the foreground is placed well to the right, while the channel of space that has been left still holds the centre of attention, with the boats on the left and right giving a perfect balance.

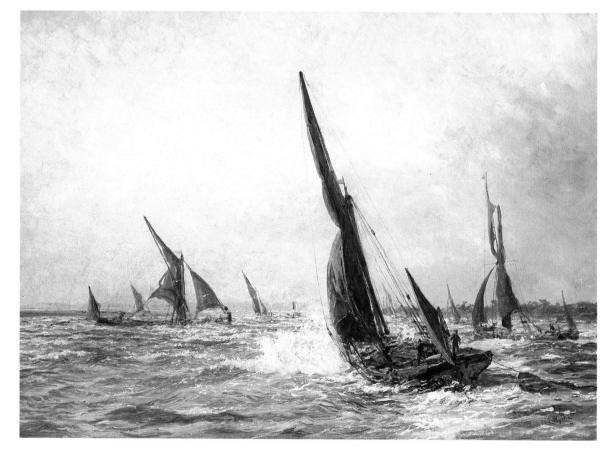

SPRITSAIL BARGES UNDER SAIL
signed oil on canvas. 14in x 20in, Royal Exchange Gallery

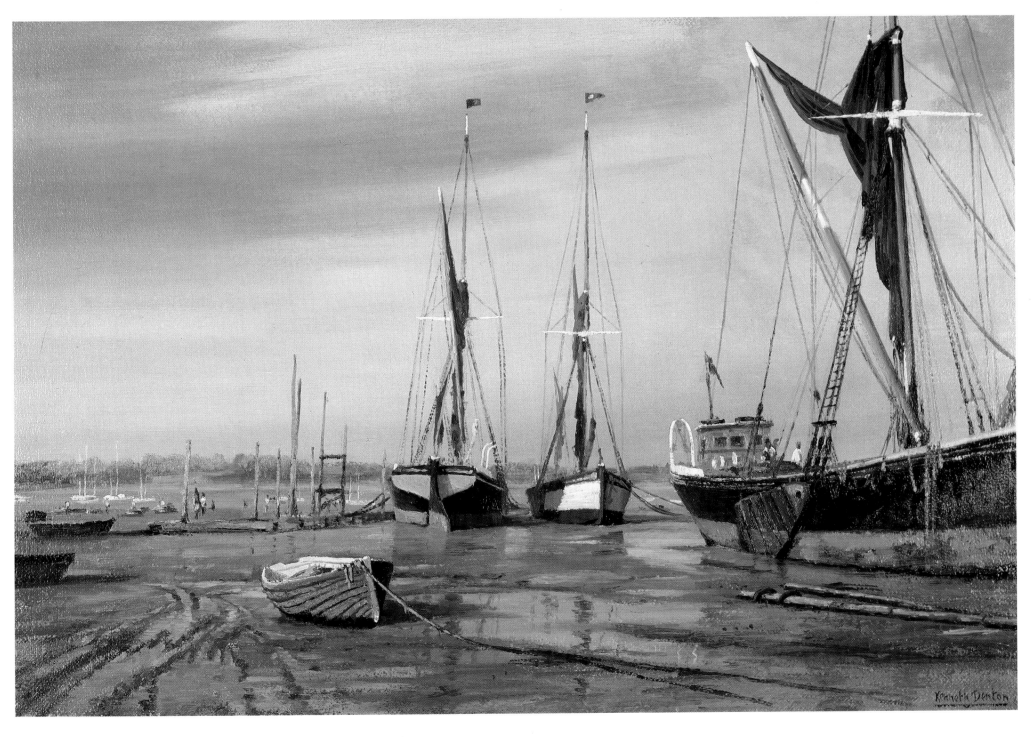

BEACHED BOATS ON THE MEDWAY
signed oil. 20in x 30in, E. Stacy-Marks Ltd.

Apart from his landscape paintings, Kenneth Denton has always been fond of painting scenes along the Medway, many of which really fall into the category of marine pictures, a field where his work rivals that of his landscape painting (seen in the landscape section of this book).

The painting on this page is one of his oils painted along the Medway. The scene is dominated by beached boats, several with their slender masts reaching skywards so that they occupy a large section of the painting, which would otherwise be occupied by a vast expanse of sky and nothing else.

It is finely constructed with the beached green rowing boat set to the left of the painting balancing well with the beached boats on the far right, and with plenty of space between the boats so that the excellent portrayal of the wet sand and the pools of water left by the receding tide are visible.

Charles Dixon

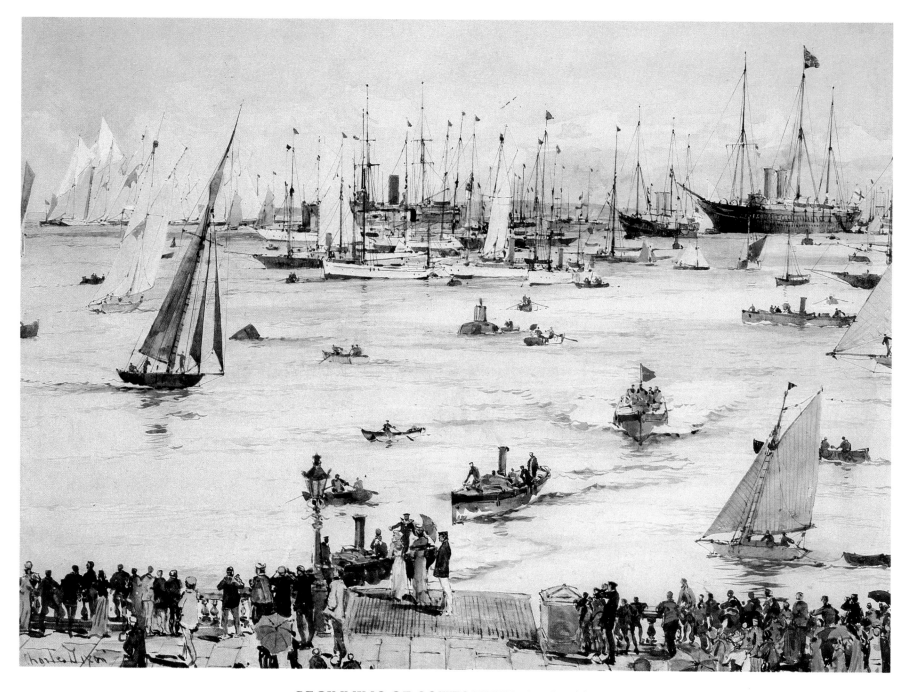

BEGINNING OF COWES WEEK, AUGUST 1904
signed watercolour and ink, inscribed on reverse. 12½in x 17½in, Royal Exchange Gallery.

Dixon has always been best known for his busy paintings of the Thames, crowded with every conceivable form of shipping fighting for space amongst its congested waters which were still full of fish, thanks mainly to the efforts of the river keepers of the various fishing associations who did their best to carry out the by-laws of the Thames Conservancy Board. That fish were still there at all was something of a minor miracle, considering that as late as 1890 the river below London was considered to be a danger to public health because untreated metropolitan sewage was discharged into it.

To paint the watercolour shown on this page, Dixon deserted his usual haunts along the Thames and went to the Isle of Wight to record the beginning of the 1904 Cowes Week. As with most of Dixon's work, the painting is full of lively detail. In the background on the right can be seen the dark hull of the Royal steam yacht *Britannia*, while ahead of her is a host of craft at anchor. Naval picket boats approach the steps in the foreground where two women and a yachtsman are waiting to be picked up. It is the sort of painting that would particularly appeal to anyone who is interested in the shipping of the period.

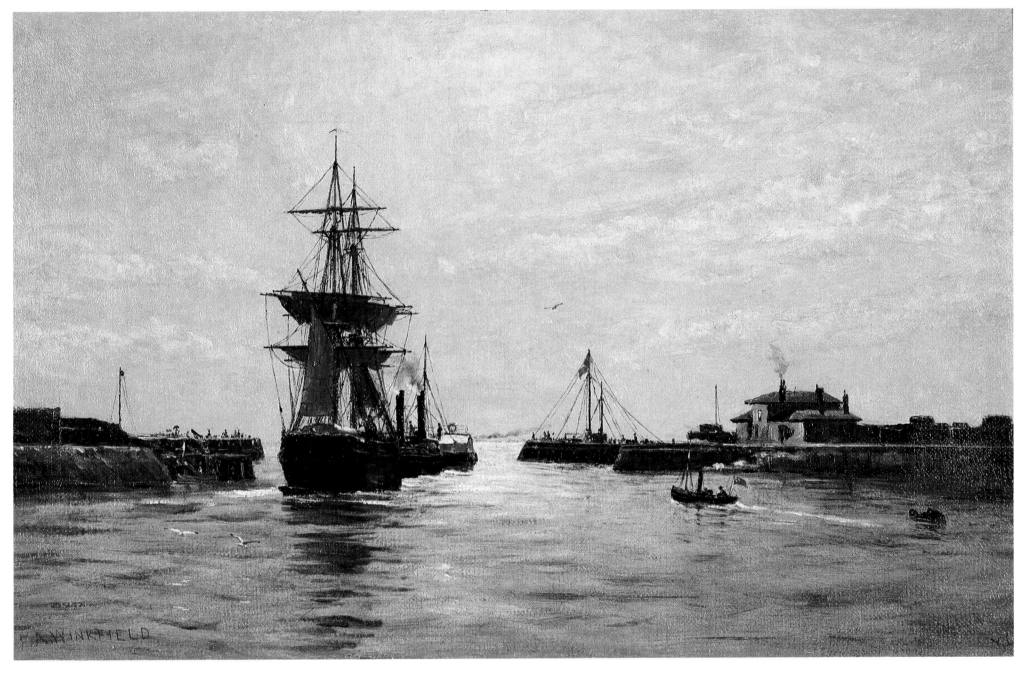

SAILING IN SUNSHINE
signed oil, dated 1886. 8¹/₂in x 13³/₄in, E. Stacy-Marks Ltd.

Winkfield was still painting well into the twentieth century and he remained a traditional marine artist to the end of his life. A highly talented and distinguished painter, his work was of an unvarying quality.

His oil, *Sailing in Sunshine*, depicts an old weather-beaten cargo-carrying sailing-ship coming into harbour with one of the early steamships close behind. What is interesting about the painting is the way that Winkfield has managed to create the effect of sunlight on the water, while at the same time making it clear by the look of the sea that bad weather is on the way.

INDEX OF ARTISTS